GUITARS
THAT JAM

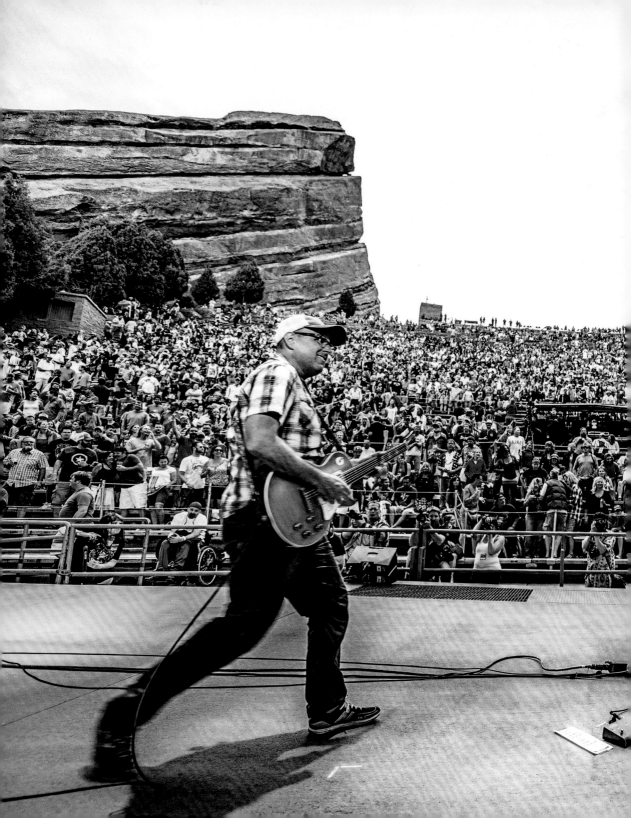

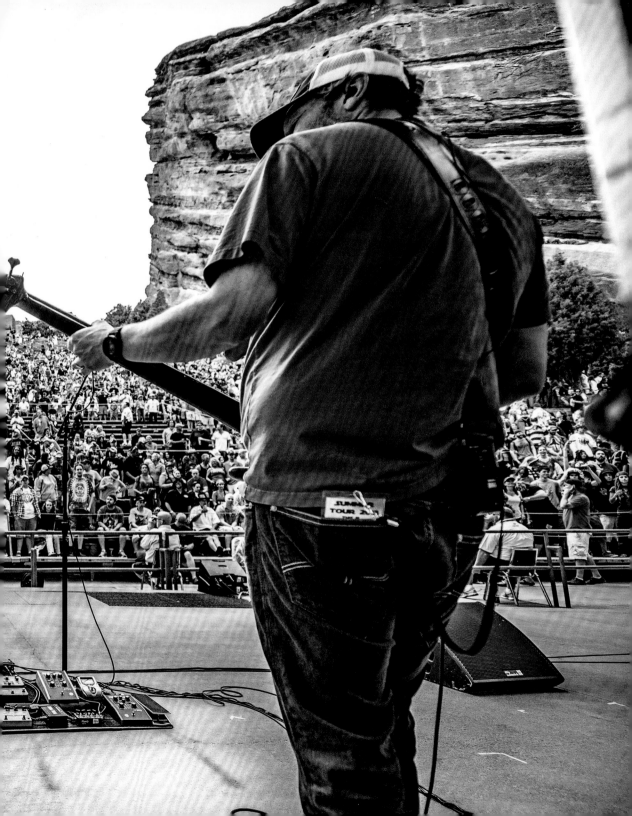

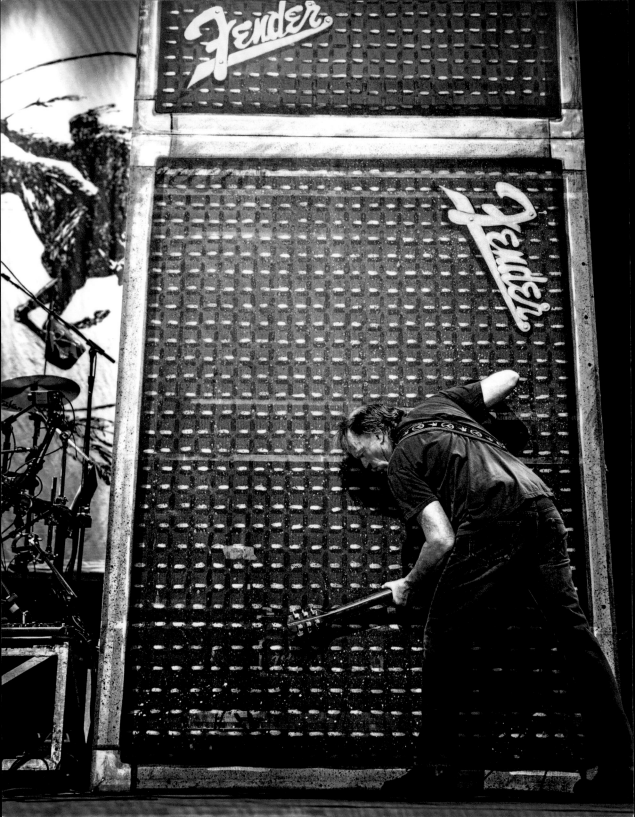

GUITARS
THAT JAM

PORTRAITS OF THE WORLD'S MOST STORIED ROCK GUITARS

Photographs by JAY BLAKESBERG

Foreword by WARREN HAYNES

INSIGHT EDITIONS

San Rafael, California

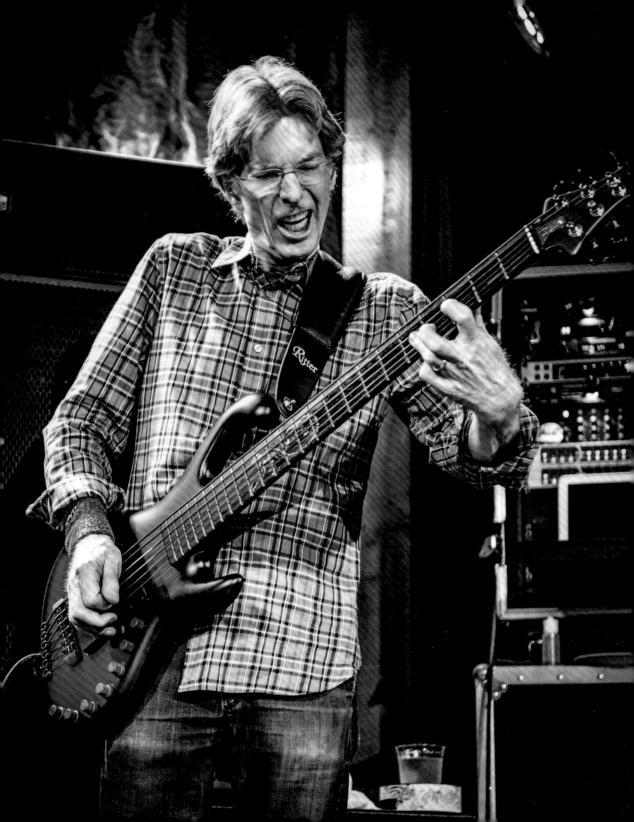

CONTENTS

FOREWORD BY WARREN HAYNES 8

JERRY GARCIA	13	J BOWMAN	101
PHIL LESH	16	JACKIE GREENE	103
BOB WEIR	19	PATTERSON HOOD	108
ROB EATON	22	GRACE POTTER	111
JIMMY HERRING	25	BENNY YURCO	115
DAVE SCHOOLS	28	SCOTT TOURNET	116
JOHN BELL	31	JON GUTWILLIG	119
PETE SEARS	33	MARC BROWNSTEIN	123
STEVE KIMOCK	34	BILL NERSHI	124
CARLOS SANTANA	40	MICHAEL KANG	127
AL SCHNIER	43	SCOTT LAW	129
CHUCK GARVEY	47	GREG LOIACONO	130
ROB DERHAK	50	TIM BLUHM	133
NEAL CASAL	53	SCOTT THUNES	135
CHRIS ROBINSON	57	BRENDAN BAYLISS	137
WILLIE NELSON	59	JAKE CINNINGER	139
DREW EMMITT	61	RYAN STASIK	143
VINCE HERMAN	63	JOE SATRIANI	144
ADAM AIJALA	64	JIM JAMES	146
BEN KAUFMANN	67	CARL BROEMEL	149
LUTHER DICKINSON	69	TOM BLANKENSHIP	151
JEFF AUSTIN	73	STEVEN DROZD	152
KELLER WILLIAMS	74	NELS CLINE	155
RICH ROBINSON	77	LARRY LALONDE	160
ANDERS OSBORNE	79	LES CLAYPOOL	163
REED MATHIS	80	STANLEY JORDAN	165
STEVE ADAMS	83	DEREK TRUCKS	167
DAN LEBOWITZ	85	SUSAN TEDESCHI	172
GRAHAME LESH	86	NEIL YOUNG	175
DEREN NEY	88	JORGEN CARLSSON	178
ROSS JAMES	91	WARREN HAYNES	181
MIHALI SAVOULIDIS	93	MIKE GORDON	184
LUKAS NELSON	95	TREY ANASTASIO	188
GEORGE PORTER JR.	96		
MICHAEL FRANTI	99	**DEDICATION**	191

FOREWORD

BY WARREN HAYNES

Above: Warren Haynes Band, Lockn' Music Festival, Arrington, VA, September 5, 2013

I GREW UP AT A GREAT TIME FOR MUSIC. My earliest memories of listening and being moved by music started with the soul records my two older brothers played when I was six—people like Otis Redding, Wilson Pickett, the Temptations, Sam & Dave, and James Brown, who was my first musical hero. The guitar sound on those records was rock guitar in its own way—dirty, nasty, raw, but also really funky and visceral. At the same time I started listening to the Beatles and the Stones and was tuning into their guitar sounds. All of that predated me actually picking up a guitar— I was singing at that point but hadn't made the connection that I wanted to be a guitar player. Then, as I got a little older, I started listening to Cream, Jimi Hendrix, and Johnny Winter, and that's what made me want to pick up a guitar.

My oldest brother had an acoustic guitar, and I was playing it more than he was, so my dad went to the local hardware store and bought me an electric guitar, a Norma, for my twelfth birthday. A year later he bought me a Lyle guitar, a copy of the Gibson SG—it was black and eerie and beautiful and kind of evil looking. Then I graduated to a Gibson SG Junior, and then to a Gibson SG Custom. So, my first three real guitars were all SG-shaped, and I loved the way they looked—there was something demonic about them. Of course, when you're young, the way the guitar looks is just as important as the way it sounds. So, in many ways, my earliest fascination with guitars was as visual as it was audible. As a kid I would spend hours looking at album covers and photographs—a lot of Cream with Clapton playing that hand-painted SG and Johnny Winter playing Gibson Firebirds and Hendrix playing his Strats and that Gibson Flying V. I remember staring at album covers and magazines and being completely fascinated—it seemed like magic to me, a whole world that I couldn't even fathom.

As I developed as a guitar player, my cohorts and I would look at photos and try to figure out what equipment artists were using. One of the first big records for me

"MUSIC IS ALL ABOUT SHUTTING OFF THE THINKING SIDE OF YOUR BRAIN, SURRENDERING TO THE MUSIC, AND RESPONDING TO WHAT'S GOING ON WITH YOUR OWN SOUND."

was *Live Cream Volume II*. I would look at that album cover and marvel at the stack of Marshall amps onstage and Clapton's SG (which I actually got to play years later), and I'd take note of every detail, trying to determine what equipment the band was using. Back then the fascination with those photos was incredible—it was a different time, with a limited number of photos available. We learned a lot and imagined a lot from looking at those photographs.

Now, I'm less concerned with how the instrument looks and more concerned with how it sounds and responds to my personal approach to playing. The instrument you play is your voice, so I've always gravitated toward instruments that sound more like my singing voice. When I listen to B.B. King or Bonnie Raitt, their voices and their guitars sound like they're coming from the same spirit, and that's what I strive for.

There are a million great guitar sounds out there, but to find one that's an extension of your personality is a hard task. Playing music is rewarding and fulfilling, but you have to put your heart and soul into it, and that requires a lot of effort. That effort—and the connection between the artists and with their instruments that enables them to find their own voice—comes through in the stories and photographs throughout this book.

There is a saying that there's music inside the instrument. That's why I hate to see any instrument behind glass. Guitars need to be played; to keep them vital, someone needs to keep music running through them. The electric guitar is a blank canvas, capable of producing thousands of sounds. It gives you more choices and range than any other instrument. It's an amazing tool, and the never-ending quest for tone and the almost infinite versatility of the instrument are what inspires creative, spontaneous, and improvisational moments in rock 'n' roll. Ultimately it's the tone that inspires you to play beyond your means and pushes you to places you wouldn't otherwise be capable of going. Music is

all about shutting off the thinking side of your brain, surrendering to the music, and responding to what's going on with your own sound and with everyone else's you're performing with.

As a soloist, I get the most gratification when I'm playing together with the other musicians in such sync that we become one organism. There's an art to being able to listen to what everyone else is doing while responding in a noncerebral way. The feeling you get varies from great to almost euphoric during those rare times when you're lost in the music—those are the moments you're chasing, and those rare, magic guitars are an essential component in finding them. When your instrument makes you feel comfortable, and the people around you make you feel comfortable—your crew, your band—that's when you can soar. My former guitar tech Brian Farmer was a big part of this for me for more than a decade. For Farmer, guitars and gear were a way of life. He lived and breathed gear! He was a very unique, funny individual who loved life and who loved music; I believe they were one in the same for him. Without people like Farmer, the show doesn't go on.

The electric guitar is the spark of rock 'n' roll. And Jay Blakesberg's unique take on rock 'n' roll photography is another spark. His love for music and unique visual perspective revive the fascination I felt as a kid looking at those old album covers and magazines. One of the things many great photographers and musicians have in common is a love of improvisation, an ability to recognize the moment when it comes and to be open to it—to let things happen organically and capture them when the lightning strikes. When you're dealing with rock 'n' roll, it's about capturing that impromptu moment. In front of you is an impressive collection of those moments and of the many amazing guitars that play a key role in inspiring them.

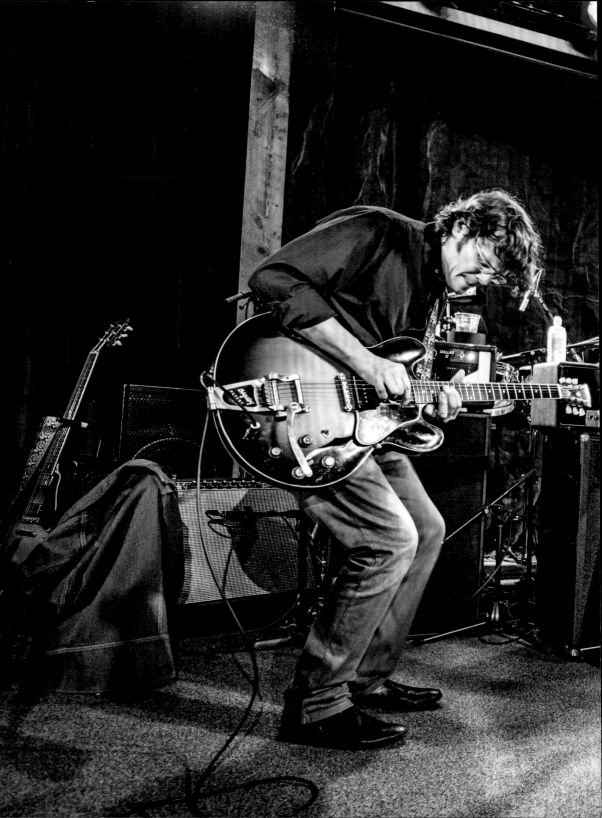

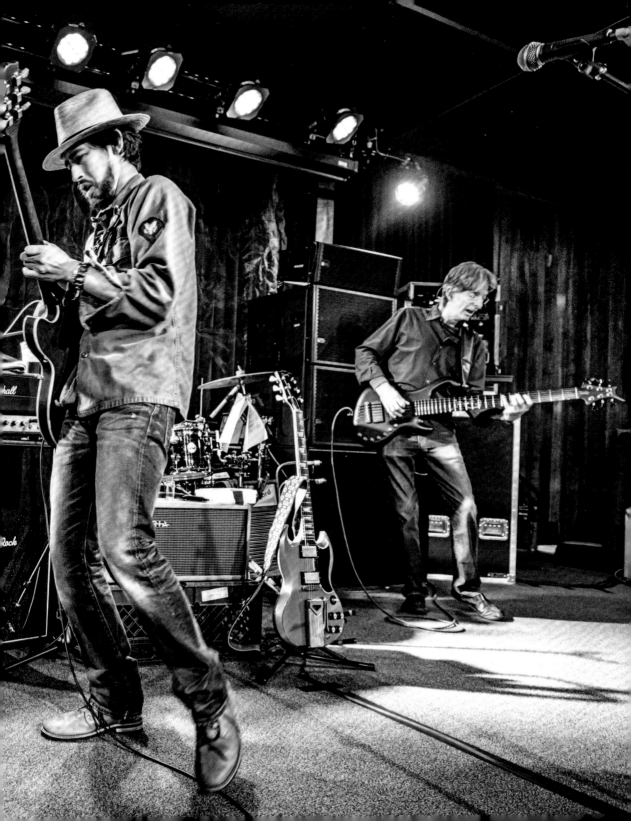

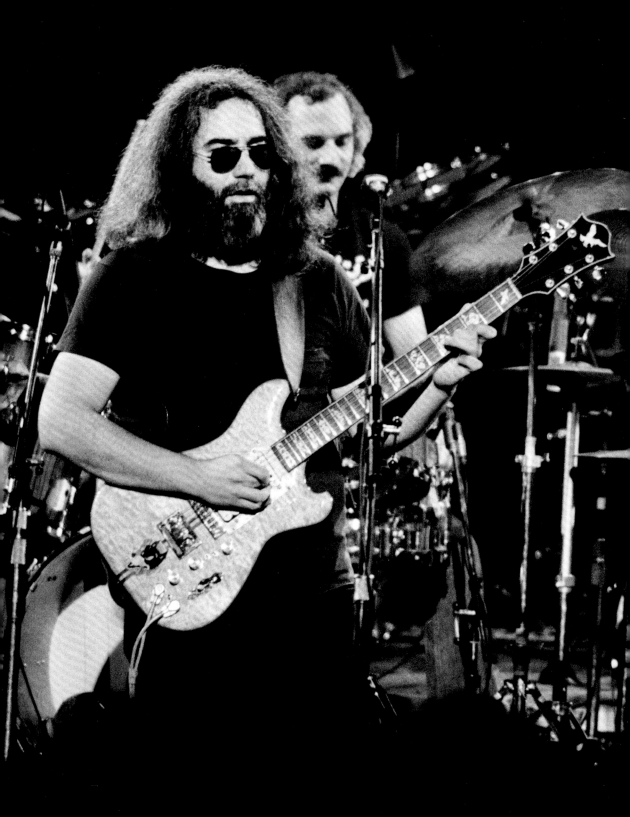

JERRY GARCIA

1973 | D. IRWIN, CUSTOM "WOLF"

IF TOM ANDERSON'S RECOLLECTION is correct, at the beginning of the *Wake of the Flood* sessions Garcia was presented with the custom guitar that would become his primary axe for the next couple of years (and intermittently for many more years) . . . Garcia's new axe had been crafted by a luthier named Doug Irwin, who, Rick Turner says, "came to work with me when we set up the chicken-shack factory [in Cotati]. He trained with me and eventually started making the guitars for Garcia and then split off and did his thing." . . .

. . . Rick Turner hired [Irwin] for a half-time job at Alembic; he spent a year or more there, learning the ropes from Turner and Frank Fuller and devoting his free time to building his own electric guitar. One day, toward the end of 1972, Garcia was in Alembic's Brady Street store and spied the first guitar Irwin had made for Alembic. "He bought the guitar right on the spot [for $850], and asked me to make him another guitar," Irwin recalled in an interview . . .

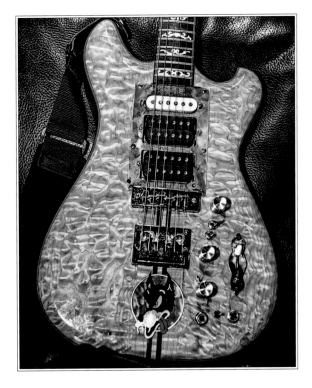

"So I built the next guitar for him," Irwin recalled in the same interview, "which I had actually started building at the time he ordered it; it was made out of purpleheart [also known as amaranth, a South American wood] and curly maple. It had an ebony fingerboard and mother-of-pearl inlays. . . . This is the one that became the 'Wolf.'" . . .

The guitar didn't receive its "Wolf" moniker until later. Garcia had put a decal of a bloodthirsty cartoon wolf below the tailpiece, and after bringing it in to Irwin for refinishing between tours one year, "I knew the decal was going to be gone, so I just redid the wolf as an inlay," Irwin said. "In fact," Garcia recalled in 1978, "it was a week or so before I even noticed what he had done!" . . . Garcia first played the Irwin guitar on the October '73 tour.

Beginning with the fall 1977 tour, Garcia stopped playing Travis Bean guitars and went back to the Irwin Wolf, which a little earlier had been retooled to include the effect loop and unity-gain buffer that had worked so well in the TB-500. Garcia never expressed any particular dissatisfaction with the Beans; perhaps he just liked the woodier feel of the Irwin axe. It was at this time, too, that Doug Irwin inlaid the "Big Bad Wolf" (as Jerry called it) on the spot where an identical sticker had been.

—Excerpted from *Grateful Dead Gear*, by Blair Jackson

13

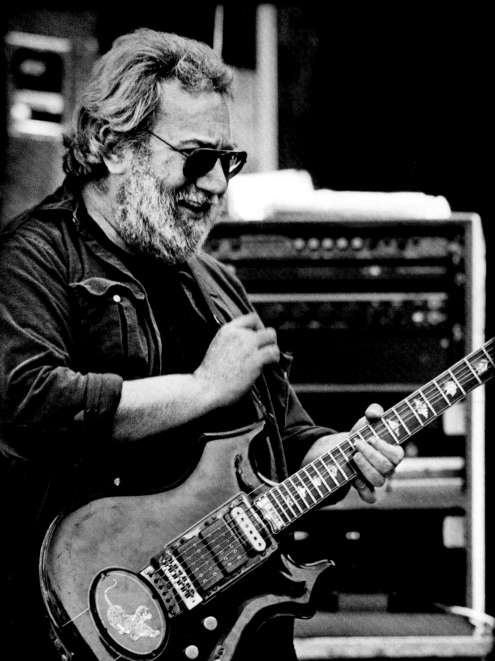

JERRY GARCIA

1979 | D. IRWIN, CUSTOM "TIGER"

Opposite: Grateful Dead, Frost Amphitheater, Stanford, CA, May 1, 1988

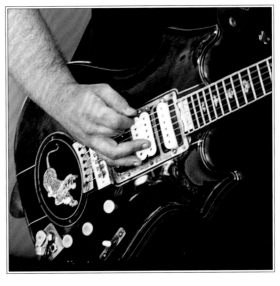

THERE WERE SIGNIFICANT instrumentation changes in the Grateful Dead during 1979, including the arrival of Garcia's second custom axe from Doug Irwin, nicknamed "Tiger" for the stunning mother-of-pearl and brass inlay of a growling beast in an oval under the bridge. Garcia first played the guitar at a pair of shows at the Oakland Auditorium—which was the de facto successor to Winterland—at the beginning of August that year . . .

Unlike Wolf, which had a golden-brown hue, Tiger was a deep reddish color because its top layer was South American cocobolo, "dragged out of the jungle on muleback," Irwin said. The body also consisted of a layer of vermillion, a stripe of maple, and a flame-maple core. The layers were expertly glued together and further bound by a thin line of brass following the body contour and across the front. The neck was western maple with a padauk inlay, the fretboard ebony with a brass binding. It had a Schaller bridge and a custom tailpiece.

The electronics included three pickups: a single-coil DiMarzio SDS-1 Strat-style in the neck position, and two DiMarzio Dual Sound humbuckers in the middle and bridge positions. (In 1982, he would switch the Dual Sounds for a pair of Super Distortion IIs.) The pickups were controlled by a five-position selector switch and two three-way toggles for coil selection on the humbuckers (hum-canceling/hum-canceling dual/single-coil). "I can [also] use the half-positions, in and out of phase, and with the humbucking and single-coil switch on each pickup," Garcia said in a 1988 interview with Jon Sievert. "So right there, that's like twelve discrete possible voices that are all pretty different. And the whole thing with guitar and effects is getting something where you can hear the difference. That gives me a lot of vocabulary of basically different tones. And that's just the electronics; the rest of it is touch. I mostly work off the middle pickup in the single-coil setting, and I can get almost any sound I want out of that." . . .

Garcia would play this guitar almost exclusively for the next eleven years, the most of any of his axes. What made the Irwin guitars special to Garcia? "There's something about the way they feel with my touch—they're married to each other," he told Sievert. "The reason I went with his guitars in the first place was they just fell into my hand perfectly. . . . I'm not analytical about guitars, but I know what I like. And when I picked up [his first Irwin guitar], I'd never felt anything before or since that my hand likes better."

—Excerpted from *Grateful Dead Gear,* by Blair Jackson

PHIL LESH

2014 ALEMBIC SERIES II BASS CUSTOM

Opposite: Phil Lesh and Friends, Terrapin Crossroads, San Rafael, CA, September 12, 2014

THIS IS A 2014 ALEMBIC SERIES II CUSTOM, but I know her as "Khaleesi, Mother of Dragons." She came to me in a very roundabout way. Thirty years or so ago, I gave Ron and Susan Wickersham a deposit on a new bass, but right after that I started playing six-string, and at that time they didn't make sixes. So off I went with a succession of sixes— Modulus, Ken Smith, Ritter—until I began craving a shorter-scale bass. Then, early in 2014 an email arrived from Susan reminding me of the deposit; so we started from there, and they delivered it in just nine weeks, on August 27, 2014.

With this instrument, I wanted to have a shorter scale (I started out playing a four-string short-scale bass, but early six-strings were only long scale), which would make it easier to play. I also wanted to see how Alembic had upped their game over the years, and man, have they ever!

The most exciting features of this instrument are the ease of playing and the super elegant tone controls, which control the attack rather than boosting or cutting selected frequencies.

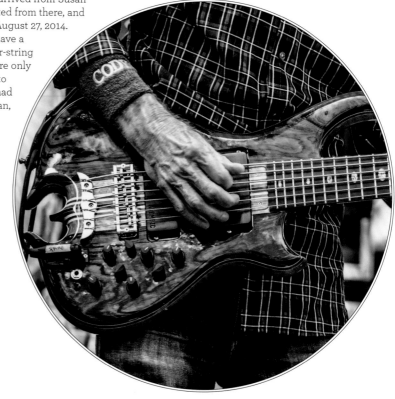

> **"I KNOW HER AS 'KHALEESI, MOTHER OF DRAGONS.'"**

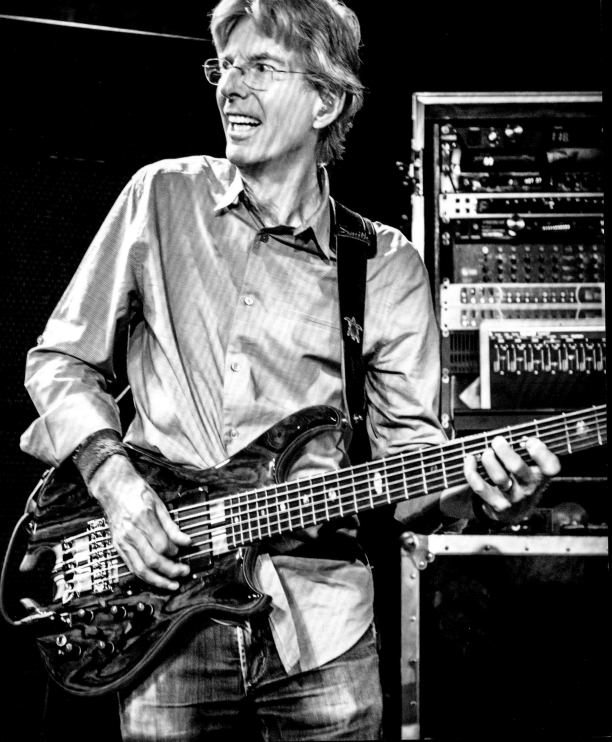

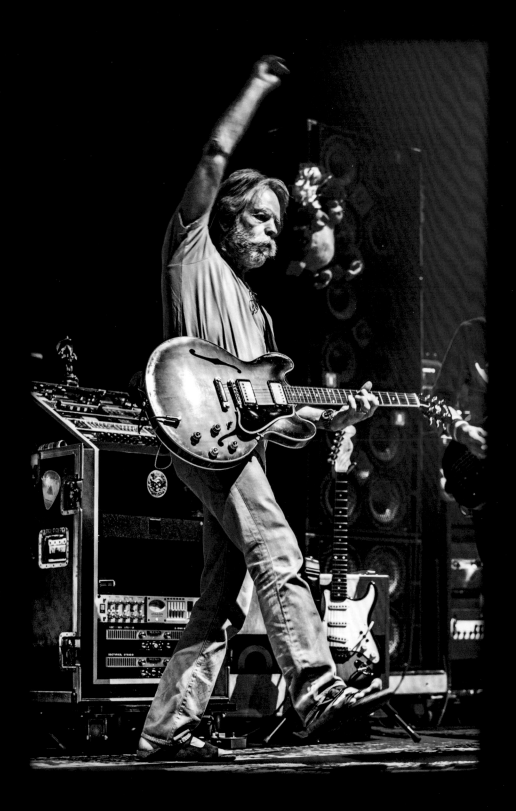

BOB WEIR

1959 | GIBSON ES-335

Opposite: Furthur, Bill Graham Civic Auditorium, San Francisco, CA, December 30, 2011

IT WAS MY FIRST TIME in Nashville—I think it was around 1970—and I went to Gruhn Guitars there—great guitar shop. I was just nosing around, playing a few guitars, and one of the guys in there was watching me—and he said, "You ought to look at this guitar." He pulled it off a rack, and I played it and fell in love with it. It was three-hundred-and-fifty bucks. Back then that was a lot of money—it was a couple months' rent—but I had to have it. It's worth a couple hundred times that now—it still has all the original parts. It's pretty much the holy grail of thin-body guitars.

I was immediately drawn to the feel of it. I also liked the way it sounded, but I loved the feel—loved the neck, which is relatively slim for a Gibson. Sonically I can do just about anything. It's not going to sound like a single-coil guitar—it's definitely a Gibson—but that said, it can get bright, real bright. In fact, I generally play it pretty bright. It has wonderful balance. The tone isn't real tubby. Sometimes Gibsons have a sort of tubby tone, but not so with this particular guitar. And it works well both in the studio and live—it's good no matter where you plug it in.

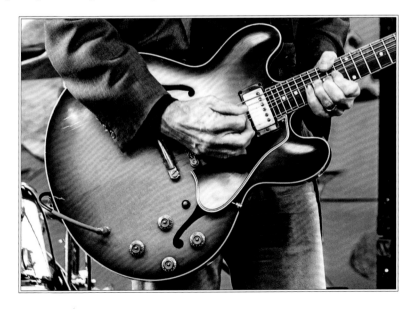

"IT'S PRETTY MUCH THE HOLY GRAIL OF THIN-BODY GUITARS."

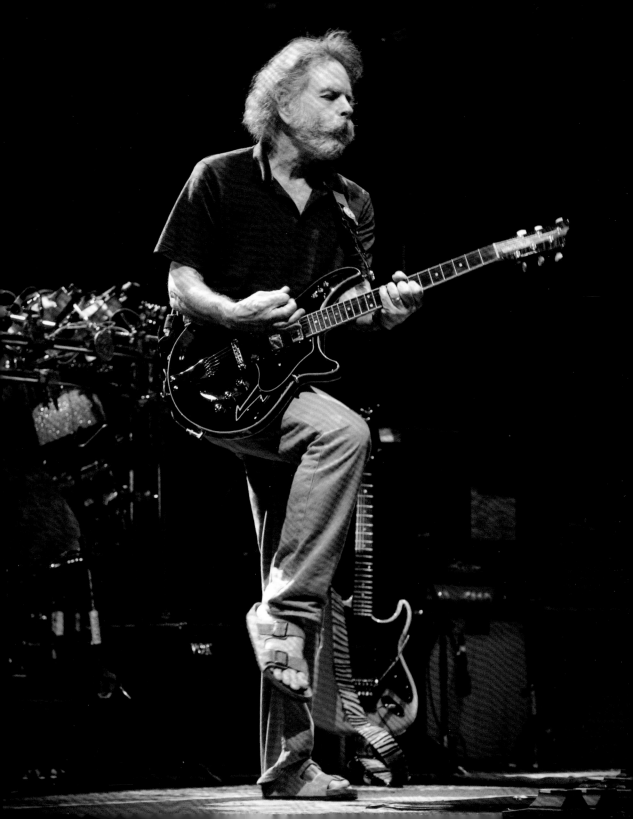

I HELPED DESIGN THIS GUITAR around 2000. I'd been working on the design for a while, and this was the third iteration of the "Lightning Bolt." With this guitar I wanted to combine the best elements of a Telecaster—the bridge pickup is a single-coil pickup like and Telecaster—and the best elements of the ES-335, with the semi-hollow body and humbuckers in the neck and middle pickup. I like to hear the wood, and the air of a semi-hollow body gives you the wood. The resonating wood colors the sound, and I like that a lot.

Every time I strap it on after I've been playing a Gibson, I'm struck by how much brighter it sounds on account of that single-coil treble pickup. It just gets a different kind of sound. It has the body of a 335, but it's brighter. It's got considerably more high end. I don't tend to select a guitar based on a particular song or set I'm playing. I used to gravitate toward the Gibson for bluesy sorts of songs, but I don't do that much anymore. I like to mix it up, but it does change the way I approach the tune. If it's a single-coil style guitar, I'll go at it one way; if it's a double-coil style guitar, I'll go at it a different way. With this guitar, the best way to describe the tone is shine, so I play to that strength when I pick it up.

"WITH THIS GUITAR I WANTED TO COMBINE THE BEST ELEMENTS OF A TELECASTER . . . AND THE BEST ELEMENTS OF THE ES-335."

BOB WEIR

2000 | MODULUS G3FH

Opposite: The Dead, Great Western Forum, Los Angeles, CA, May 8, 2009

THIS PARTICULAR GUITAR WAS BUILT IN 2003. Its nickname is "Cowboy Fancy" because it's got all those fancy inlays. It was a custom shop job made by Ibanez. It's a laser replica. Basically, Ibanez went back to a guitar they built for Bob Weir in the late 1970s and took laser measurements. They built fifteen for the United States and fifteen for Europe—a total of thirty built from scratch, by hand, using the active electronics that Bob used back in 1979 and 1980. This is one of the original thirty they made. Mine is one of the fifteen that went to Europe. It's a rare instrument.

The thirty that were built went very quickly, as you might imagine, mostly to collectors. It was one of those guitars that I always wanted, but they went so fast I never got a chance to get it when it first came out. Then a guy, knowing that I play in

Dark Star Orchestra, wrote me a note on Facebook and asked if I was interested in buying one. It was mint—just sitting in his closet, and I ended up getting it for a lot less than I would have if I had actually bought it when they first came out.

I've been playing Ibanez guitars since the mid-'70s. I still have some of their earlier ones. I've been a fan of their craftsmanship for a long time, especially the earlier stuff. Their electronic schemes are what interest me the most. As an engineer by trade, I understand the concept of active electronics and how to get the most out of them, so I can get all different types of colorings and tones with this guitar, making it the most versatile guitar I own.

The three smaller knobs on the bottom are bass, middle, and treble. Those controls alone are beyond what most instruments have. Then I can split the coils of the double-coil pickups; I can make it play with three single coils; I can turn the pickups on and off. I can pretty much get any tone. It can act like any other guitar; it can act like a double humbucker guitar; it can act like a Strat with three single coils. I play with the tones all the time, which drives everybody crazy. Sometimes I get a great tone, and I just let it sit, but sometimes I'm tweaking it all night long.

You can look back at photos of Bob Weir from 1979 to probably as late as 1983 and see that his Ibanez was the only guitar that he played. So for me, as a Deadhead, it was one of those things that I always wished I had, and it finally came to fruition. That's the beauty of it. It's a rare instrument and something that's connected to the Grateful Dead.

My favorite aspect of this guitar is the electronics, which are very sophisticated. Most guitar players just want a volume control and a pickup selector. This is way more involved than that, and because of my engineering background, it fits right in with my brain—it's wired like me.

ROB EATON

2003 | IBANEZ BWM1 (BOB WEIR MODEL ONE)

Opposite: Dark Star Orchestra, Gathering of the Vibes, Bridgeport, CT, July 31, 2014

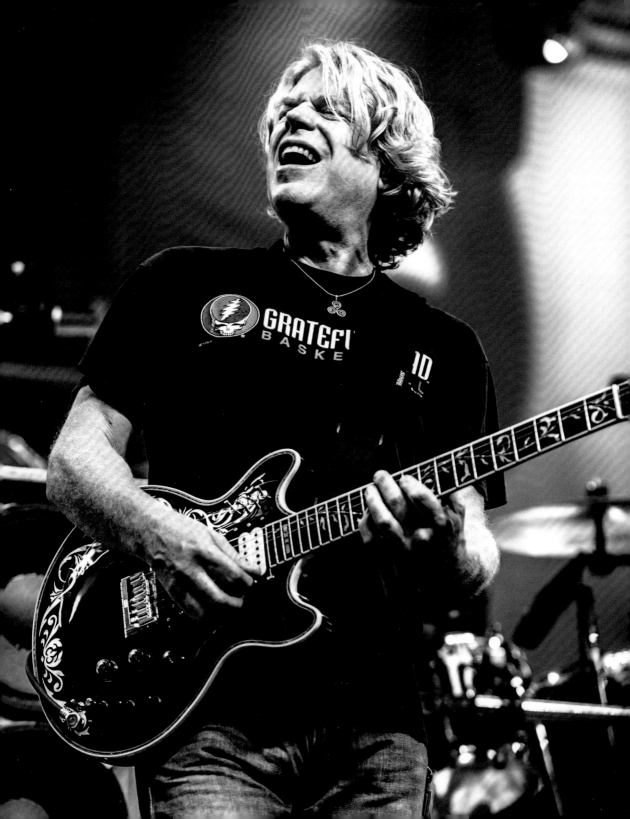

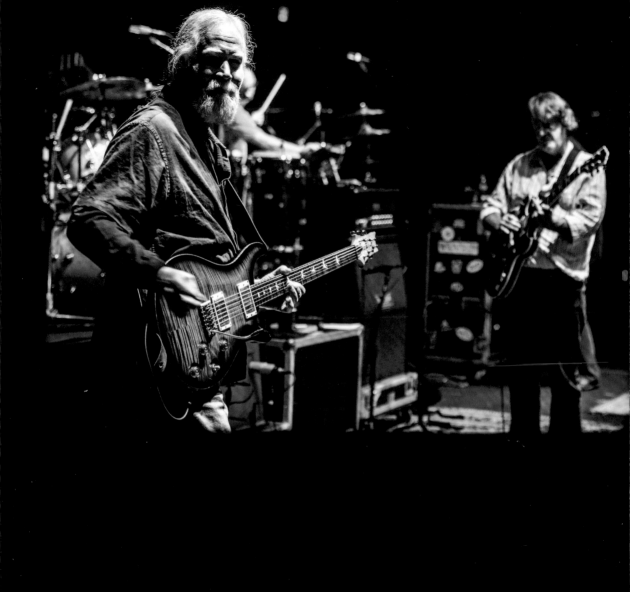

JIMMY HERRING

c. 1996 PAUL REED SMITH

Opposite: Widespread Panic, Fox Theater, Oakland, CA, March 29, 2014

THERE'S A GUITAR THAT I GOT A LONG TIME AGO that I used to play with Phil in the Dead. It's a blue PRS that was passed around to a lot of different bands. I found out later that it was a factory second. I don't know what makes it a factory second, but I love the neck on that guitar. The guitar pictured was built with a neck trying to emulate that one, but it has humbuckers instead of P-90s, which my blue PRS has.

So when this "black burst" PRS was made, I asked them to make the same neck as the other blue guitar, which is called a "soap bar cut." It's the same scale length and the fingerboard is the same, but the part of the neck that sits in your hand is a little different—a little fatter.

There are subtle differences in Paul Reed Smiths and Gibsons and Fenders that have to do with the length of the neck. Strats and Teles have what's known as a twenty-five-and-one-half scale length. A Paul Reed Smith is twenty-five inches dead even, half an inch shorter. You have twenty-two frets in a half-inch shorter neck, which makes the frets closer together.

Fenders make you play a little bit harder when you're bending notes. With a Gibson, you don't have to push as far because you've got the same number of frets in a shorter distance. The tradeoff is, when you get high up on the neck where the high notes are, the frets are really close together on a Gibson and it makes it a little bit tougher to navigate up there. On a Paul Reed Smith, the frets are a little bit further apart, it's subtle, but it makes a big difference. That's the thing that took me twenty-five years to figure out! I just pick up a guitar and play it and go, "Oh my god, this is great." But you start to realize that if you play a Fender a lot, and you do a lot of big bending, you notice your arm starts hurting.

Paul Reed Smith started making their newer models with a little bit longer scale length. Instead of being a half-inch shorter than a Fender, it's a quarter of an inch shorter. So the scale on the new PRS that I've been playing a lot is twenty-five-and-a-quarter. These are subtle differences, but, man, to someone who's been playing this long, you can really feel it.

JIMMY HERRING

2010 | PAUL REED SMITH NF3

Opposite: Widespread Panic, Lockn' Music Festival, Arrington, VA, September 6, 2014

THIS IS A PAUL REED SMITH NF3. It's not the most extravagant guitar you've ever seen, but it has a really unique sound. PRS gave me three guitars to check out when they finally started making guitars with longer scale lengths. Of the three, this was my favorite. It's kind of like a Strat on steroids, because it's got humbuckers in it, but they're skinny humbuckers. That's what they call the "narrow field," and that's why they call the guitar the NF3, because it has three of those narrow-field pickups.

This guitar plays really well. It's right in between a normal Paul Reed Smith and a Fender. That quarter of an inch in scale length matters, too. It makes a difference in giving the guitar a completely unique voice. People might not believe that something that minute can make that much difference, but it does, especially if you play all over the neck where you play every fret on every string on the guitar. In the big picture, it makes a big difference.

In addition to the great feel and ease of play, it's got some great sonic qualities that fall between a single-coil and a humbucker. I'm able to get some single-coil kind of sounds if I don't turn the volume on the guitar all the way up. When you turn the volume on the guitar up all the way, you suddenly realize, "Wait, these are humbuckers. Holy crap." They're skinny humbuckers, but they're still humbuckers, so they're still fat and noiseless. That's why they call them "humbuckers," because they buck the hum.

Of course, nothing is a real single-coil but a real single-coil, but these get you in the neighborhood. I like them because they don't sound like everyone else. I like the range of tones you can get just by turning the volume up and down. When it's up all the way, it's raging. Then you back down on the guitar, and it cleans up.

I've owned and played many Paul Reed Smiths, and I can tell you this: I went to their factory and if I had any reservations about them, I don't anymore after going there. It's mind blowing. The detail—the commitment coming from each and every employee—is incredible. I went all around the factory and met people at their workstations and looked at what they were doing. They've got people there working on stuff that probably won't come out for another ten years; they're that committed to the future.

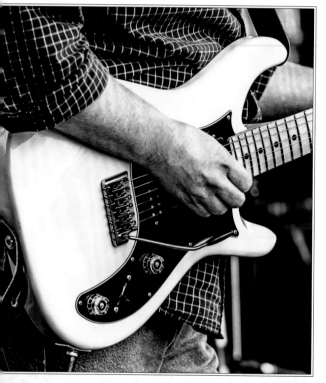

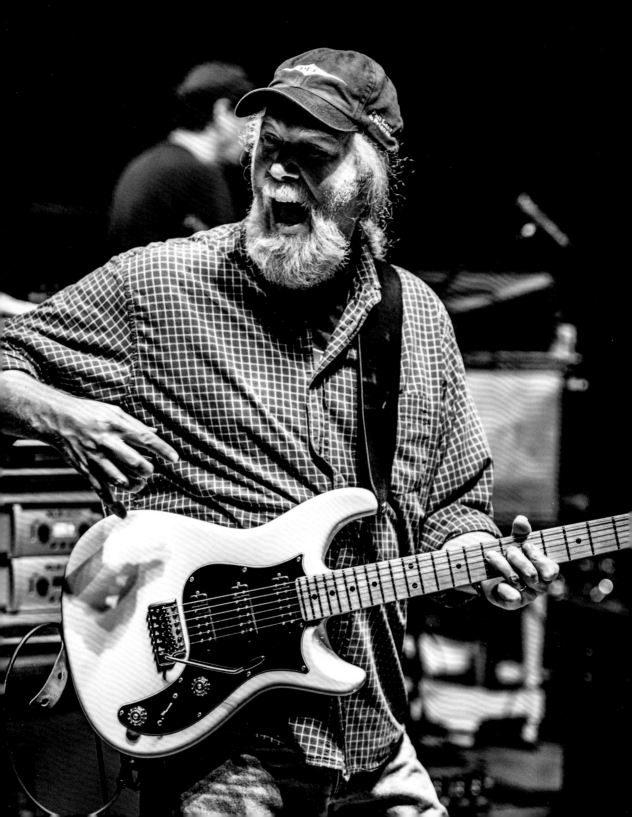

DAVE SCHOOLS

2011 | MODULUS QUANTUM 6 BASS

Opposite: Widespread Panic, Fox Theater, Oakland, CA, March 29, 2014

THIS IS THE Q6 BY MODULUS, and it is the second through-body that Joe Perman of Modulus built. He took it upon himself to start making through-bodies. Originally what put Modulus on the map a long time ago as a boutique guitar company was the graphite neck running all the way through, but they stopped making them for a while. And Joe, being the luthier supreme that he is, took it upon himself to make them again, and I got number two. Les Claypool got number one, and I believe Mike Gordon had them do up a five-string for him for number three.

This is a six-string bass, which I like to have in the mix with Widespread Panic. This one has a distinctly different sound than the '97 that was my number one for a long time. That one is named "Home Team." This one is named "Myrtle." When Anderson Page delivered it to me at the 25th anniversary concert he told me what it was made out of: The beautiful wood is northwestern burl myrtle, so right away I said, "I'm calling it Myrtle."

Myrtle is much more piano-like, much more versatile, much more unforgiving than Home Team, which has a more old school, solid thud to it, a big, round bottom end that makes it easy to play some of the heavier stuff in the Panic catalog. Myrtle took a lot more getting used to. You have to play it in a much more precise manner. Myrtle also has got a lot more mid-range boost. It's a six-string bass, so it's going to get some bottom end, but it's a different kind of bottom end. The fundamental note rings out very true, so you better finger it just right. That sounds a bit rude, but I think that's the rule that we should all live by!

Though I've only had this bass since 2011, there've been a lot of standout moments with it. There was an especially good and poignant show in Cedar Rapids, Iowa, at the Paramount Theater in October 2014. It was at the same venue as Mike Houser's last show with the band in 2002. He was in the process of fighting pancreatic cancer when we played that last show with him. Leading up to the 2014 show, I realized that it was the first time we'd played there in the twelve years since, so we started the show with the first song that we encored with twelve years earlier. A lot of people were aware of what was going on. It was another great show filled with spontaneity and psychic connection. That really is what makes one show so much more amazing than another one: the level of the connection.

On top of that was the timeliness of the gift from my friend Anderson Page and Modulus. I was an endorser, but they never told me they were making me this instrument. Anderson and Joe put a lot of thought and effort and energy into making it special, the way that I like it. To me, it's a marvelous bass. It sounds amazing, it's lightweight, it's functional; all the controls I need are either in my fingers or at my fingertips, but really, it's the thought that counts, and they really put some thought into it.

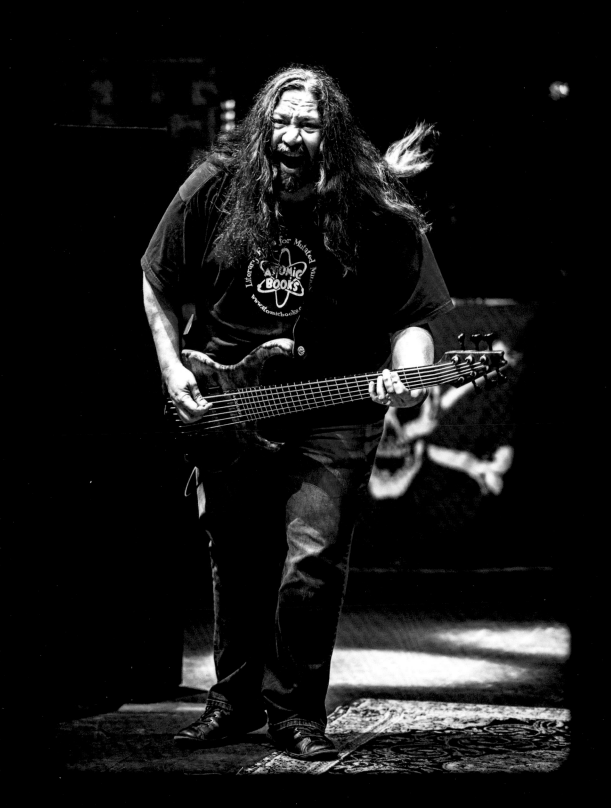

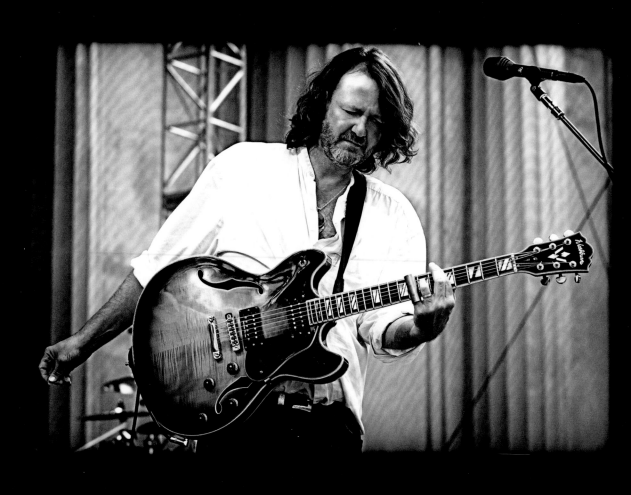

JOHN BELL

1990 | WASHBURN HB35

WHEN WIDESPREAD PANIC WAS IN NASHVILLE recording our first record with a major label, Capricorn Records, folks came out of the woodwork with endorsements. Washburn came by and laid this guitar on me. What I really dug about it was the ability to interact with my speaker and get controlled feedback because of the hollow-body setup. The key word in there is "controlled."

The instrument has a nice breath to it, and a nice action, which was set up very well originally. And it has a really strong neck, which is important because in lieu of a whammy bar, I tend to just bend the neck itself.

This guitar is with me all the time. I've started playing a cousin of it, really for no other reason than it was a gift from the folks at Washburn, and I gave this one that had been with me for twenty years a rest. After I played with that other guitar, when I came back to this one, it shut down on me; it wasn't putting out a signal, the action went screwy. We have since made up. It took it a little personally that I went to prom with somebody else!

But I got it going again, and we're still an item. It has the advantage of being twenty-five years old, so it has warmed up a little. Its edges are smoothed out. It has

become a part of me, along with any modifications I've made along the way. When it's really going well, the guitar becomes an extension of you. This was the first guitar that consistently allowed me to reach that point of connection. As a result, I've been able to make myself available as a band member to the point where the separateness between the band members seems to fade, and we play as one. Those are the moments you live for, because when you're working with six people onstage, you might not be soaring every minute. You try, but those moments are a gift, and sometimes I don't know if I'm the pilot or the guitar's the pilot.

Behind the scenes, I've had three guitars techs who have been part of this instrument. Joel Byron is my current guy. Sam Holt was with us for a while, but he's moved on to writing songs, and he's got his own band. Wayne Sawyer was the first guy who was with us. He learned how to be a tech with us. He has since moved on to another plane. Those are the guys who kept this guitar ready for action every night. Sometimes they get overlooked in the mix, but they're really as much a part of the story of this guitar as anything.

PETE SEARS
1977 | D. IRWIN, CUSTOM "DRAGON" BASS

Opposite: Moonalice, Union Square, San Francisco, CA, September 10, 2014

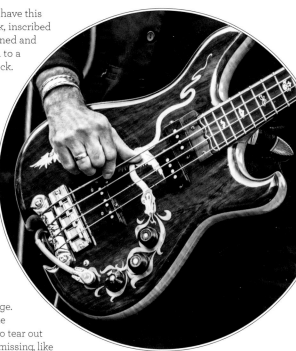

I WORKED CLOSELY WITH the Doug Irwin Custom Guitar Shop to have this bass built, which has the classic D. Irwin round silver plate on the back, inscribed with my name. Luthier Tom Leiber, who worked in Doug's shop, designed and built the bass. My only requests were that it be similar in look and feel to a Fender Jazz bass, but, of course, with the classic Irwin-shaped headstock. Although the dimensions are different from a Jazz bass, it still manages to retain the classic lines, but with many beautiful added custom touches to the shape. I also asked for passive circuitry and a combination Precision and Jazz pickup configuration.

Tom used a beautiful bird's-eye maple on the back and underside of the neck, and cocobolo wood on the front. Tom was helping Doug design the very beginnings of Jerry Garcia's "Tiger" guitar at the time, and they used the very same block of cocobolo wood on my bass. My bass was finished and delivered to me in 1977. Tom did some amazingly intricate inlay work on the neck and body, including a silver inlaid dragon with LED eyes that light up. The dragon weaves it's way across the front of the bass, with flames licking around the control knobs. The custom guitar finishes that were used in those days tend to yellow with age, so the Dragon is now a subtle shade of gold, and it is very beautiful.

Unbelievably, my brand new D. Irwin Dragon bass was stolen during a riot at a Jefferson Starship concert we were playing at Lorelei in southern Germany in 1978. I hadn't even had a chance to play it on stage. I got it back in 2012—how is a whole other story—but now I play it all the time. The original luthier, Tom Lieber now of Lieber Instruments, had to tear out various modifications done to the pickups during the thirty years it was missing, like taking out a badly wired battery that had been installed in an attempt to make it active. It's now, once again, the earthy, woody sounding bass it was always meant to be.

The Dragon has special significance and exudes a certain vibe to me when I play it. It represents the 1960s experimentation in music, art, and thought. When I play it live, it often takes me back to playing Indian music with the trio Sam Gopal's Dream in the psychedelic clubs and festivals of 1960s London, especially when I find myself in an interactive, improvisational setting.

The Dragon bass has a smooth action up and down the neck, along with many tonal possibilities for playing different types of music. I use flat-wound strings as they offer a deep, round, punchy sound—especially with the Precision pickup. I am also able to get plenty of highs if needed. And, of course, the Dragon bass looks and feels amazing. More than anything, though, I love the action on the neck—it's like no other.

STEVE KIMOCK

1972 | CHARLES LOBUE EXPLORER

Opposite: Steve Kimock Band, Sweetwater Music Hall, Mill Valley, CA, December 15, 2013

I DIDN'T GO AFTER THIS GUITAR; this guitar came to me. You could say more than anything that they were both gifts. When I got this, I was playing in a band called the Goodman Brothers. We lived on a farm in Pennsylvania. The whole setup was kind of a commune.

There was more than one band involved in this, and the guitarist in the other band, who was known by the name of M.K., played theatrical hard rock, and he used to throw his guitars a lot and spin them around his body on the strap, lots of guitar throwing. Apparently, Explorers don't throw well. He got the guitar and didn't have it long before it was thrown and broken. He repaired the headstock, but realized that the guitar was not very aerodynamic. I had maybe two Stratocasters at the time, and he said, "Hey, you want to trade the Strat for the Explorer?" So that's how I got it. That was '74 or '75. But I didn't go looking for it, it was one of those "to each according to his needs" commune deals, and it just turned pretty instantly into my main guitar.

I think Charles made four Explorers. The most visible belongs to Rick Derringer who did a Guitar Player cover with his LoBue guitar back in '75. LoBue also made basses. I think there was a lot more visible, iconic use of his basses. He made Gene Simmons's first axe bass, for example. He also took care of the New York guys. The punk guys like Alphonso Johnson had a couple of LoBue fretless guitars that he played later on in Weather Report.

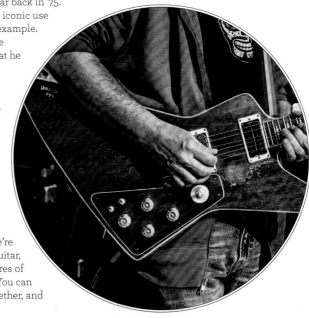

LoBue became a friend, and since he passed I've been trying to find his guitars and get them under my roof so eventually I can pass them on together. I have three of those Explorers. I don't know where Derringer's is. It might be with Gibson still, or it might be in Nashville, or it might have been destroyed in the flood. Nobody knows. But I'm seeking them out, because I loved the dude. Charles was a very special guy. He was in my life for many years.

I think what I like most about the guitar is that it's been with me through everything. It does whatever I need it to do. It's a great big dominating sort of thing in the mix. That guitar will eat the room; it's one of those guitars. You can't pick it up unless you mean business. It's like, "Okay, we're not screwing around here!" Also when I'm picking up this guitar, I'm picking up a lot of stuff, a lot of memories. I've got pictures of it from pretty far back, and it was beautiful back in the day. You can see now that it's pretty beat up, but so am I. We're aging together, and old friends with gray hair are hard to find.

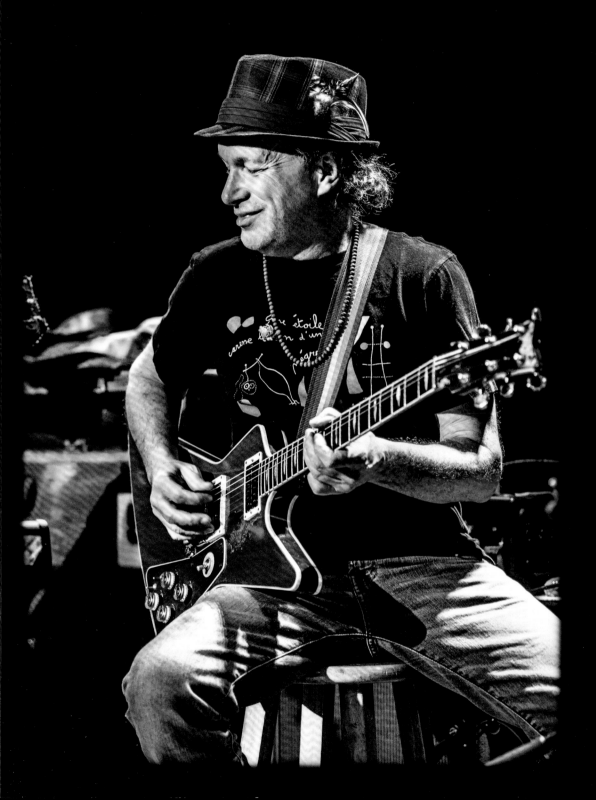

STEVE KIMOCK

1960 | FENDER STRATOCASTER

Opposite: Ratdog, TRI Studios, San Rafael, CA, January 25, 2012

THIS WAS ANOTHER GUITAR THAT FOUND ME. Again, back in the day, back to the Goodman Brothers routine, when we were in Pennsylvania in the mid-'70s and contemplating a move to California. Kind of a "load up the truck and move to Beverly Hills" kind of deal.

We had one guy who was helping us with financial backing and management stuff, who was a great dude. He said, "You need anything? You need anything for this trip? What do you want? You can have anything you want."

And I said, "I want a pedal steel." I'd started playing a pedal steel when I was sixteen. I got one for a hundred bucks, and I'd always dug the pedal steel, but I didn't have one at the time.

So he says, "Pick one out." I got a brand new maple body, ten-string, E9 Sho-Bud. A straight-up Nashville kind of deal. Four pedals, one knee lever, and I played that in the band.

This was '78 or '79. I was caretaking a sheep ranch in Bodega Bay, California. That was my gig. I had a trailer, a jeep, a dog, that kind of thing. I was that guy. I was in my shepherd phase. I completely missed the '80s being off the grid. The ranch was way the hell down a long, little road that nobody would ever go on. Dead end, went nowhere, behind a couple of locked gates.

So I was hanging on the ranch, and I look up the hill, and here comes a guy down the driveway. In one hand, he's carrying a white Stratocaster, and in the other hand he's carrying a Les Paul goldtop. He's walking down the driveway; I've never seen this guy before. He walks up to the trailer, and he says, "I saw you playing that maple Sho-Bud. Do you want to trade it for one of these guitars?"

At the time I had the Explorer and I had an L5 Gibson. So I said, "Well, I don't have a Fender. And I don't play the pedal steel much right now. Sure." So I took the Stratocaster and gave him the pedal steel, which weighed about one hundred and thirty pounds in the case. I gave him a ride back up the hill. I have no idea how he found me, but he found me down there.

That's where the Stratocaster came from. I didn't like the pickups. They were kind of strident for me. I was used to the L5's pickups. It was really rocking the finger-coil thing. I hadn't had it for very long, and I replaced the pickups with the ones that are in it now. I never tried anything else. I had one Silvertone pickup just lying around that I had bought from somebody for ten bucks, and I got a pair of Danelectro bass pickups, and they've been in there every since.

With all my guitars there's an emotional, karmic connection while playing, and having that energy attracts instruments and people that are into them. Occasionally you're playing and doing a good job, and somebody will come up to you and say, "Play this!" And you do, and it turns out to be just right.

I've played more shows than I can remember with this guitar, but there's one

> "I WAS IN MY SHEPHERD PHASE. I COMPLETELY MISSED THE '80s BEING OFF THE GRID."

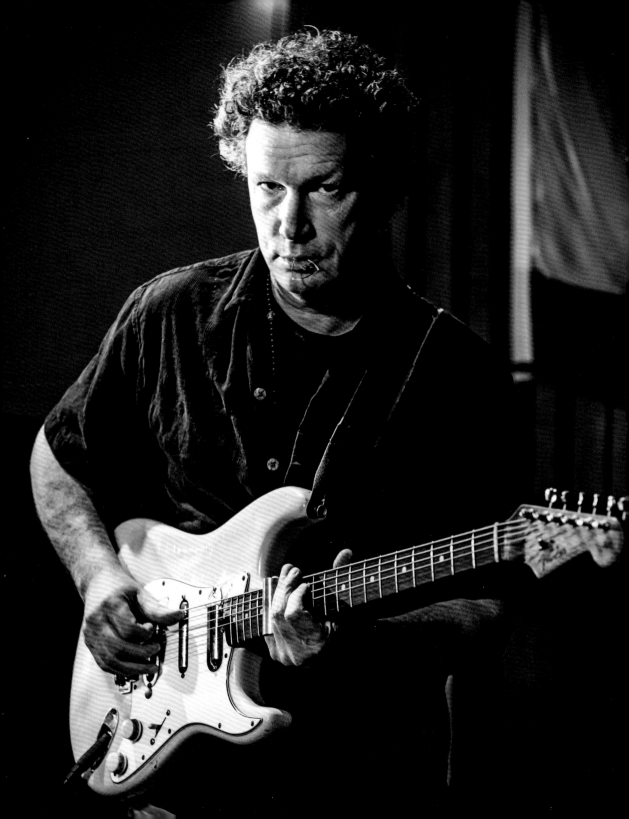

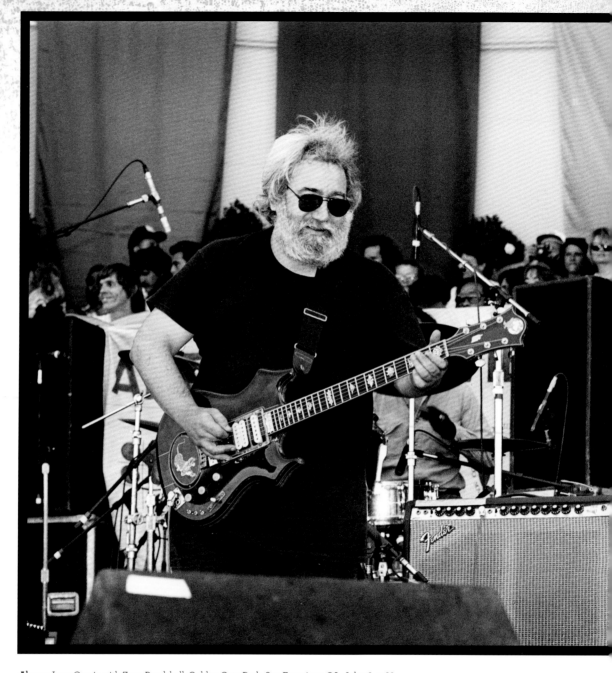

Above: Jerry Garcia with Zero, Bandshell, Golden Gate Park, San Francisco, CA, July 16, 1988

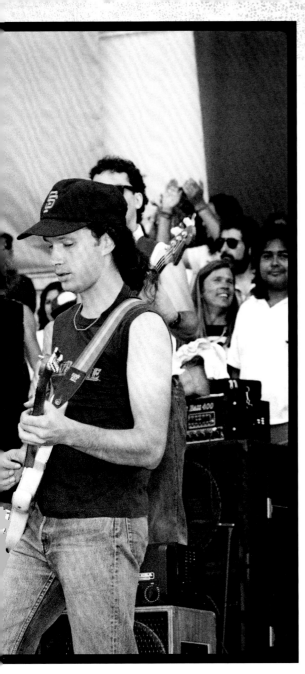

"WITH ALL MY GUITARS THERE'S AN EMOTIONAL, KARMIC CONNECTION."

that stands out. I was playing with Zero in Golden Gate Park. For whatever reason, Zero had become the core band for a bunch of guys that were celebrating the end of the Soviet-American Walk for Peace, where Soviet musicians and American musicians walked across the entire country together from New York to San Francisco. They were having a big party in the park to celebrate, and there were a gazillion people there. It was a big party because Paul Kantner and Grace Slick from Jefferson Airplane were there, as were Jerry Garcia and Mickey Hart.

So we're playing, and all of a sudden, people start going nuts. And I'm like, "What the fuck are they yelling about?" I look back, and from the top of the band shell, here comes Jerry Garcia with his guitar. It's Garcia and Steve Parish and they're walking down the stairs. They're obviously really ready to play because they're walking really slowly. It's like one step, then move their foot to the next step, and every step that they walk down very slowly and carefully, the place is going more and more nuts.

So they get to the bottom of the stairs, however many tunes later while people are freaking out, and Jerry walked across the stage in front of me. I'm set up on the very end, on stage left, the audience's right, and Jerry's amp is on that side. So he walks to his end, he's about to plug in, when the MC comes over and says, "Wait! Wait! One more song."

And I'm looking at the guy like, "You've got to be kidding me. After that entrance? The guy's standing on stage. It's one more song."

But Jerry goes, "Oh, okay." And he walks from my right, three steps, and stands on my left, no longer on stage, holding his guitar, waiting for one more song. No pressure.

So we played "Little Wing." I played the Stratocaster, and I was like, "Okay, fuck it, I'm just going to blow it up." So I do the giant blowing up "Little Wing" thing with Jerry standing right there. We finished the tune, then he takes the three steps past me and my amp and plugs into his amp. And he said the most wonderful thing. He said, "Hey, man, don't make me look bad, okay?" Which completely let all the "Oh, shit" kind of tension out of the air. We had a great jam and a good time.

CARLOS SANTANA

2006 | PAUL REED SMITH SANTANA II

THIS IS A 2006 PRS that I call "The Salmon Guitar." I've been playing PRSs for a long time, and the story of how Paul Reed Smith and I connected is well documented. Paul was a young, passionate luthier. He managed to get backstage and show me one of his prototypes. It was not like a Yamaha, Fender, or a Gibson. It had its own DNA. We worked together to get it where I wanted it, and the rest is history. I have been a loyal PRS endorser and player ever since. Together, we gave birth to PRS Guitars. This particular model is a Santana II.

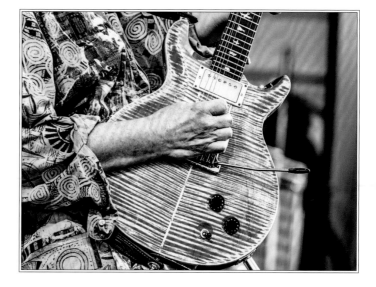

This has been my main guitar since 2006, and it has been used during almost every live show and recording from 2006 to present. With this guitar in hand, I have had the honor of playing with John McLaughlin, the Allman Brothers (Derek & Warren), Rod Stewart, Steve Winwood, and Steve Miller, among others.

It has been fitted with proprietary PRS locking saddles and PRS Phase III open-back locking tuners. It has a Brazilian rosewood neck and fingerboard. PRS represents quality, integrity, and consistency. It does not matter what the weather is or the venue, a PRS Guitar will not fail you. As a musician and a bandleader, with that consistency, I am able to soar and complement the other musicians. I don't have to worry about my gear. That consistency is my favorite single quality about this guitar.

> "AS A MUSICIAN AND A BANDLEADER, WITH THAT CONSISTENCY, I AM ABLE TO SOAR AND COMPLEMENT THE OTHER MUSICIANS."

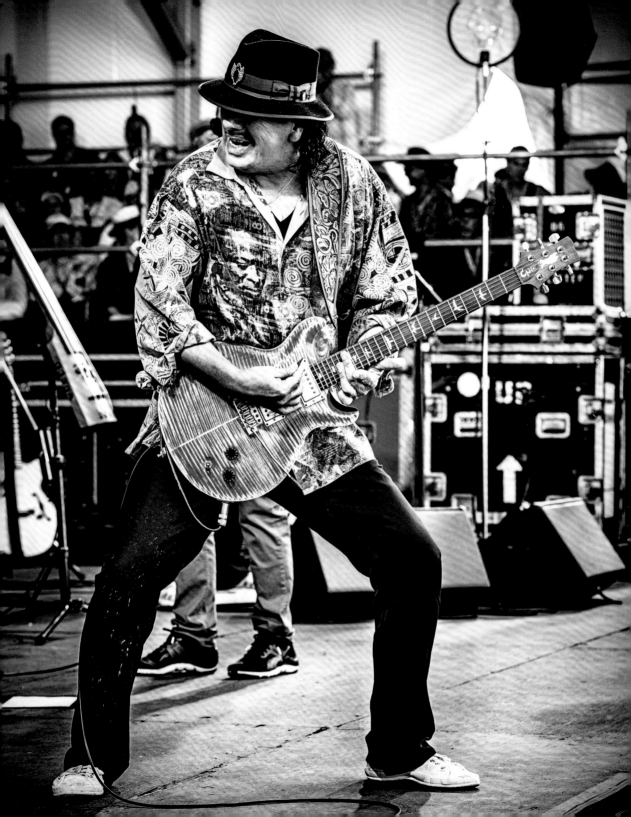

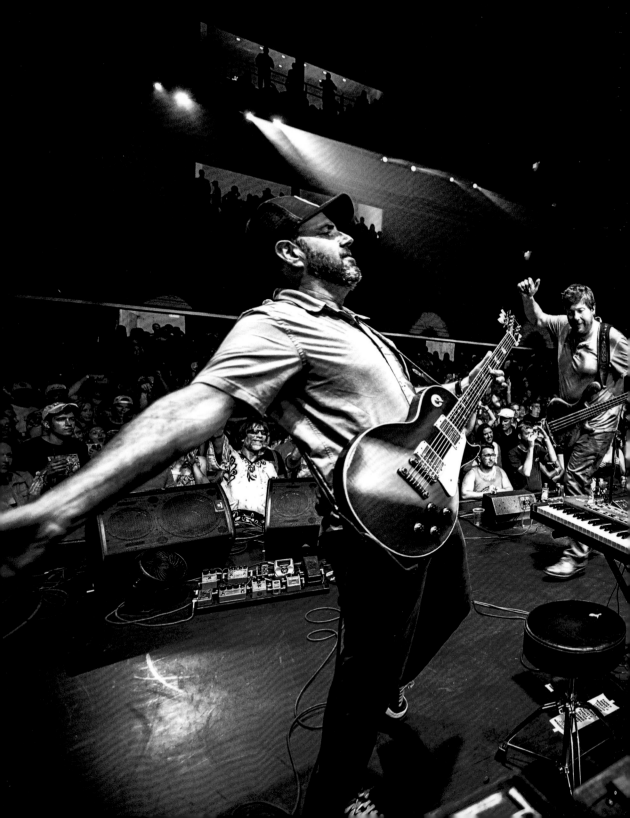

THIS INSTRUMENT WAS SOMETHING I had been seeking for a while, not this exact guitar, but something from the era. There are so many classic players that I grew up listening to who played Les Pauls, from the Allman Brothers to Jimmy Page—so much rock history that the Les Paul has been a part of. Even today, you've got guys like Warren Haynes who live and die by their Les Pauls. It's just one of the most versatile, Swiss-Army-knife guitars out there. If you're going to have a one-guitar quiver, I think the Les Paul is the guitar to have.

This guitar has become my go-to since I got it in 2012. For me, the key was finding the right amp to go with it. I found a vintage Marshall Bluesbreaker amp, and when I paired it with the guitar, it became a defining moment for me. In many ways I found what I was looking for. Not to say that I'm done exploring—you can never be done as a guitar player—but I really settled into something that I'm happy with.

This guitar is heavily modified, but everything that I've done to the instrument has been with the aim to restore it. When I got it, it had been stripped of its finish and converted to a sunburst. The guitar is supposed to have soap bar pickups but didn't. And it only came with some of the original parts, so it was a painstaking process in the first six months to source out all of the original parts for this guitar. I didn't try and put the original pickups back in since it had already been routed for humbuckers, so I found some vintage PAFs from that era and really tried to restore it to its original glory. It's part of the fun, part of the process. As a guitar geek, I really enjoy restoration.

Beyond all that, my love for this instrument is more tactile than anything. The guitar feels really good. Not just holding it in my hands—which feels great because it's an old piece of wood that's been through a lot—but there's a warmth to it, it's worn, and when you strum it unplugged, it has a resonance to it too, and there's something about that I love. Sonically, it's got that thing where it's both clean and robust, and all it takes is rolling up the volume knob a bit to push it into those more saturated, overdriven tones. It's a versatile instrument, and a classic.

AL SCHNIER

1956 | GIBSON LES PAUL GOLDTOP

Opposite: moe., Civic Theatre, New Orleans, LA, April 25, 2014

AL SCHNIER

1974 | GIBSON EDS 1275 DOUBLENECK

Opposite: moe., moe.down, Mohawk, NY, September 3, 2011

I HAPPENED TO SEE THIS GUITAR on eBay one day and it immediately caught my eye. The interesting thing about it was the year. It just didn't make sense; Gibson wasn't making double-necks in 1974. Seeing one in a custom color from that era immediately got my attention.

Once I got the guitar, I disassembled it and dated all the parts. Then I sent all of that information to Gibson, and they verified the year. Turns out they only made one double-neck guitar in 1974. There's literally only one on their records—this is the one, and in a custom color!

Around 1970 Gibson stopped production of the double-neck guitars. Between 1970 and 1978, the only way to get one was a custom order. Really the only people that were getting them were eccentric musicians or rock stars. You had Alex

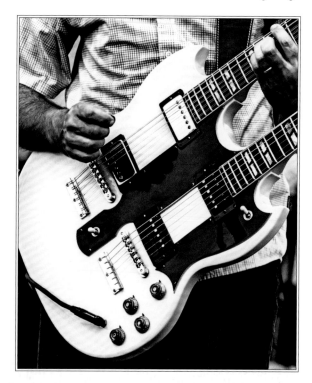

Lifeson from Rush who had a white one just like this, and also Don Felder from the Eagles who had this very same guitar. It makes me wonder who ordered this guitar and where it ended up and why. I'd love to trace it back to one of those guys, but I have no idea. It's just bizarre that it was the only one made, and I wound up with it because some dude had it on eBay.

But beyond the mystery and rarity it's a great guitar to have. I used to keep a twelve-string on the road that I would play on a few different songs. Now I have the option of alternating between the twelve-string and the six-string within the context of a given song—there are probably half a dozen songs that I use it on. I love it! I love being able to go to the twelve-string. It's gotten to a point where I started writing songs with that in mind, knowing that I can play twelve-string and six-string live on a single tune.

It's also such a great stage prop. When Frank Robbins, our guitar tech, walks out with it and hands it to me, the crowd instantly cheers because there's a double-neck guitar on stage. I don't even have to do anything, just put the double-neck guitar on.

Spectacle aside, I actually love the sound of this guitar—I think about it all the time. I keep thinking that I should get an SG from the same era, just a six-string, because I love the tone this guitar gets. But I also wonder if the sheer mass of the thing doesn't have something to do with why this particular instrument rocks so hard and sounds so good—maybe it's twice the guitar, twice the tone.

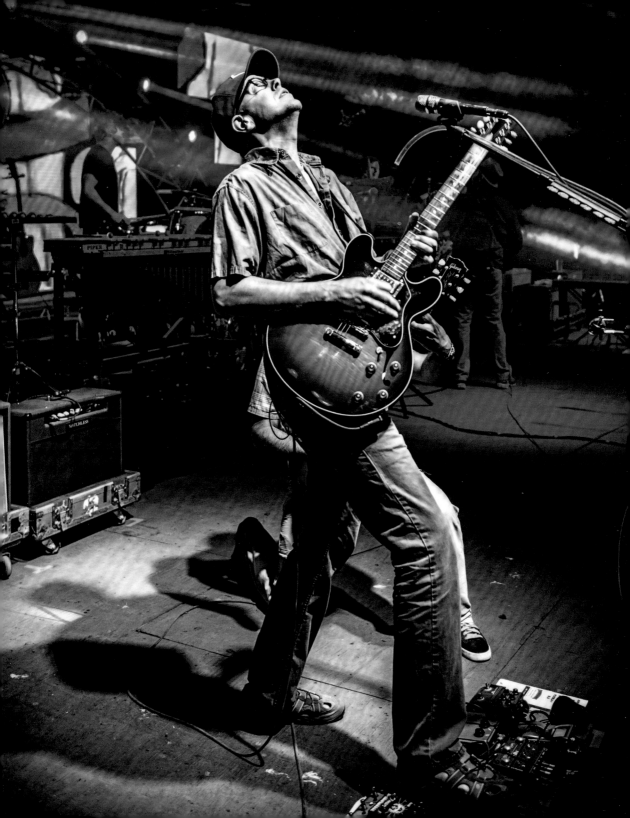

CHUCK GARVEY

2013 | COLLINGS I-35 LC

Opposite: moe., Summer Camp Music Festival, Chillicothe, IL, May 24, 2014

A COUPLE YEARS AGO, I became really intrigued with 335s. I'd played a couple but never really found a great one that I latched onto. Then I started reading about Collings and their assembly techniques. They don't make a carved top; it's a laminated top, but they do it in a way that gives the guitar a really even tone even though it's a semi-hollow-body. This one has ThroBak pickups, which get a classic PAF sound and output.

So I got in touch with Collings and they hooked me up with a guitar. They found one that another artist was using in Nashville but didn't really bond with for whatever reason. So, when we were there, there was a local guitar dealer that had the guitar, and someone brought it over to the show that we were playing in Nashville, and I started playing it right away. It immediately felt amazing.

The thing that really clicked with me was the guitar's versatility. I could use a pick, I could finger pick, I could play slide on it—everything I did felt very comfortable. Some guitars are great for everyday playing, but not necessarily set up for slide, or maybe they're great rhythm guitars, but playing lead or fingerpicking doesn't necessarily feel great—and this guitar seemed to be able to do just about everything.

Sonically, it's got a little less bass than a solid-body. Not much; it's very subtle, but it's just a little more centered on the mid-range where all of the best sonic stuff happens. And it also does a couple of interesting things like feedback in a different way than a solid-body guitar. But my initial draw to it wasn't a tonal thing, it was more the feel of it. When it feels really good to play an instrument, you become a little more inspired—like a barrier has been removed—so you can be more direct and expressive. That was the first thing with this guitar, I just felt like I could do a lot of the stuff that I wanted to do, and I didn't have any blind spots. In fact, the day that I got it, I played it on stage. You can't always do that with guitars. In the past, I might have waited until the next day so I could have a little time with it to check it out, sound check with it a little bit more, but I literally just plugged it in and played it with my setup and really didn't change anything and that's pretty awesome.

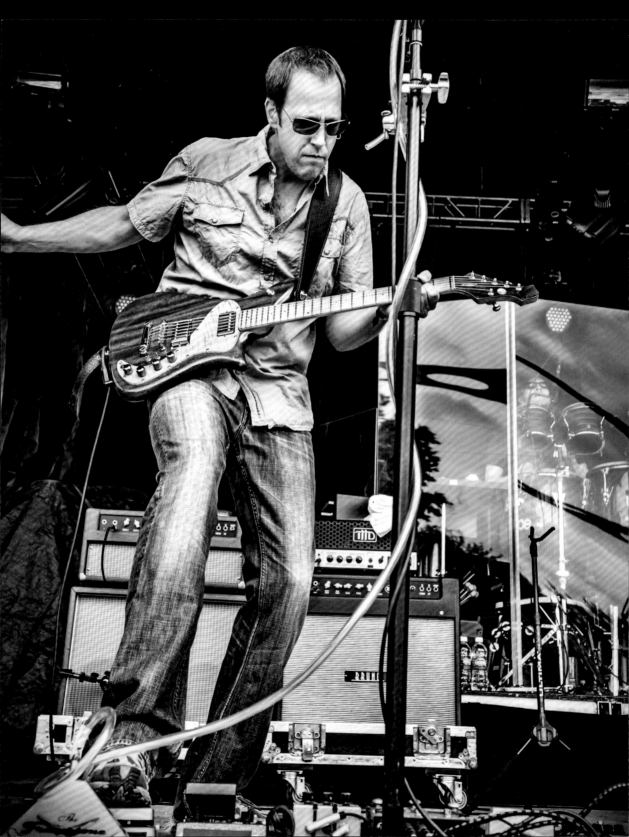

MY RELATIONSHIP WITH BECKER GUITARS began when Dan Becker came to Snoe.down, a festival that moe. does. He brought a couple guitars for me to check out. The first one I tried was fast to play, like a little sports car. I really liked the handmade craftsmanship of it, though, and it was light and fit really well. The body was mahogany, and the fret board and the pick guard were a kind of flame maple.

That first Becker I played was a demo guitar. And then we talked about it a little bit more, and I got a second guitar with much denser mahogany, and it was like a shredder guitar. It was really snappy. I said, "I think I'd like something that sounds a little bit darker and plays a little slower." Then he made the one that I ended up keeping, which is pictured here. He chose different wood for this guitar—the mahogany he used is a little bit softer, and it has a little different transient attack and feel to it.

It has special Lindy Fralin humbucker pickups, which were chosen because they can be coil tapped with better results. You can tap one or both and blend with the volumes and get different sounds out of the guitar. They've got a little more output when you tap them, so the single-coil sounds are strong, and I find myself using the bridge single-coil sound quite a bit.

With this setup the guitar has clarity and some bite, a little bit like a Telecaster, and it's got this really clear, snappy sound that cuts really well when the whole band is playing. I'll blend that with the neck humbucker, and that's a really nice sound as well. So I have a rhythm sound, and the single coil by itself works well as a lead sound. I also use an EL84 amp that compresses a bit, and the single-coil sound works well with that amp and a booster.

I sat in with the Allman Brothers Band when they did the "One for Woody" thing at Roseland in New York using this guitar, which was incredible. We've also played with Gov't Mule a bunch of times, and we've known Warren Haynes for a while. Whenever I get a chance to sit in with those guys, Warren always looks at me and checks out the guitar. When I wasn't playing it at our album release, he walked out on stage and asked, "Where's that other guitar?" It definitely makes an impression both sonically and visually.

CHUCK GARVEY

2010 | BECKER RETRO-GRAD

Opposite: moe., Summer Camp Music Festival, Chillicothe, IL, May 27, 2011

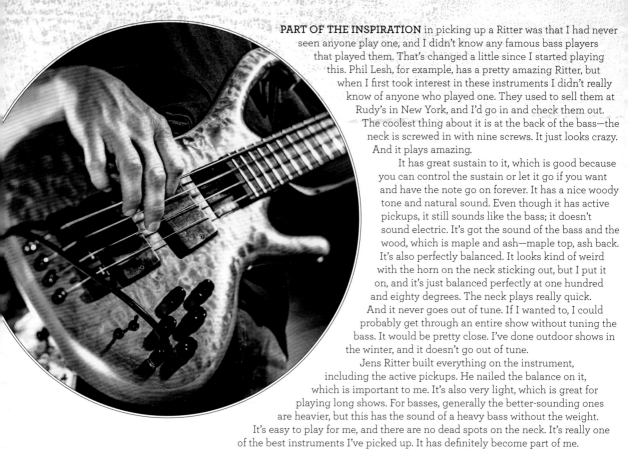

PART OF THE INSPIRATION in picking up a Ritter was that I had never seen anyone play one, and I didn't know any famous bass players that played them. That's changed a little since I started playing this. Phil Lesh, for example, has a pretty amazing Ritter, but when I first took interest in these instruments I didn't really know of anyone who played one. They used to sell them at Rudy's in New York, and I'd go in and check them out. The coolest thing about it is at the back of the bass—the neck is screwed in with nine screws. It just looks crazy. And it plays amazing.

It has great sustain to it, which is good because you can control the sustain or let it go if you want and have the note go on forever. It has a nice woody tone and natural sound. Even though it has active pickups, it still sounds like the bass; it doesn't sound electric. It's got the sound of the bass and the wood, which is maple and ash—maple top, ash back. It's also perfectly balanced. It looks kind of weird with the horn on the neck sticking out, but I put it on, and it's just balanced perfectly at one hundred and eighty degrees. The neck plays really quick. And it never goes out of tune. If I wanted to, I could probably get through an entire show without tuning the bass. It would be pretty close. I've done outdoor shows in the winter, and it doesn't go out of tune.

Jens Ritter built everything on the instrument, including the active pickups. He nailed the balance on it, which is important to me. It's also very light, which is great for playing long shows. For basses, generally the better-sounding ones are heavier, but this has the sound of a heavy bass without the weight. It's easy to play for me, and there are no dead spots on the neck. It's really one of the best instruments I've picked up. It has definitely become part of me.

ROB DERHAK

1999 | RITTER CLASSIC BASS

Opposite: moe., Ogden Theatre, Denver, CO, December 7, 2013

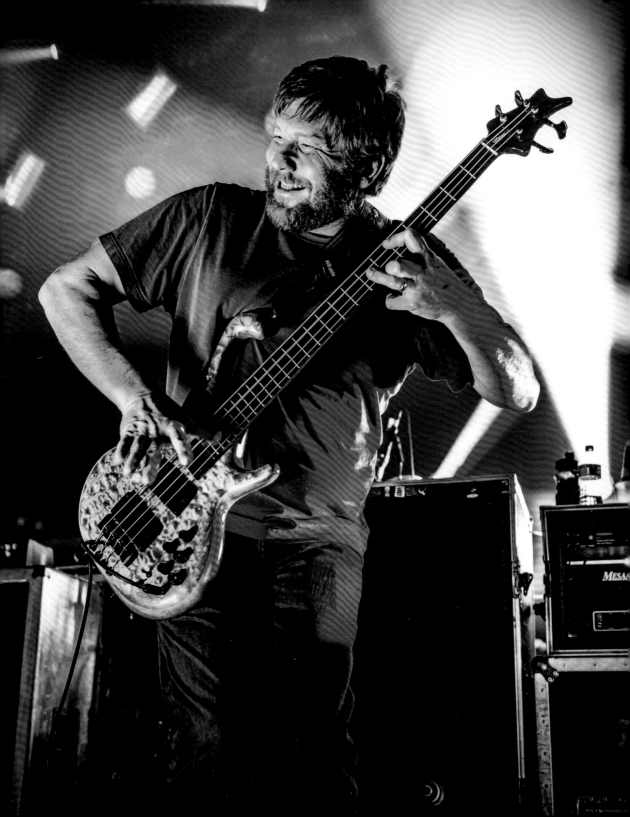

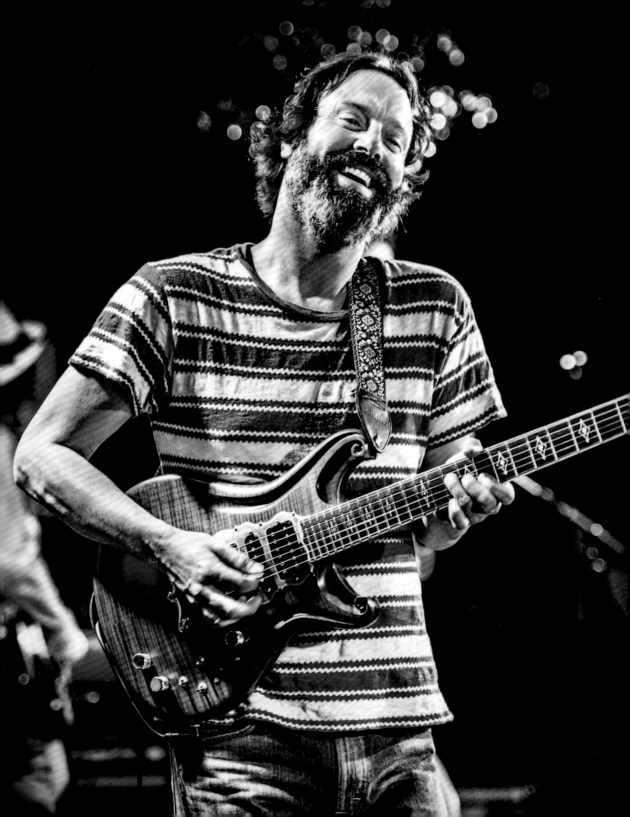

NEAL CASAL

2014 | SCOTT WALKER GUITARS SANTA CRUZ, CUSTOM

Opposite: Chris Robinson Brotherhood, Terrapin Crossroads, San Rafael, CA, May 1, 2014

SCOTT WALKER OF SCOTT WALKER CUSTOM GUITARS made this guitar in Santa Cruz, California. The guys in Chris Robinson Brotherhood nicknamed it "Musket." The body style is something Scott has done before; it's one of his models, the Santa Cruz, but as far as the pickups and the electronics and also the shape of the neck, those are things that I worked on with him. I made a few trips to his workshop to discuss all the different features and what I wanted out of the guitar, including what I needed, the things I wanted to keep, the things I wanted to discard, and also to have him shape the neck to my specifications.

Playing a three-hour show with the CRB every night—well over a hundred shows a year—our band covers a lot of sonic ground. I was finding that with the traditional, off-the-rack Gibson SG that I was playing there were certain corners that I couldn't get into, certain sounds I just couldn't get. With CRB we're going for a pretty broad sonic palette, so I needed something that had a broader sonic spectrum.

Some friends recommended Scott Walker, and he turned out to be very much the right guy to work with. I'd been looking at different guitar companies for at least a year, but none of them resonated with me. When I looked at Scott's guitars, I knew instantly that he was the guy to work with. He also works with Barry Sless and Steve Kimock, who turned out to be good guys for me to talk to before having the guitar made. Barry, in particular, was very helpful. I went to his house and played all of his Walker guitars. He owns five of them. I spoke to Barry about some things that worked for him, and I got a feel for Scott's work. After meeting with Barry and looking at his Walkers, I was able to make some decisions on what I wanted, what I didn't, and I went from there.

I met with Scott several times. We discussed different pickup options, how the neck would feel, how many frets the guitar would have, the weight of the guitar, and the electronics. There were a lot of things I wanted to do with the pickups that I couldn't do with my other guitar, involving coil tapping, multiple pickups, collections, onboard effects loops, push pull pots, boosters, buffers, different pickup combinations, lots of things. We eventually narrowed it all down to what I have at the moment. One of the specifics is the humbuckers, which are Lollar high-wind Imperial pickups. Scott recommended the Lollars very highly. He'd worked with Jason Lollar closely on a lot of his guitars, so I trusted that recommendation, and they sound great.

I waited ten months for this thing. It was over a yearlong design process and then a ten-month waiting period to get it. I was waiting for and dreaming about this guitar, but right before I went to pick it up, I thought to myself, Well, geez, I hope I like this thing. Just because you've waited ten months and put a bunch of thought and money into something doesn't mean you're guaranteed to like it. But this guitar has far, far exceeded my hopes for it.

> "IT WAS OVER A YEARLONG DESIGN PROCESS AND THEN A TEN-MONTH WAITING PERIOD TO GET IT."

Another thing I should mention about this custom guitar is that it was inspired by playing the Wolf guitar, Jerry Garcia's first custom guitar. I got a chance to play that guitar for the entirety of a CRB show a couple years ago. The current owner of the guitar was kind enough to send it down to us at the Great American Music Hall one night. That guitar changed my life. It changed my perception of what a guitar could be, what kind of possibilities you have in front of you, and the importance of working with someone on a guitar. The difference between a store-bought, off-the-rack guitar and a guitar built by a lone artisan who pours every bit of his soul into it is immense. I got a lot of ideas for my current guitar from playing Wolf. I'm certainly not trying to sound like Jerry Garcia or trying to sound like anyone else, for that matter, but playing Wolf opened up my mind and inspired me in the continuous search for my own voice.

When I played Wolf, I noticed how dense the guitar was. By that I don't mean heavy, but just how dense, and tightly molecularly packed that guitar is. It's very solid. The notes just jump right off the extremely hard surface of that guitar, and I wanted mine to have a similar feel. No chambers, no hollow portions, nothing. I wanted the most solid wood possible for this guitar, so Scott suggested flame maple for the top, a mahogany back, a rosewood neck and an ebony fretboard. I wanted a very lively, bright, solid-feeling guitar.

The true test of this guitar came in November 2014. I did two shows with Phil Lesh & Friends at the Capitol Theatre in Port Chester, New York. It was me and Adam, our keyboard player from CRB, and Chris, too. We sat in for a couple shows with Phil and Joe Russo. Eric Krasno was the other guitar player, who I'd never really played with before. The real test of this guitar came then, because we were thrown into a somewhat unfamiliar situation in front of a bigger-than-usual crowd. There was very little rehearsal, we were really doing it on the fly, and that's when you find out if your instrument really stands up to some more-demanding tests. I noticed that the guitar just stood right out, had no problem carving out its own place in the mix. For solos, its voice was easily heard; it has such excellent tone and really complemented all the other instruments.

When I got this guitar in April 2014, the difference in tone and presence was felt immediately. Everyone heard it, I could tell the difference, Chris could tell, the people in my band could tell. The people who follow us closely immediately commented, "Hey, man, you really raised the bar here." I also got a new amp in 2014, and I built a new pedal board, and I got Kidd Candelario to make me some really high-quality cables. It all adds up; it all contributes to the improvement in the sound. Across the board this guitar has been the best move I've made in a long time as far as instruments go.

For the guitar it's clarity. Clarity is the word. There's a clarity that I'm after in everything I do. To speak with my own voice in my work, that's what I'm after. You can be inspired by greats of the past. But ultimately what I'm after is to speak in my own voice with clarity. So whether it's a live show or a recording, I strive for a singularity of voice that speaks out clearly, unambiguously through the muddle, through the mix, through the clatter and chatter of noise and billions of voices screaming across the surface of the earth. I would hope for my voice to come through clearly and soulfully. That's really the reason that I had this guitar built. That's what I was after—a simple clarity of voice.

Opposite: Chris Robinson Brotherhood, Great American Music Hall, San Francisco, CA, November 22, 2014

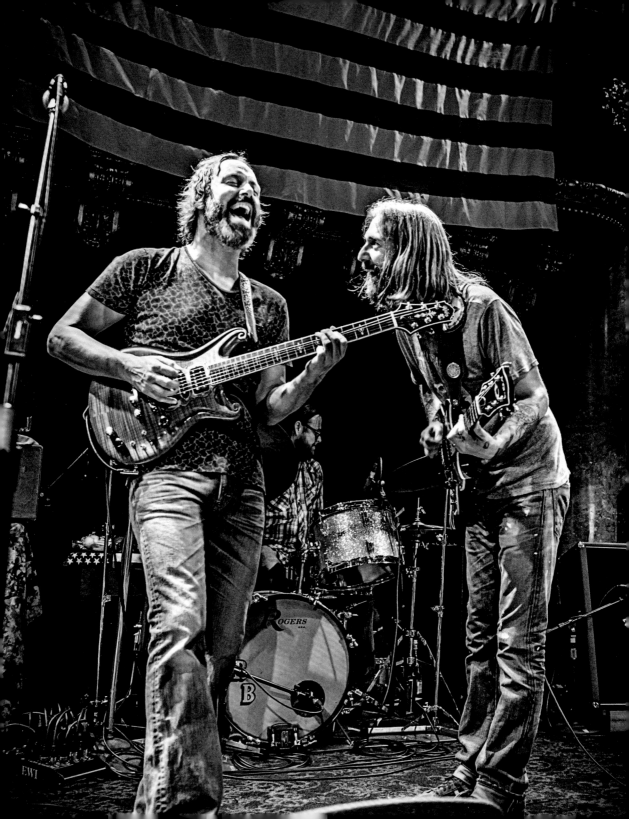

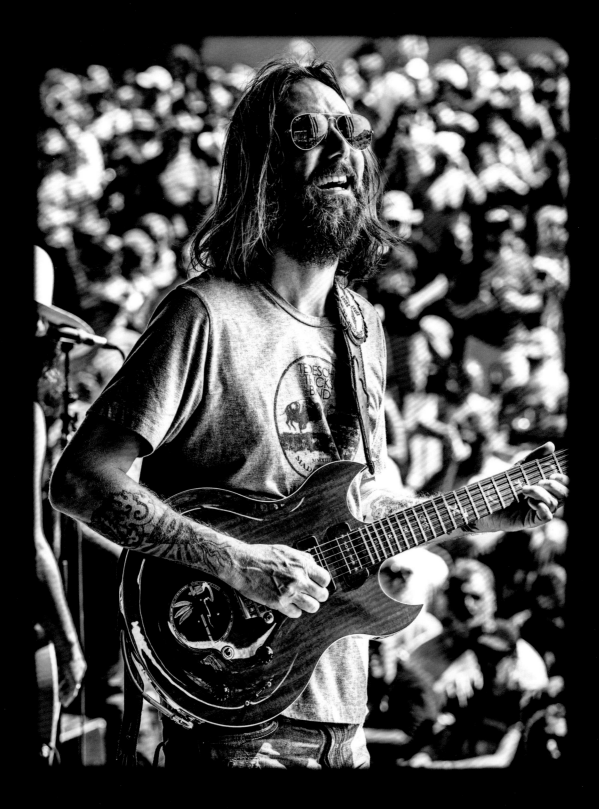

CHRIS ROBINSON

2012 | VOX VIRAGE CUSTOM

Opposite: Chris Robinson Brotherhood, Mountain Jam, Hunter Mountain, NY, June 8, 2014

VOX INTRODUCED THEIR GUITAR LINE a few years ago, and I got ahold of one—just a production model Virage. I loved the guitar, and I was playing their amplifiers. I got a call from Vox designer and luthier Rich Lasner, and he came to a show in San Francisco and said, "Hey, would you be interested in us making you a custom guitar?" My jaw hit the floor. "Of course!" It was a real honor to have a great guitar designer and company offer to build me something. I played that first guitar with CRB (Chris Robinson Brotherhood), and VOX came to me again and said, "Can we improve on it? Can we make you something else?" That's where this guitar came from. I call it the Peace Pipe. Rich designed the guitar and put in their Vox pickup system, but with three pickups. My guitar is the only one with three pickups.

The inlays were the other part of getting this guitar built. Rich let me design as much as I wanted, so I designed the inlays on the neck. Alan Forbes, CRB's poster artist, designed the Peace Pipe inlay that's on the body of the guitar. In addition to those custom inlays, this guitar has crystal frets, making it a real

hippie guitar. I like the feel of them; they create a unique sustain, and the frets themselves are a little lighter.

As far as the pickups go, I like a very loud but clean sound. And these pickups give me that. If I dig in, I don't really need to rely on the amp as much. And the pickups are versatile. With certain settings I can get a real Stratocaster sort of sound without actually playing a Strat. The pickups go from a P-90 to a humbucker with the flip of a switch, because that's how the Vox is designed, and I love it.

I like the idea of getting as much dynamic sound and sonic capability as possible out of one instrument, and this instrument does that for me. But it also has its own specific sound. For whatever reason, this guitar was put together in a certain way, and it vibrates and hums in its own unique way. And with the crystal frets I feel like I get a clean, crystalline sustain and a sparkle that really suits my rhythm playing. There's a real clarity. With this guitar I know what colors and textures are available, and they interweave in a nice musical mosaic with the whole band. I think you're just looking for stuff that has its own individual identity, sonically. I've played this guitar at a lot of shows since I've owned it and for me it's been all one big, buttery, euphoric jam. It's honey melting in the sun. And the coolest part is, it's mine, and no one else can go to the store and get one.

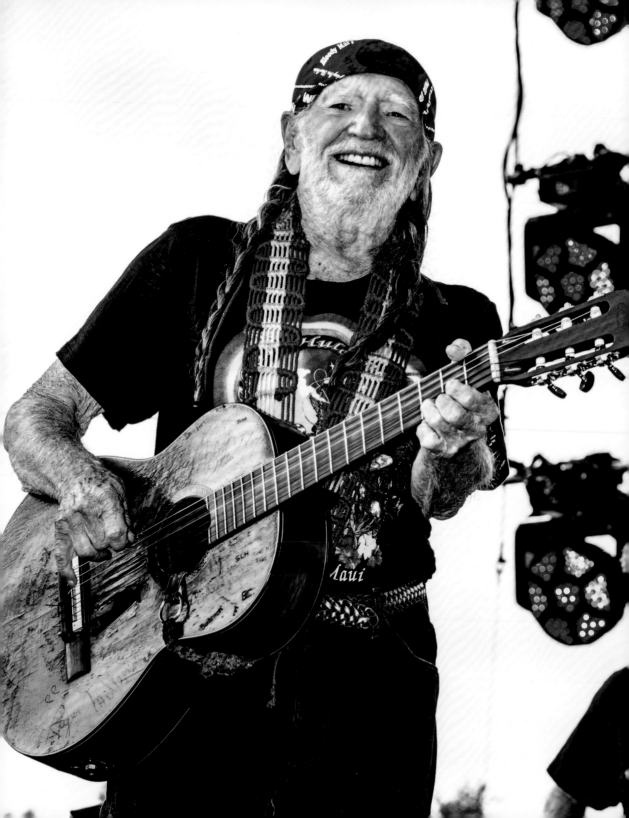

WILLIE NELSON

1969 | MARTIN N-20 CLASSICAL, "TRIGGER"

Opposite: Willie Nelson, Lockn' Music Festival, Arrington, VA, September 7, 2014

AS WILLIE NELSON FAMOUSLY SAID, "Roy Rogers had a horse named Trigger. I figured, this is my horse!" Nelson bought Trigger in 1969 from Shot Jackson in Nashville, Tennessee. The guitar has been Nelson's go-to instrument since then, evidenced by what has to be classified as extreme but somewhat charming wear. The top of this guitar is made of Sitka spruce, which came from the Pacific Northwest; the back and sides are Brazilian rosewood; the fretboard and ridge are composed of ebony from Africa, and the neck is mahogany from the Amazon basin.

A classical, nylon-string guitar, this Martin could have easily fallen into the hands of a flamenco guitarist. As fate would have it, Trigger was recommended to Nelson after a drunk stepped on his previous axe at a show at the John T. Floore Country Store in Helotes, Texas, and busted it up beyond repair. After learning from Shot Jackson that the guitar was unsalvageable, Nelson bought Trigger from Jackson for $750 in 1969.

In the more than forty-years since, Nelson has played countless shows (including the *Austin City Limits* pilot in 1974) and recorded many groundbreaking albums with Trigger, including *Willie Nelson and Family, Phases and Stages, Shotgun Willie, Red Headed Stranger, Stardust, Spirit,* and many more. Famously fascinated by the guitar playing and tone of Django Reinhardt, Nelson found that Trigger got him into the tonal universe of Django, and with that at his fingertips, there hasn't been much need to replace his old horse, despite the gaping second hole in its top (which Nelson contends makes the guitar sound better). Aging well together, there is perhaps no more well-documented or iconic connection between artist and instrument than the connection between Willie Nelson and his guitar, Trigger.

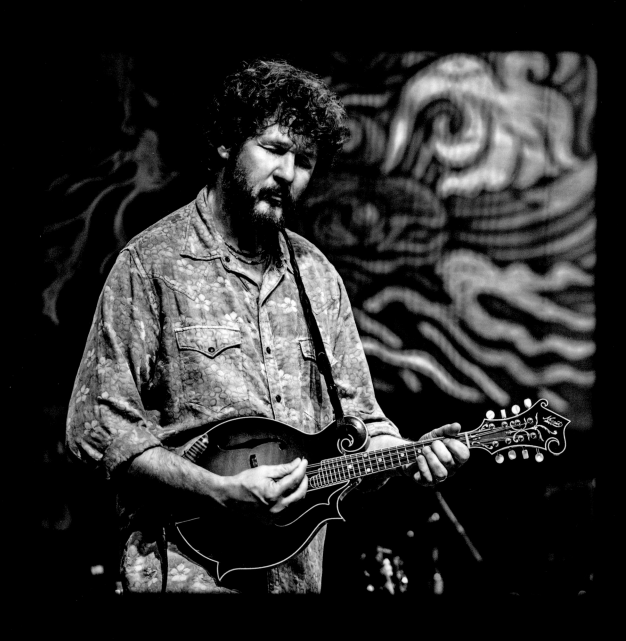

DREW EMMITT

1996

NUGGET F5 DELUXE MANDOLIN

BUILT BY MIKE KEMNITZER IN CENTRAL LAKE, MICHIGAN

Opposite: Leftover Salmon, The Fillmore, San Francisco, CA, December 6, 2014

I ORDERED THIS INSTRUMENT from Mike Kemnitzer in 1992, and it was built to my specs and delivered in 1996. Tim O'Brien was the musician who inspired play a Nugget.

I've spent a lot of time with this mandolin and have played a lot of shows, but the time Levon Helm borrowed it to play "Rag Mama Rag" at the Little Feat commemoration of Waiting for Columbus in Washington, DC, is a standout moment.

I love playing this mandolin because of its beautiful tone, ease of playing, and wonderful feel. It has the greatest neck and fretboard and is a thing of beauty to look at. It also sounds awesome plugged in, thanks to the built-in LR Baggs bridge pickup. The only modification I've made is the curly maple armrest, which I added for comfort.

The best thing about this instrument is that I don't play it—it plays me.

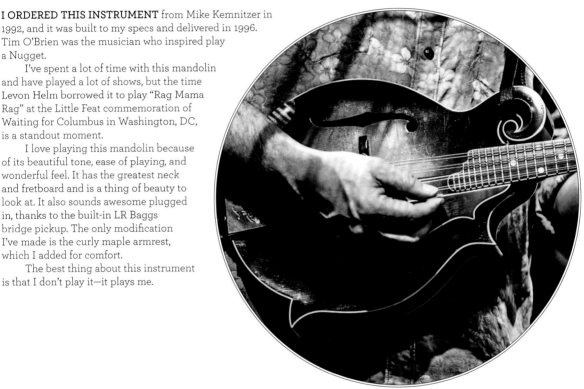

"THE BEST THING ABOUT THIS INSTRUMENT IS THAT I DON'T PLAY IT—IT PLAYS ME."

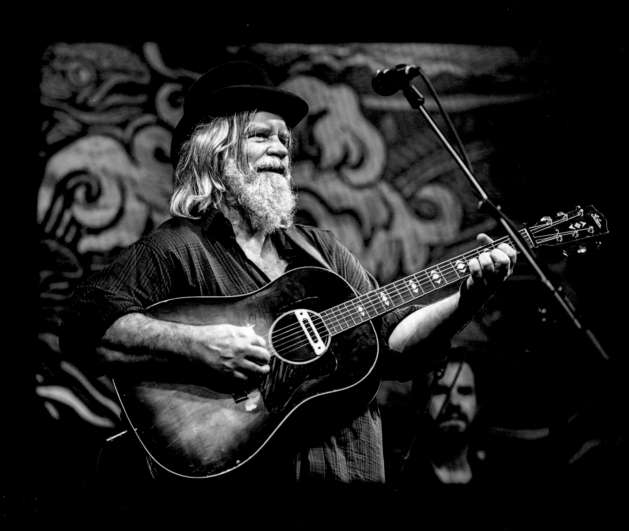

VINCE HERMAN

1996

GIBSON AJ REISSUE

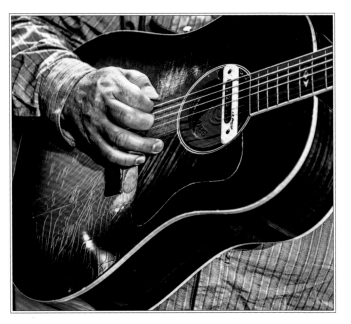

I FOUND THIS GUITAR through Gary Burnette at Bee-3 Vintage Guitars in Asheville, North Carolina. It was sitting in a room of pre-worn Martins priced at ten times the amount of this new instrument. After playing a few of those amazing old cannons and wishing I had a ton of mailbox money to buy them all, I reached for this more affordable delight. I was immediately stunned by the great bottom end and balanced highs of this guitar. It played like butter, it fit my hand, and it was brand-new old stuff. It was standing up to fifty-year-old masterpieces of guitar making.

The guitar's a Gibson 1996 Vintage Acoustic Jumbo reissue of a 1930s design. It's glued together with old-fashioned hide glue and is hand carved by recovering veterans in Montana.

Mr. Burnette played hundreds of that model at the factory and bought a few of his favorites. Sometimes the wood just comes together well on an instrument, and the magic happens. I think that happened with this one.

I play in a loud bluegrass band, plugged in and all that, so I'm constantly trying to make it a loud and realistic-sounding acoustic guitar at stage volume with varying degrees of success. I even lost faith in it and gave it to a friend for a few years when other guitars seemed to work better onstage. Now it's back in the main guitar position and holding steady. I hope I don't wear it out soon, but that's another story.

"IT PLAYED LIKE BUTTER, IT FIT MY HAND, AND IT WAS BRAND-NEW OLD STUFF. IT WAS STANDING UP TO FIFTY-YEAR-OLD MASTERPIECES OF GUITAR MAKING."

ADAM AIJALA

2004 | COLLINGS D1

Opposite: Yonder Mountain String Band, The Fillmore, San Francisco, CA, April 14, 2012

I STARTED PLAYING ELECTRIC GUITAR AT THIRTEEN, but I wasn't drawn to flatpicking and bluegrass until a bit later in life, shortly before I met the guys in Yonder Mountain in 1998. I learned that most people consider dreadnought guitars with either rosewood or mahogany backs and sides to be the standard among bluegrass guitar pickers. Well, two guitars and six years later I happened upon this guitar and not by accident. David Grier, who I consider one of the greatest guitar pickers of all time, played an old '55 Martin D-18 and I just loved the tone. I knew my pockets weren't deep enough to afford a vintage guitar, but I've always loved Collings guitars. The next time I visited the Collings home base in Austin in 2004 I found this D1 and fell in love. Acoustically, even with all of the electronics inside the body, it still sounds great, and it cranks when plugged in too. It has a better feel than any of my other guitars. It's also my workhorse, so it travels a lot and is exposed to all ranges of both temperature and humidity, which is hard on acoustic instrument It has stayed strong through it all. Because it plays so well, I haven't needed to modify it, with the exception of adding a powered pickup, internal mic, and stereo jack.

My favorite single quality of this guitar has to be its familiarity. Thanks to Collings for making such great guitars!

"IT HAS A BETTER FEEL THAN ANY OF MY OTHER GUITARS."

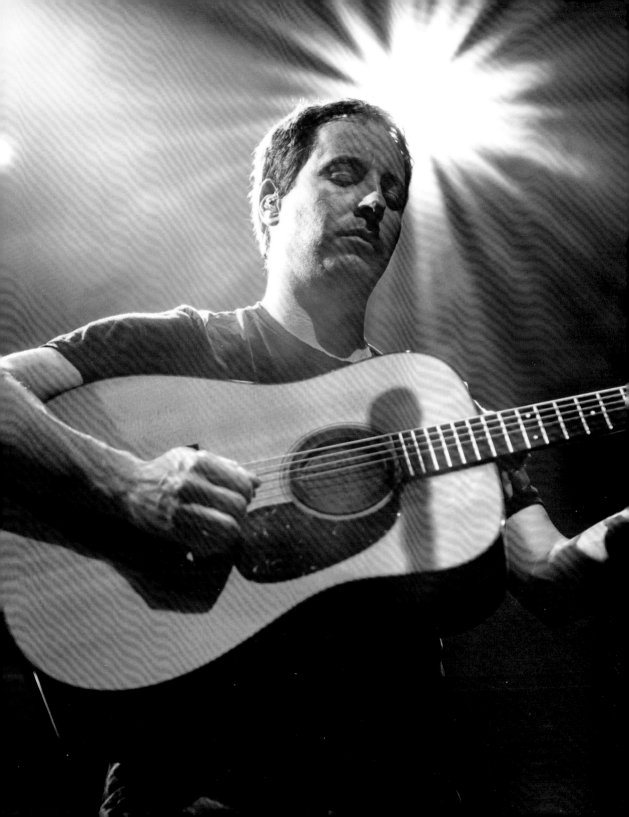

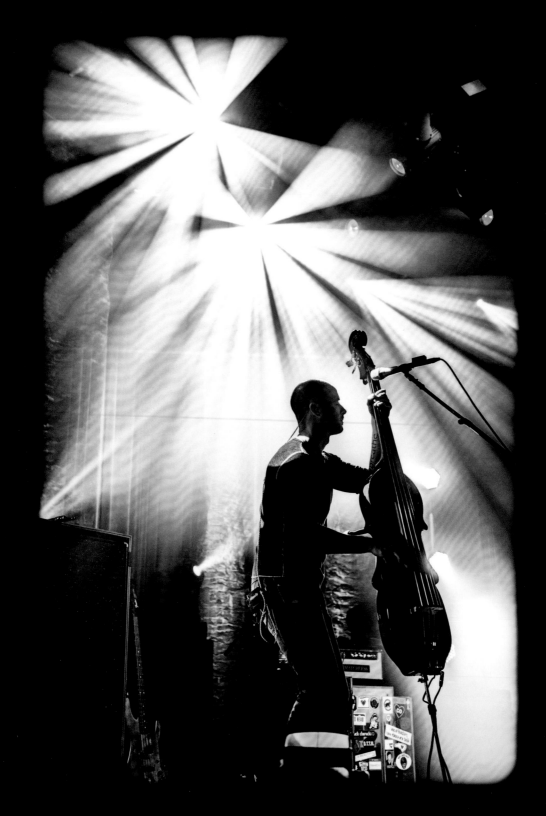

BEN KAUFMANN

2011 FIVE-STRING G. EDWARD LUTHERIE EMINENCE UPRIGHT BASS

Opposite: Yonder Mountain String Band, The Fillmore, San Francisco, CA, April 27, 2013

I SAW BYRON HOUSE PLAYING ONE OF THESE in Sam Bush's band ages ago, and he let me check it out. Yonder was starting to do more air travel, and flying with a full-size upright bass is a very special kind of pain in the ass. The Eminence bass comes apart in this clever way and can fit in a hard case designed for golf clubs. What began as a practical decision grew into a real love affair with what the instrument can do at rock 'n'roll volumes.

Somewhere along the way, I decided I wanted less of a traditional acoustic upright bass tone and more of a thundering, silver-grilled, 1970s rock 'n'roll kind of a sound. I wanted a bass tone that someone jumping off a building could land on safely. The Eminence bass was a big part of my solution.

I love how this bass produces such a clear, powerful low end. It still seems counterintuitive to me that this smaller, skinnier bass can make a bigger sound than anything I was able to get out of a "proper" upright bass, but it's there.

"I LOVE HOW THIS BASS PRODUCES SUCH A CLEAR, POWERFUL LOW END."

LUTHER DICKINSON

2010 | BAXENDALE CANJO DIDDLEY BOW

THE FIRST CANJO I OWNED was made by Joel Byron of Baxendale Guitars at a workshop for children and was given to me by Scott Baxendale, master luthier, during a concert in a record store. There was an open window to my left, and Scott leaned in and handed me the canjo, laughing when he saw my wide-eyed excitement, fully aware of how I love funky, handmade guitars. I instantly knew what to do with the instrument, quickly tuned it to G and D, which is called "double-noted" in Mississippi, and kicked it off with "Rollin 'n Tumblin," a classic diddley bow song.

The instrument changed my life because "Rollin 'n Tumblin" became a staple of our live shows and the cornerstone of the next North Mississippi Allstars record, *World Boogie Is Coming.* This record is modern day Mississippi blues exercising the aesthetic of primitive modernism. The canjo, played thru a pedal board and a 100-watt amp, is primitive modernism at its finest!

Historically, the diddley bow is a piece of broom wire nailed to the porch of a house. The wire is tightened by wedging bottles against each end and then nailing them in place. Another bottle is used as a slide, and either a plectrum or a small stick is used to pick or strike the string. You hear stories from all the great bluesmen about playing a diddley bow before they got ahold of a guitar. A handheld version is made with a two-by-four, using a coffee can as a resonator. I made one of these when I was a child. Jack White made one in the movie *It Might Get Loud.*

This last summer, while touring Europe and opening up for Robert Plant, I played my diddley bow constantly. I love the freedom in limitations, and a few strings on a broom-handle neck suit me just fine.

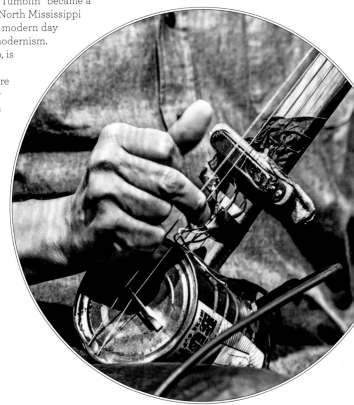

LUTHER DICKINSON

2012 | GIBSON ES-335

Opposite: Phil Lesh and Friends, Terrapin Crossroads, San Rafael, CA, May 16, 2013

MY GUITAR STYLE IS BASED on the idea of playing fingerpicked, open-tuned, acoustic-based country blues in a loud, electrified rock 'n' roll setting. For years I have been hustling the electric guitar to respond and even sound like an acoustic guitar. In my mind's ear, the tone is not electric but loud acoustic: pure, woody, clear, and fat, a universe of harmonious, infinite, hollow-body sustain at my disposal. I am guilty of sticking to this tone even when it is not appropriate. This is my sound.

I grew up playing fully hollow Gibson ESs: my dad's 175, a 330, even my beloved Epiphone Casino. The ES stands for "electric Spanish," as in Spanish guitar. This concept is perfect, exactly what I want and love. Old-school Harmony, Silvertone, Truetone, and Kay hollow-bodies are also ideal. I was satisfied, until I hit the road.

Fully hollow guitars sound and feel great at home, in the studio, or in small clubs, but they don't respond the way I want at high volumes. They feed back like crazy in the loud environment my career evolved into. In my early years on the road, as the rock 'n' roll gigs got bigger and louder, the old guitars proved unpredictable

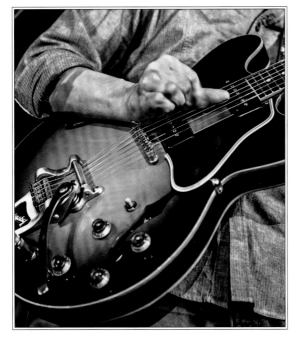

and unstable. All my old and funky guitars fell apart. The wear and tear of guerrilla-style touring is too rough on the old gals if you don't have the means and parts to work on them every day.

Chris Robinson gave me my first ES-335. The eureka discovery was the ES-335. Semi-hollow, with a block running through the body, it has just enough stability to sing thru a 100-watt (or 150-watt!) amp while still responding and sounding similar to an acoustic guitar. Debuting in 1958 as the first "semi-acoustic" electric guitar, I think it is the pinnacle of American guitar design, combining traditional acoustic guitar aesthetics with the pioneering modern invention that is the electric guitar.

When Gibson approached me about designing my own model, I took my collection of '50s tobacco sunburst ES Gibsons to the shop. It was obvious I have "a type." They decided to re-create the finish of my Dad's 175 and call it the "Jim Dickinson burst." Gibson shaped a neck that was not too skinny, copying the neck on my '54 LG-1. The first prototype was a beautiful 335 [pictured opposite] but I wanted to make my guitar more unique, so in an attempt to stretch the 335 toward an acoustic response, we decided to use my favorite old-fashioned P-90 pickups and add a Bigsby for more resonance [pictured left]. The guitar was called an instant classic—the 335 that never was. I am satisfied but still dreaming about the ultimate tone.

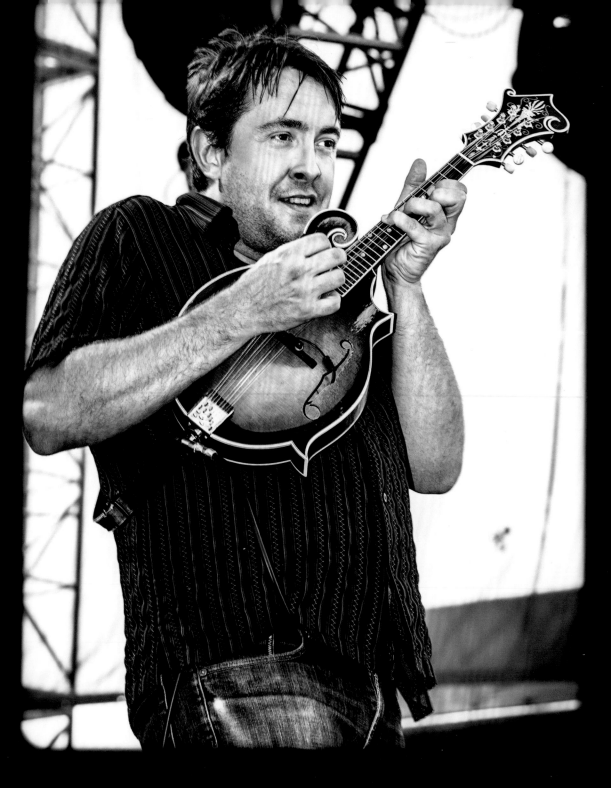

MIKE KEMNITZER'S MANDOLINS are some of the more sought-after mandolins a player can get. If you order a mandolin from him, you may not even see it for a few years. His craftsmanship is meticulous. He listens to the wood to bring out the charm of different cuts, and he knows how to work it to give players every tool they need. It seems guitar and mandolin players are chasing a sound, and Mike has an amazing way of bringing that out of the wood; all you have to do is play it and work it, and you'll find it.

The wood for this instrument—which is spruce and maple—was all cut in Colorado at nine thousand-something feet; it's really hard wood. I live in Colorado, and this mandolin was made about fifteen minutes from my house. So it's a high-country mandolin, and it's got that dry, yet real big sound.

This instrument came to me in a pretty cool way. In 1999, Drew Emmitt bought this mandolin from a guy named Ned Alterman. Ned was a local banjo player who played a little bit with the Salmon Heads, Vince Herman's first band. He was always at the kind of gigs that were going on in the late '90s on the front range of Colorado. I was there the night that Drew Emmitt bought this mandolin from Ned. I stood between them while Ned handed it to Drew. Drew opened the case and started playing. I had never heard anything like it in my life. Not only was this the mandolin that I had heard so much about, the Nugget mandolin, but Drew Emmitt was playing it! It was one of those "holy shit" moments.

Drew let me play it a little bit that night. It was beautiful! I told Drew that if someday he wanted to sell this mandolin to anybody and he didn't call me first, I was coming for him. Now mind you, I had probably fifty-three dollars to my name, so we laughed, but I was sitting there thinking, "I want this so bad! This mandolin is amazing."

In 2007, I was sitting in the back of a tour bus with my old band, and the phone rang. When I saw that it was Drew, I knew what he was calling for. Backstage at Telluride in 2007, he handed it to me, and it was mine. When I got it, it was pulsating. It was a living thing; it really wanted to be played. Drew said, "I just don't play it often enough." You have your primary instrument, you know. You might have another great instrument, but your primary one, that's your thing. That's your breath. And Drew just said, "You need to have this mandolin."

JEFF AUSTIN

1984 NUGGET F5 DELUXE MANDOLIN #76
BUILT BY MIKE KEMNITZER IN ELDORA, COLORADO

Opposite: Grateful Grass, Gathering of the Vibes, Bridgeport, CT, August 1, 2014

KELLER WILLIAMS

2001 | MARTIN HD-28

Opposite: Grateful Grass, Gathering of the Vibes, Bridgeport, CT, August 1, 2014

MY MAIN INSPIRATION for playing solo acoustic guitar is Michael Hedges, who played a Martin D-28, so naturally I had my eye on those for a long time. Then Michael Travis, one of the drummers from the String Cheese Incident (and also an amazing guitar player), told me that the new HD-28 had the most low end he had ever heard in a dreadnought acoustic guitar. At the time I had been playing a big jumbo twelve-string, so I was looking for something that could move air in the subwoofer department. In 2001, when I received my brand-new HD-28, I knew Michael Travis was exactly right, and I was glad I had taken his advice. The guitar, which I named "The High Diva," came from the factory with a Fishman pickup installed. I immediately put on heavy strings and tuned it down a whole step, and I played like that for many years, just the way it arrived from the factory.

When it needed new frets, Martin sent me another HD-28 as a loaner to use while The High Diva was in the shop. Same company, same model, but made a different year—and it was a completely different guitar. The sound was different. The feel was different. I bought that guitar as well and mostly used it as an experimental guitar, but nothing really compares to The High Diva. Beyond its perfect tone, its easy playability, and its intoxicating scent, the low end—both live and through the speakers—remains my favorite quality about this guitar.

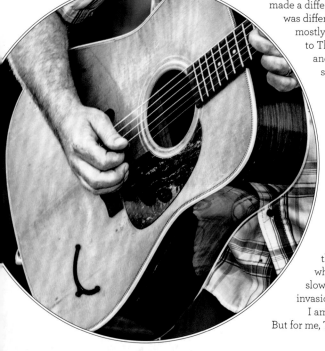

The *H* in *DH* is for *herringbone,* which was a binding design on the original D-28. Somewhere along the way, the herringbone disappeared from the D-28. Michael Hedges played one with no herringbone. Mine is a reissue that brings back the herringbone concept from the glory days. Some of it has peeled away, which reminds of the later D-28s like Hedges played. Because of that, I think it looks cool and refuse to fix it.

I enjoy experimenting with electronic sounds via MIDI. I've always had a separate guitar on a stand in play position that has a guitar synth pickup. The only real modification on this guitar is the addition of the new wireless MIDI pickup from Fishman. The black bracket under the strings as well as on the body holds this particular MIDI pick up. Since it's wireless, which to me is mind-blowing, I can spin around in circles while slowly fading in a string quartet, or a horn section, or an alien invasion—all with a warm acoustic tone underneath.

I am constantly searching for different guitars that can beat this box. But for me, The High Diva reigns supreme.

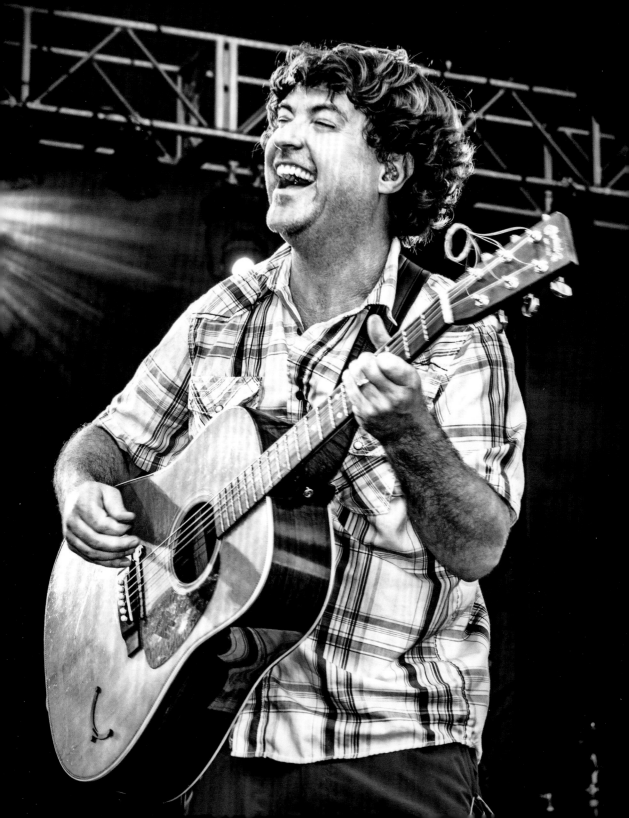

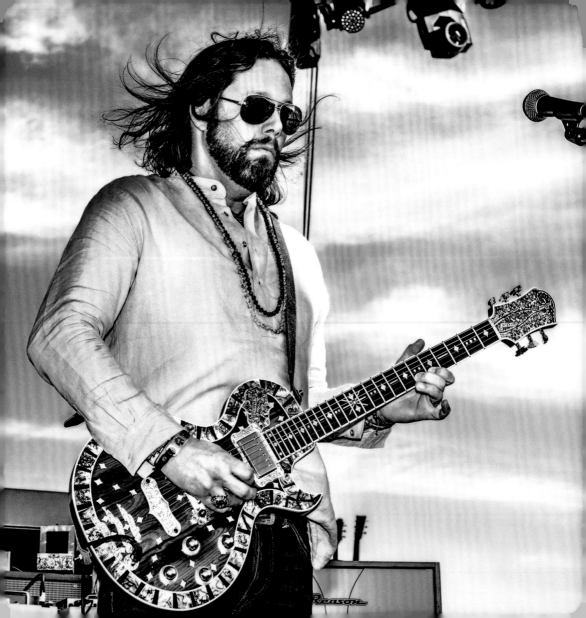

RICH ROBINSON

2014 | TEYE-EL DORADO

Opposite: Black Crowes, Lockn' Music Festival, Arrington, VA, September 7, 2013

I'VE ALWAYS LOVED ORIGINALITY in the design and sound of instruments, and Teye is making beautiful and unique instruments. This El Dorado has a Mexican rosewood hand-inlaid top, with purple abalone and ebony mosaic, a walnut neck, black korina body, mother-of-pearl inlaid ebony board, and chrome hardware, all of which contribute to its unique look.

Teye made the guitar for me after I bought my first guitar from them. That first instrument was so special I reached out and met with Teye. We designed three more guitars together, and this is my favorite. My love for luthiers like Tony Zemaitis and James Trussart brought me to Teye, whose approach to guitar making is right up my alley. When I saw this instrument for the first time, I was in awe. But beyond the fact that it's a beautiful instrument, the neck fits my hand unlike any guitar I've held in the past. It's perfectly suited to me and the way I play guitar, and I love everything about it—the feel, the way it sounds, and, of course, the way it looks; it's a work of art and beautiful to behold.

"IT'S A WORK OF ART AND BEAUTIFUL TO BEHOLD."

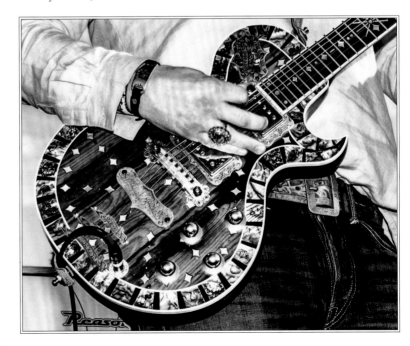

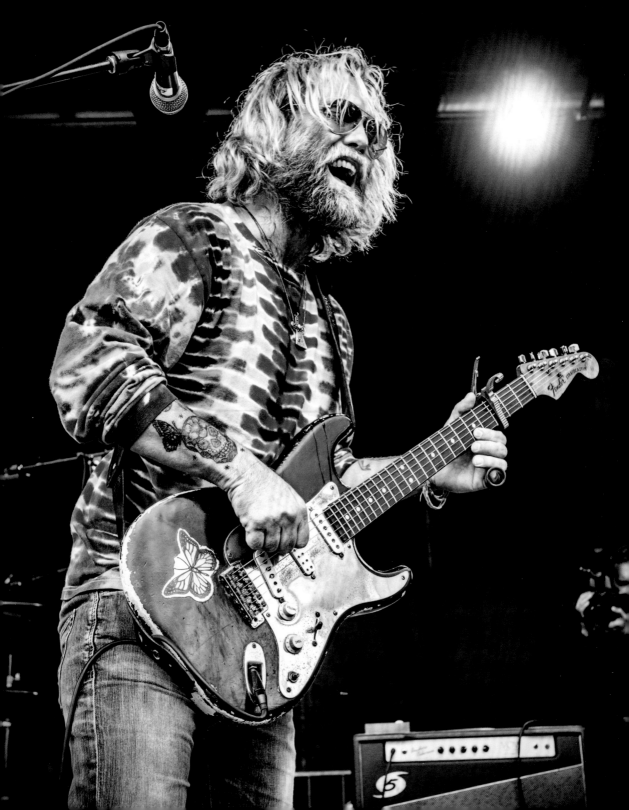

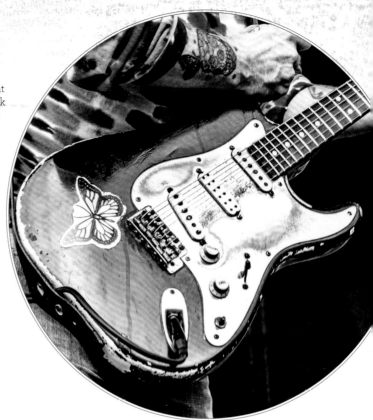

I FOUND THIS ORPHAN GUITAR BACK IN 1986 at Rock 'n' Roll Music, a New Orleans music store. I took it off the rack and knew we were made for each other. She is my musical twin. She's got a bird's-eye maple neck and an African ebony fretboard, and she's had a few minor modifications, including a Seymour Duncan single-coil humbucker pickup in middle position, two extra springs (for five total) in the back of the tremolo bar, and a chrome pickguard.

I left her at a festival once, back in 1999, after a four-day drug and alcohol binge. It sobered me up for three years! Luckily she found her way back to me. She has been and is essential to my musical identity. She responds to everything I do, and makes me play her style when I can't come up with anything myself. She's a brilliant guitar, and I love her toughness.

"SHE HAS BEEN AND IS ESSENTIAL TO MY MUSICAL IDENTITY."

ANDERS OSBORNE

1968 | FENDER STRATOCASTER

Opposite: Anders Osborne, Mountain Jam, Hunter, NY, June 1, 2012

REED MATHIS

1995 FENDER AMERICAN STANDARD JAZZ BASS

Opposite: Tea Leaf Green, Brooklyn Bowl, Brooklyn, NY, May 10, 2014

MY BELOVED BASS is a 1995 Fender Jazz American Standard. It is one of the first basses they made when they started handmaking them in America again. I saw it hanging in the music store in Tulsa, Oklahoma, and it seemed to call to me. I played it for about half an hour without ever plugging it in, and I knew it was the instrument I would play for the rest of my life. It was loud and clear, even unamplified. It's been my only bass ever since—nineteen years!

The Fender Jazz bass is one of the most iconic instruments in rock history and has been played by most of my bass-playing heroes. A short list would include John Paul Jones, Aston "Family Man" Barrett, Jaco Pastorius, and Paul McCartney.

I've played around 3,500 gigs on this bass, and it is covered in battle scars. The sunburst finish is completely worn off in the three specific positions my right hand uses. It's been left behind at Tipitina's in New Orleans and the Belly Up in Aspen. It's sung on the stages of Carnegie Hall, the Fillmore, Cain's Ballroom, and the Berlin Jazz Festival. It's been played by Bakithi Kumalo and Les Claypool, and it's made over fifty records.

The only modification I made to it was to have a friend cut the pickguard down and spray-paint it black. It's funny, just that simple cosmetic change is enough to make many people think it's some kind of fancy custom bass!

I love this instrument for many reasons. Obviously, I love it because it's been with me for so many years and so many shows. I love it because it's bent to my hands, and my hands have bent to it. I love it because I know exactly what it likes. I love the way it looks. I love its weight. But my single favorite quality about this bass guitar is its bold and beautiful voice, so clear and powerful. It outshines any other bass I've ever played. Grateful!

"I KNEW IT WAS THE INSTRUMENT I WOULD PLAY FOR THE REST OF MY LIFE."

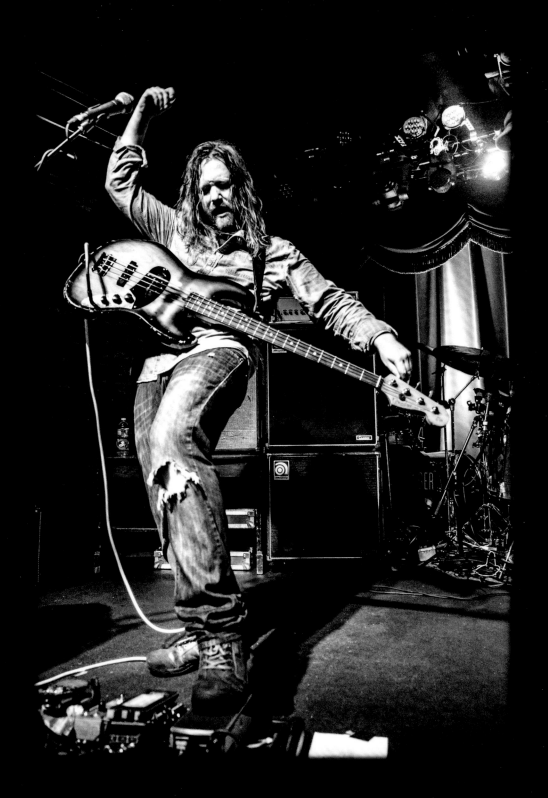

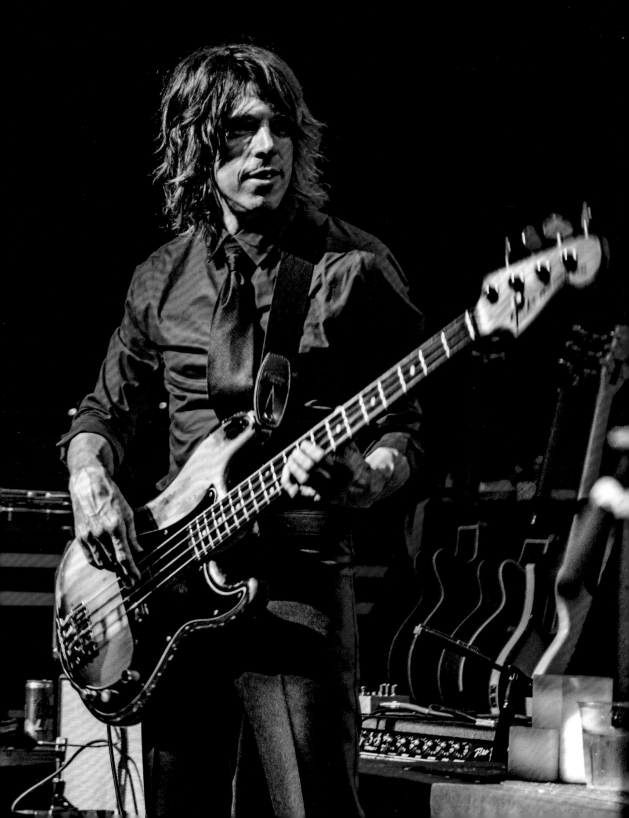

STEVE ADAMS
1974 FENDER PRECISION BASS

Opposite: ALO, The Fillmore, San Francisco, CA, February 11, 2014

DONALD "DUCK" DUNN AND JAMES JAMERSON were two players I started paying much closer attention to around the time I got this bass, which was almost fifteen years ago. I love what they recorded, the tone they got from their instruments, and how they approached playing a song. Their style was something I really wanted to bring into my own way of playing. The Fender P-Bass was the instrument they used to do what they did, so naturally, I wanted one.

Leo Fender introduced the Precision Bass in 1951. It was essentially the first commercially successful electric bass guitar. It was solid and simple and worked great playing just about any kind of music. Because of its success and versatility, it ended up in the hands of many great bass players from that era: James Jamerson (Motown), Bill Black (Elvis Presley), Duck Dunn (Stax), George Porter Jr. (The Meters), Doyle Holly (The Buckaroos), Bob Bogle (The Ventures), Carol Kaye (The Beach Boys), and the list goes on. Without even really knowing it, I was raised on a lot of music that had that P-Bass sound tucked right in it, so I think it has always been my reference point for how a bass guitar should sound.

My good friend, former ALO drummer Shyam, found this bass for me. He had been rounding up a nice collection himself, and knowing my playing better than anyone else at the time, he had a strong hunch I would dig this one. He was absolutely right! It brought me immediately closer to the sound I had been chasing. I've hardly played any other bass since. It has gone with me to practically every recording session I've been a part of; it has been around the world and then some. It has survived airline baggage handlers, extreme weather conditions, stage-crashing psychedelic zombies, and even a crazy van roll in Lyman, Wyoming.

It came to me with a Leo Quan Badass Bass II Bridge, which is a common upgrade on the P-Bass. And I had to replace the pickguard since it was cracking near the input. It also came with a substantial gouge in the back of the body, probably from a belt buckle. It's not exactly an intentional modification, but it's certainly a remarkable change to the shape of the body.

I feel this bass has become an honest extension of my life—my personality, my struggles, my victories. It has traveled with me, seen what I've seen, helped translate my ideas and efforts into music and art. The tone, the feel, and the reliability are all things I've come to trust and love about this bass. And with all that, it is the gateway through which I bring joy and inspiration to the world the best I can.

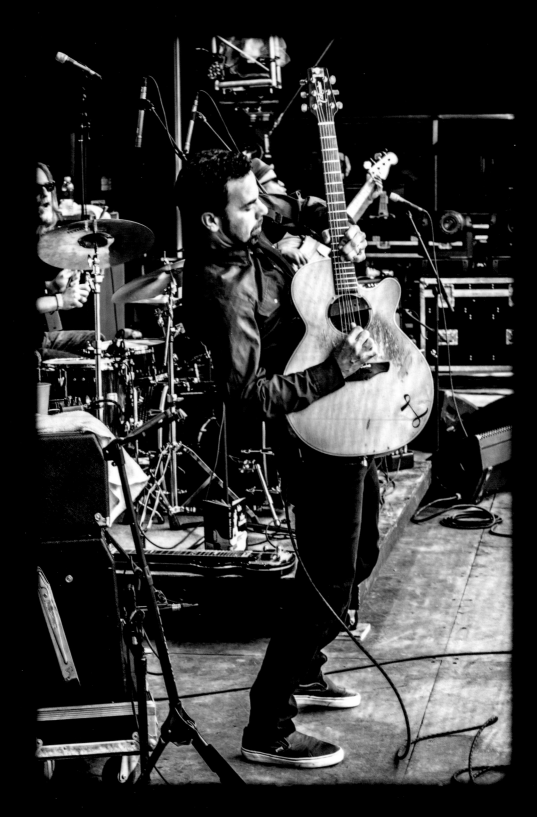

DAN LEBOWITZ

2004 | TAKAMINE EAN40C

Opposite: ALO, Mountain Jam Festival, Hunter Mountain, NY, June 9, 2013

I STUMBLED UPON THE ELECTRO-ACOUSTIC THING a while back, and it came really naturally to me. At the end of the day, I'm looking for a tool to get the ideas out of my head and into the "air." If an instrument can aid in the inspiration of those ideas, it's a winning combo!

I've owned this guitar for about ten years now, but since I don't switch guitars too much, it's got fifty years worth of playing on it, easy. It's been around the world and back several times over and is just as happy in the studio. If it weren't for my regular superglue patching sessions, the top of the guitar would have worn away ages ago. This thing is a real workhorse.

This instrument is heavily modified. Prior to my days as a full-time, touring musician, I apprenticed with a luthier. During that time I got a lot of experience pulling guitars apart and rebuilding them, so I'm pretty fearless when it comes to bringing out my tools. I've gutted the electronics and put my own in, I've repaired cracks and braces, and I've refretted it several times, because I like bigger frets than it initially came with. For each thing I've changed on this guitar, there were several experiments I tried out and then reversed back. You never know if you don't give it a shot.

For me, this is an electric guitar. That's how I play it—plugged in. What I like about it is that it resonates and responds unlike any other type of electric guitar I've played. It's not like an arch-top, it's not like a solid-body, it's not like a semi-hollow-body. I suppose you could call it a "flat-top electric." At this point, I'm so deep into this thing that other guitars often feel strange to me. When I'm playing, I don't want anything between me and the ideas. Put simply, this guitar feels like home sweet home.

GRAHAME LESH

2013 | GIBSON ES-335

Opposite: Phil Lesh and Friends, Terrapin Crossroads, San Rafael, CA, June 13, 2014

I HAD LONG BEEN IN THE MARKET for a semi-hollow-body guitar after seeing Ross James's Fender Coronado and my brother Brian's wonderful ES-335. The look, the tone, the weight, and the gravitas of instruments like those were exactly what I wanted. I had always loved the tone that players like Bob Weir, Ryan Adams, Warren Haynes, and Luther Dickinson got from 335s, and more recently some of my favorite players, like Tim Bluhm and Deren Ney, have done wonderful things with them. Their tone is so versatile and works with so many of the styles that I wanted to explore. So when I found this guitar I jumped at the chance and haven't looked back. My first show with this guitar was on January 8, 2014—the day after I purchased it—with the Terrapin Family Band. I then played another TFB show with it the afternoon of January 12, and a show that night with my band Midnight North.

This guitar is a little too young to have any notable stories, but I'm in the process of creating some! As far as I can tell it wasn't played live before me, so the shows I've played this year, the songs I've written on this guitar, the crazy feedback noises I've made at Telstar shows, and everything else that's happened are the first that this guitar has experienced.

When I got it I had a basic setup done, but other than that I'm playing it exactly as it came out of the box. This guitar came to me with the perfect base—it's beautiful, it sounds great, and it's impeccably made—but that was only the foundation for me to build on. Every note I've played on it since has made it more my guitar, and every time I play it the weight sits more comfortably on my shoulder so I can more easily convey what I want in the music I play. I'm still learning all there is to know about this instrument, and I imagine I'll be discovering more nuances for many years to come.

My favorite quality about this guitar and other semi-hollow-body guitars is the vibrations that rumble through my core with each note I play. It feels like a conduit to the music we're playing, which really adds to the musical experience.

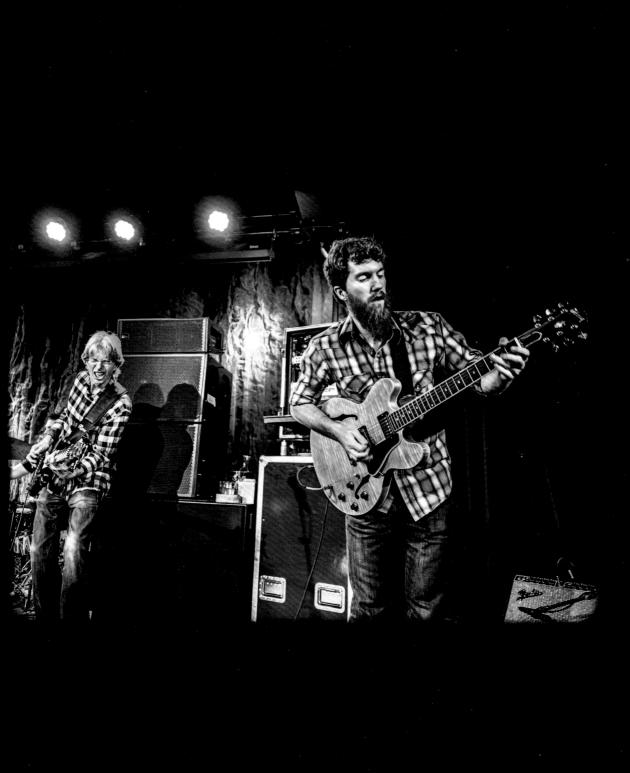

DEREN NEY

1972 | GIBSON ES-335

I FIRST SAW THE "ELECTRIC SPANISH"–STYLE GUITAR in the movie *Back to the Future*. I had no idea how it actually sounded; it just looked incredible to me. The curvy shape, the f-holes, the binding, it all looked so beautiful and tough. I've owned this particular guitar since fall 2012 and, in addition to living up to my *Back to the Future* expectations, Warren Haynes's guitar tech Brian Farmer liked how it sounded and told me so more than once, which meant a lot to me at the time and means even more now.

I haven't really modified this instrument, but there is a truss rod cover with a rose inlay on the headstock. This is to honor a girl I knew who was kind and inspiring to me when I needed it most. She was also a total fox.

My favorite thing about this guitar is the feel of it—the physical way it hangs from my shoulder is just right. I can almost forget it's there because it's so natural. It makes playing instinctually much easier. And I love that tonally it sits between the full warmth of a Les Paul and that hollow kinetic sting of a 330. It can sing and howl and do a little of everything between. Different guitars have different uses, but this is the one I use when I don't want to think about too much, when I just want to leave all possibilities open.

The neck on this one is carved right in between the '60s banjo-like slimness and the later '70s thickness, and I can't find any, even from that year, that are quite the same. I don't get how those necks feel so different from guitar to guitar, but this one is just right.

"TONALLY IT SITS BETWEEN THE FULL WARMTH OF A LES PAUL AND THAT HOLLOW KINETIC STING OF A 330."

ROSS JAMES
2009 | FENDER TELECASTER

Opposite: Phil Lesh and Friends, Terrapin Crossroads, San Rafael, CA, June 13, 2014

MOST OF MY FAVORITE GUITARISTS PLAYED TELES at one point or another, so I'd always wanted one and picked up this instrument in 2009. Since then it's been my main guitar and usually the only one I travel with—it's been with me all over the world. I haven't done much to it as far as modifications, but some of the musicians from the Terrapin Crossroads family got me that Bigsby tailpiece for my birthday last year, which I love.

I've had a lot of great performance moments with this instrument, but the one that stands out came on the night of the "Move Me Brightly" webcast at TRI Studios when everybody came over for a bar show at Terrapin Crossroads afterward. That guitar was used as house guitar and played by almost everybody who played at TRI that night, including Neal Casal, Jonathan Wilson, and Jon Graboff, to name a few. I think it picked up a little bit of mojo from those guys.

When I got this in 2009, it was the first halfway decent guitar I'd ever bought. I was just killing some time with a friend of mine at a guitar shop. I had no intention of buying anything. Then I picked it up—that was it, I had to have it. I overdrew my checking account when I bought it. I was so broke at the time, but I couldn't say no.

There's a lot to love about this instrument but my favorite attribute is the way the neck feels and looks—I play this guitar completely differently than I play any of my others.

MIHALI SAVOULIDIS

2008 | BECKER HORNET CUSTOM

Opposite: Twiddle, Gathering of the Vibes, Bridgeport, CT, August 1, 2014

I MET DAN BECKER AND LUTHIER RYAN MARTIN through a friend who brought them up to one of our shows. Becker was showing the Hornet and a couple of the other models. As soon as I saw the Hornet, I really wanted it, but I don't think we talked seriously about getting one into my hands for at least another year.

In fact, I don't think this guitar would have ended up in my hands if it weren't for a little accident Becker had with it. Dan was building the guitar for a studio musician, and it was hanging on a rack in the shop and fell. The whole bottom broke out, but Dan was able to fix it. He did such a good job restoring it that it became his showpiece, and I ended up with it.

Sonically, my favorite attribute is the ability to sustain a note without having to use a compression pedal. It's super responsive to where you're standing on stage in relation to your axe. It's literally a matter of leaning forward 3 inches or back 3 inches, and I can pretty much hold out any note for any extended period of time that I like. That was something I was really looking for in a guitar.

The pickups are Seymour Duncan Custom Shop. They're called "Becker Buckers." They work really well with the Hornet. The way they respond to it is great. It's got a twenty-four-fret scale, so it's a full two octaves, which works well for me, because I like to play up high on the neck. The tone and volume knobs are stacked for the humbuckers; they also have coil taps in them, so I can go from that Fender single-coil sound to the Gibson humbucker sound, which makes the instrument versatile. And the entire guitar is made of purpleheart and yellowheart wood.

Visually the guitar really intrigues people. It's so unique-looking that people inquire further into what kind of guitar is it, where it's from, and who made it, which in turn leads them to look more into Twiddle. In fact, I think the iconic shape has given me a definition as a guitarist. Everyone now associates this guitar with me. Fans have even made stickers of me with the guitar as a silhouette, which I think is awesome.

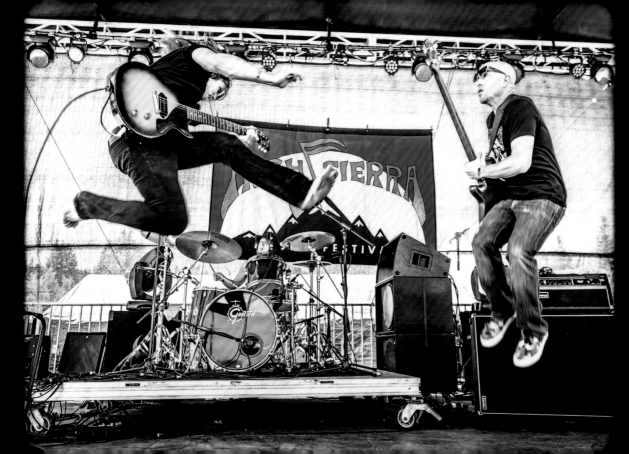

LUKAS NELSON

1957 | GIBSON LES PAUL JUNIOR

Opposite: Lukas Nelson & Promise of the Real, High Sierra Music Festival, Quincy, CA, July 6, 2013

I GOT THIS GUITAR FROM A COLLECTOR who's a friend of Larry Cragg, who helped me source it. Larry was Neil Young's guitar tech for more than thirty-five years and he's a great aficionado of guitars and amps—especially vintage guitars and amps. Larry had worked on my guitars before and knew I was looking. He brought this to me and I knew it was worth considering, so I nabbed it. It was well played when I got it, but also well maintained—lots of character, but well cared for.

Though I've only had this guitar for a few years, I've had a lot of great moments with it. My favorite so far is when I stuck a red-tailed hawk feather up near the tuner pegs and played a set with Neil Young. That's a pretty good way to bless a guitar. My band was backing Neil up at the Nebraska pipeline extension protest in 2014, and that was the first time we'd played a show with Neil. We played two more shows with him at the Bridge School that were all acoustic.

This guitar is surprisingly versatile, even though I barely change the knobs at all. I always keep the knobs the same—the volume all the way up and the tone knob exactly where it's at—and yet I can get so many different sounds by just playing it differently. I can play it soft and it gets real soft, and I can play it hard and it just growls and screams. You don't expect it. The name of the guitar is "Georgia," but the other name for it is "the Spanish Inquisition," because nobody expects the Spanish Inquisition. It's got an unexpected growl and a lot of spirit.

GEORGE PORTER JR.

2009 LAKLAND BOB GLAUB SIGNATURE BASS CUSTOM

Opposite: Funky Meters, Stern Grove, San Francisco, CA, July 13, 2014

THIS IS MY CURRENT PRIMARY BASS. It's a 2009 Lakland that's been custom-modified to my specifications to closely match the feel of my forty-two-year-old Fender Precision bass. Traveling with my P became a problem, because airlines kept losing it and it was only a matter of time until it was permanently lost or damaged, so I really wanted a replacement I could travel with. My manager approached Fender in 2007 to build me a new custom P for my sixtieth birthday, but they turned me down.

Back when I was on tour with Gov't Mule, Greg Rzab—the other bass player who was endorsed by Lakland—called Dan Lakin to come out to the sound check before a show in Chicago and bring some basses out. He did it, and I picked up a blonde Bob Glaub because it looked just like my old P bass when it was new. I liked that first Lakland, but I didn't play it much because the neck was a little too wide for me.

In 2009, Dan contacted me and suggested that they build me one. The result is this customized U.S.-made Bob Glaub model. The body wood is alder, the finish is natural, the neck has a bird's-eye maple fingerboard, and the neck width is a custom 1.625"—identical to my old P.

This bass goes everywhere I go. It has traveled the world with me. In those travels it has been played by Oteil Burbridge, Tony Hall, Ron Johnson, and Eric Krasno—to drop a few names!

I am very happy with it, and grateful to Dan Lakin and the Lakland family for making it for me. It plays just like the old P, the neck feels just like the old P, and it sounds great, which is the best part. It is also considerably lighter than that great old P, which I called "the Tree."

May your groove be phat!

MICHAEL FRANTI

2008 MATON ECW80C ACOUSTIC/ELECTRIC

Opposite: Spearhead, Mountain Jam, Hunter Mountain, NY, June 8, 2014

THIS GUITAR WAS THE SECOND GUITAR I ever owned. It was made by an Australian company called Maton. I was on a trip to New Zealand and I needed a guitar for a TV appearance. I asked the record label if there was a guitar I could borrow, and they brought me a guitar that belonged to Neil Finn (lead singer of Crowded House). I really liked it, so while I was on tour I contacted Maton, and they sent me a guitar. A couple years later, in 2003, Maton brought me another guitar, and that's the one pictured. I haven't owned a lot of guitars in my lifetime. I don't collect instruments for the sake of obtaining them. All the guitars that I own I play on a regular basis, and this one, which I call "the Sound of Sunshine," is no different.

While at a festival in North Carolina, I met a man who was painting skateboards and surfboards. I asked him if he could paint my guitar, and he agreed to do it. I left him the guitar, trusting that he would put a cool design on it and that he would return it to me. The only direction I gave him was No naked ladies! because many of his skateboards had them prominently featured. Four days later, he showed up in Asheville with the finished guitar. I loved it! He did such a great job—it looks like the painting is inlaid into the wood.

I've let a lot of people borrow and play this guitar. Some people don't want their guitars touched, but I always hand my guitars to groups of kids, fans, other musicians . . . whoever. It's been broken and damaged, but I just fix it and keep playing. My guitars are workhorses. I play the chords that are necessary for me to sing my songs. I don't need twenty different guitars to do that, just two: one to play onstage and one as backup in case I break a string.

I love playing this guitar because I can take it anywhere. The two guitars I own have been with me to Iraq, the Gaza Strip, Israel, Brazil, Indonesia, Folsom prison, San Quentin prison, and countless schools, streetside gatherings, and campfires—and when I get home, I unpack them and they live on the couches at my house until it's time to go on tour again.

I love the sensation of holding the guitar against my body and the feeling of it vibrating as I sing. I feel like I'm inside the music—like I'm a part of it as it's happening. This guitar is so familiar, and that's my favorite quality about it. You can see where it's worn out from where my pick hits it, and it carries the history of where I've been and the shows I've played.

J BOWMAN

1974 | GIBSON LES PAUL CUSTOM

Opposite: Spearhead, Mountain Jam, Hunter Mountain, NY, June 8, 2014

I'VE OWNED THIS GUITAR FOR FIVE YEARS now, since 2009. It's my first real good guitar—an amazing guitar. It sounds amazing. It plays great. It does it for me. If I happen to sound good, it's not me; it's the guitar!

For me, the draw to a vintage Les Paul is pretty simple: Jimmy Page. Jimmy Page and Keith Richards. The tones on "Kashmir" and *Exile on Main St.* are it for me. I wanted to play and sound like that, and where better to start than by getting a Les Paul?

I picked this one up in a small guitar store in Ithaca, New York, a bit impulsively. I was walking around one day before a gig; I saw this guitar shop and I walked inside. They had a few of them up on the wall, and I grabbed three or four and played all of them. This was the one. It had that creamy feeling. And it was so versatile; it could be crunchy, it could be creamy, it could be clean. I could lay into it and get some dirt out of it—everything I was looking for. Because of this I've tried to keep it as original as possible, aside from basic maintenance, though I did have to replace the volume pots, because they stopped moving. I sweat so much that it corroded them out and they wouldn't turn. Gross, but hey, this guitar sees over three hundred gigs a year.

I've gotten to live some of my wildest dreams with that guitar—pure rock 'n' roll fantasy: jamming with Santana, more than once; playing Madison Square Garden. I've been all over the world with this guitar, and it keeps warming to me. It gets better with every gig, every place I go.

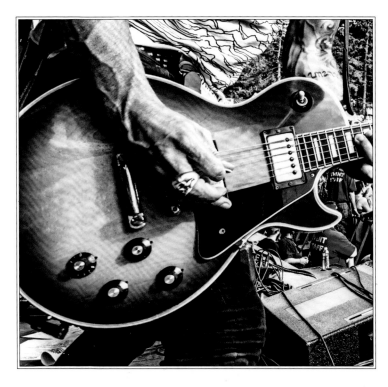

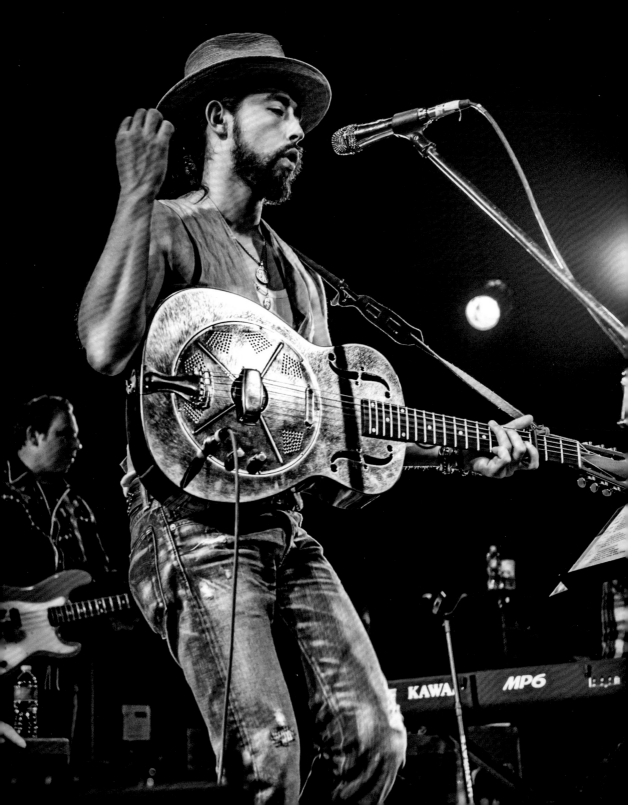

JACKIE GREENE

2010 NATIONAL RESO PHONIC NRP RESONATOR WITH HOT-PLATE LIPSTICK PICKUP

Opposite: Jackie Greene Band, The Catalyst, Santa Cruz, CA, January 28, 2012

I'VE BEEN HEAVILY INFLUENCED by the sound of early bottleneck blues playing. I'm one of those weird people who like the way these guitars sound when played just as an acoustic guitar. They have a garage-ish, lo-fi quality that I love. I had other resonators with pickup systems before, but none of them suited my needs. (I play it through an electric amp.) One day, I was searching for modern resonator guitars on the Internet and this one popped up. I went ahead and called about it, and they had one to me in a week.

That was in 2010, just bought it new from the factory. Since then it's become a part of my daily arsenal and gets played on one or two songs a night. The Hot Plate really suits my needs. It's a factory modification they can do to add the lipstick pickup and volume controls, which adds to the completely unique sound of this instrument. It's kind of difficult to play, and that makes me play differently. It's heavy, and in general kind of a pain in the ass— just as a good blues guitar should be! And I love the fact that it sounds terrible to most people.

"THEY HAVE A GARAGE-ISH, LO-FI QUALITY THAT I LOVE."

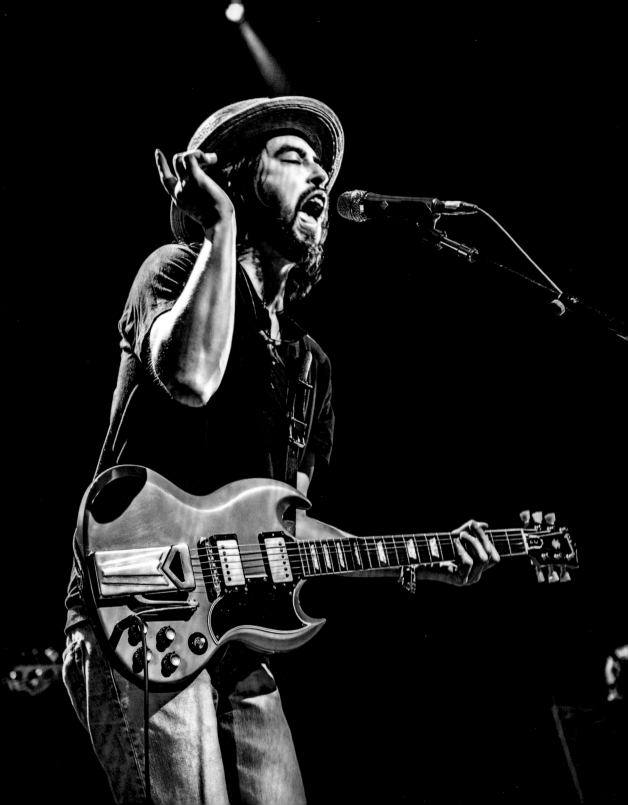

JACKIE GREENE

1961 | GIBSON LES PAUL

Opposite: Jackie Greene Band, The Fillmore, San Francisco, CA, November 21, 2012

MOST PEOPLE WOULD CALL THIS a Gibson SG, which is what it looks like, but it's from 1961, and they still called it a "Les Paul" back then. They stopped making the single-cutaway Les Paul in 1960 and in 1961 reintroduced the model, but with this new body shape. I believe Les Paul himself didn't like the new shape, so he made Gibson remove his name from it. By late 1963, they were known as SGs.

SGs are my favorite all-around guitars, along with the 335s. Many great guitarists have played SGs: Angus Young, Derek Trucks, Sister Rosetta Tharpe, even Jimi Hendrix had one for a hot minute. I used to have a white three pickup model that Sister Rosetta played, and I loved it, but this one suits me better. I've owned about eight different SGs and this one is my favorite, it's my workhorse. If I can only bring one guitar to a gig, this is it. It's light, it sounds amazing, and the neck is perfect.

Sadly, this guitar was refinished sometime in the '70s in Pelham blue—they only made them in cherry wood in 1961. That cuts the value in half, for sure, but I've grown to really love the color. This is the guitar I always grab when I don't know which one to grab—it's easy to play and it suits me really well.

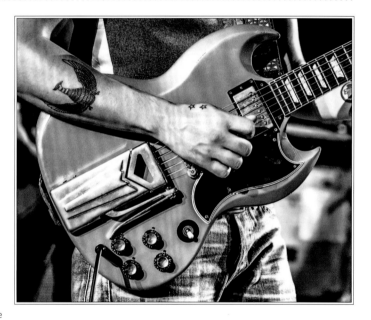

"IF I CAN ONLY BRING ONE GUITAR TO A GIG, THIS IS IT. IT'S LIGHT, IT SOUNDS AMAZING, AND THE NECK IS PERFECT."

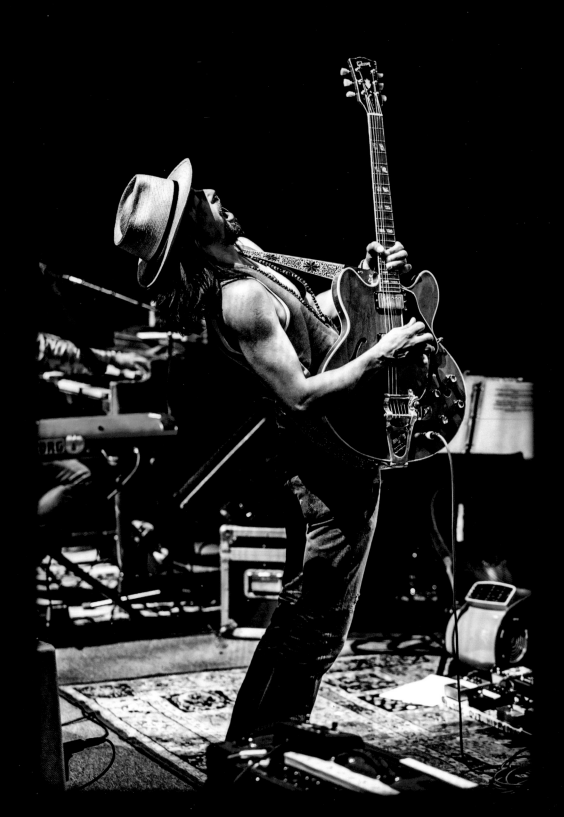

I'VE HAD THIS GUITAR SINCE 2010. I bought it in Chicago and paid far too much for it. I just wanted it really bad. There were a few to choose from, and this one was the winner. I think we had a show that very night, and I brought it out to play "Five Long Years," which is a slow blues tune that guitarist Freddie King recorded in the '70s. Seemed like the right thing to do at the time. Freddie King had a big influence in my picking up this guitar. Freddie played a red ES-345 and several different ES-355s. He's one of my heroes.

I've made several modifications to this instrument. I added the Bigsby tailpiece and disabled the Varitone. I also disabled the stereo output, effectively making this guitar a mono ES-335. When you modify vintage guitars, it devalues them like crazy, but I don't think I'm going to sell this one any time soon, so I don't mind.

Even though it has the narrow, less desirable late '60s nut width, the neck is pretty chunky, chunkier than any of my other post-1965 335s. It actually makes the neck pretty awesome. This instrument is another one that sees daily use—it sounds amazing straight into just about any amplifier, and using the bridge pickup with the tone rolled back to about seven is magic.

"IT SOUNDS AMAZING STRAINING INTO JUST ABOUT ANY AMPLIFIER."

JACKIE GREENE

1966 | GIBSON ES-345

Opposite: Jackie Greene Band, The Fillmore, San Francisco, CA, November 25, 2011

PATTERSON HOOD

2002 | GIBSON SG

Opposite: Drive-By Truckers, Lockn' Music Festival, Arrington, VA, September 5, 2014

I PLAY A LATE-MODEL GIBSON SG, which I bought at Musician's Warehouse in Athens, Georgia. I think the first record I made with it was Drive-By Truckers's Decoration Day album. I originally had two SGs, exactly alike, but donated one to an auction for Nuçi's Space.[1] I wish I had it still. It was the cheapest (at the time) SG that was a Gibson and not an Epiphone. I recently needed to buy a new one (I broke the neck on the one I play all the time while in Duluth on tour), and they no longer have the crescent moon inlays on the neck and are lighter weight. But Scott Baxendale fixed my original, and it's as good as ever.

I've always loved the SGs. They have a crunchier sound (to me) than the Les Pauls and aren't backbreaking heavy. I have a sweet 1969 Les Paul goldtop that is an amazing guitar, but I almost never play it anymore. I honestly just like the sound I get on the SG for my songs.

Funny, but there is absolutely nothing special about my Gibson SG except that I like it so much. It's not vintage and has no real history except for about a thousand Drive-By Truckers shows. I've broken the neck on it two or three times (can't even remember for sure) in that thin spot where the neck and the headstock merge. Most SGs break right there. I play it very hard. I've never been a guitar smasher, I just play it so hard that it ends up breaking.

I've never been a fancy guitar picker. I tend to play minimal, melodic guitar lines, more composed than ripped, with an emphasis on the actual tone of each note. I found my tone a few years ago with the combination of the SG, a 1972 Fender Deluxe Reverb amp, and a reissue Fender Reverb tank. I use a minimum of pedals and go for a thick but crunchy tone. Visually, I love the crescent moon inlays on the neck. It's a sweet detail, subtle but very cool.

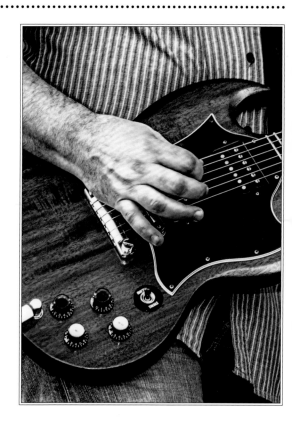

[1] Nuçi's Space is a nonprofit health and resource center for musicians in Athens, Georgia.

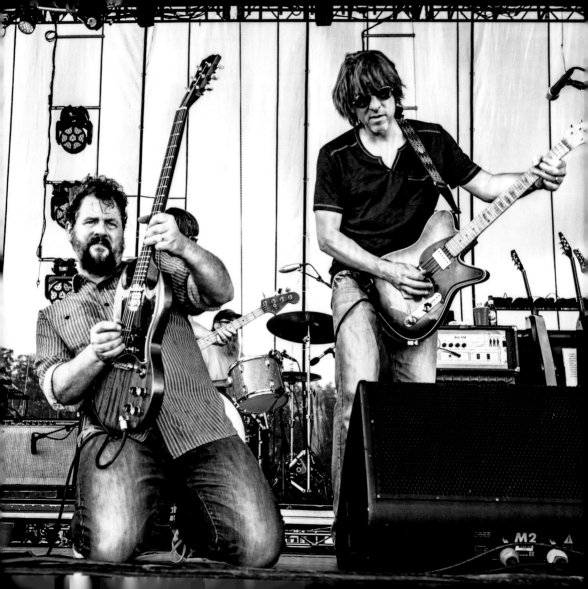

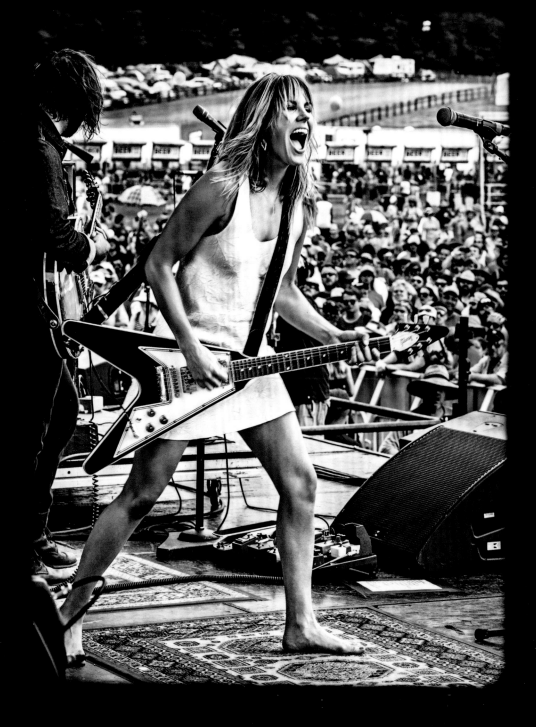

I GOT INTO THE FLYING V because I was obsessed with Albert King. I can only imagine that when the V first came out in 1958, it was a bit of a head-scratcher for folks; but when King played it, he made it look effortless and not at all bizarre, like it had been around forever. There was definitely an awkward adolescent phase for the Flying V in the '80s, but I think it's finally rounded the bend back to being a tried-and-true gem from the Gibson vault. There's something about the weight distribution; it can swing like a pendulum and stabilize itself quickly—which works perfectly with my stage antics and more muscular style of playing.

Gibson and I teamed up and designed and constructed the V while we were in Nashville working on *The Lion The Beast The Beat* with Dan Auerbach. I was so thrilled to be able to go into the factory and get a sense of what goes into the making of a fine instrument. My dad is a woodworker, so you'd think that would teach me to be gentle—but I'm pretty hard on all my instruments—so I knew I needed to design a beautiful warrior of a guitar . . . a Viking! I remember when the prototype was delivered to me, and it felt like I had won a trophy or something! I think it's on display at the Rock 'n'roll Hall of Fame now. Luckily I've gotten over my Pete Townshend phase of smashing guitars, but I figured the original "Flying Grace" would probably be safer in their hands!

Somebody recently sent me a picture of Lenny Kravitz playing my V with Bruno Mars at Madison Square Garden. I don't think he knew it was my guitar—he may have just thought it was a slick-looking fucker, but either way I was psyched. Also my dear friend and beloved guitarist Warren Haynes called me and said, "I'm gonna play your guitar on that Albert King song "Feel Like Breakin' Up Somebody's Home" tonight at the Beacon. I can't tell you how happy that made me. I've played and toured with him for a decade now, and I've watched Warren blow people away every single night. Never in my wildest dreams could I imagine him playing my guitar. It was a real honor. But to be honest, when you're lucky enough to

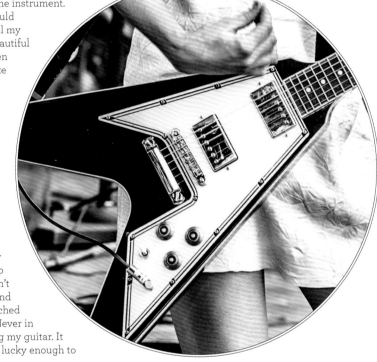

GRACE POTTER

2012 | GIBSON GRACE-POTTER-SIGNATURE FLYING V, "THE FLYING GRACE"

Opposite: Grace Potter & the Nocturnals, Lockn' Music Festival, Arrington, VA, September 7, 2014

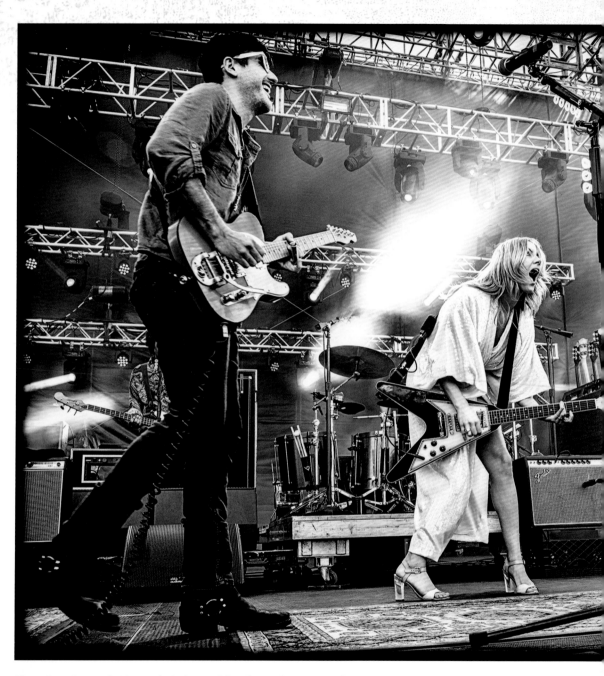

Above: Grace Potter & the Nocturnals, Gathering of the Vibes, Bridgeport, CT, July 27, 2013

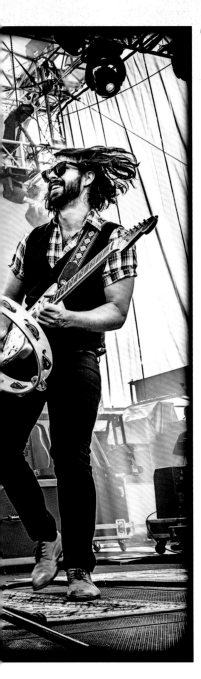

"ITS DESIGN IS INSPIRED BY A COCKTAIL NAPKIN FROM ONE OF MY FAVORITE BARS."

have a guitar made in your honor; and luckier still that people want to own it; it's significant no matter if it's a famous rock star, a young virtuoso, or just someone who scrimped and saved for a year to get it and can't even play a G chord yet. Seeing my signature guitar in the hands of a happy owner is all I need.

After we played a show at Bogart's in Cincinnati with Derek Trucks, we all went to Mike's Music together just to geek out. We were all eyeing a lot of instruments—my bass player at the time haggled with Derek over this killer '60s P Bass they both wanted (my bass player won if my memory serves me). I really needed a new guitar because I had just smashed my last one onstage at the All Good Festival (yep, Pete Townshend phase). I had my sights set on this gorgeous '71 cherry Flying V with a faded patina finish on the back from some dude's belt buckle. Sadly I didn't have enough money to buy the Flying V, so I scuffled out of the store and had sugarplum dreams about it for months. It was only later that Matty scraped together the $2,000 to get it for me for my birthday.

The modifications I made to this instrument that I'm most proud of were aimed to make the sonic quality as classic as possible. I wanted vintage humbucker pickups for that sweet, old-school sound. I explained how I often jump between a bold, resonant, darker, blown-out lead tone and then tighten it up with that snotty personality, so when you switch from bridge to neck, you can really hear the difference, which creates a big personality. If you want to jump between the two pickups you can get a lot of really interesting sounds and manipulations. Gibson re-created it with the Burstbucker Pro—rhythm and Pro—lead pickups, using the enamel-coated wire very similar to the PAFs from the days of old. There are a couple of physical characteristics as well that make this baby special—this is the only full-sized V to ever have a binding. Another modification I made is the pickguard—its design is inspired by a cocktail napkin from one of my favorite bars. It's an old joint that's been around forever and their whole aesthetic is timeless. One night while I was drawing up the plans for what I wanted the V to look like I looked down at the cocktail napkin and said, "That's what I want it to look like"—I basically just stole it. So don't tell them.

I love this guitar because it's mine! It captures all of my personality and the essence of the edginess of rock 'n' roll. It tells the story of my relationship with flying Vs, from the cherry one that I first owned (which is the color of the back of this guitar), to the white one that I played when we really hit the scene hard, to the black flying V that I spent a lot of time playing in the darker era of the band. All those colors are captured in the look of this instrument. The presence of those colors sends me back in time and also propels me forward, daring me to be better, braver, stronger, weirder . . . I feel a little bit more powerful and sexual and disgusting and dirty and ready to take over the world when I have it over my shoulder. But mainly, when I plug that fucker in and turn it up, it sounds good.

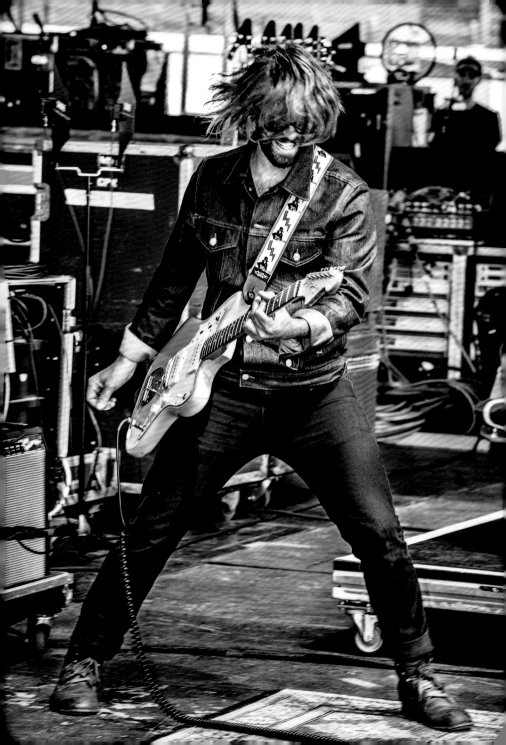

SO MANY OF MY MUSICAL HEROES have played Fender Jazzmasters, but what really won me over about this guitar was when I was in a recording session with Grace Potter & the Nocturnals, and the tune we were working on called for a really clean, heavy tremolo guitar tone. I wound up playing a black 1962 Jazzmaster on the track and instantly fell in love with the feel and the tone of the guitar. After that session I acquired my blue custom Jazzmaster.

The day I got this guitar, which was in 2011, we were in Los Angeles working on the GPN *The Lion The Beast The Beat* album. I played it on that record and I've used it in just about every show and recording session since then.

The only mod I made to this guitar was swapping out the Fender bridge for a Mastery bridge, other than that I've left it alone. As it is, this instrument speaks to me unlike any other guitar I own. It's super funky and full of tonal textures. And I love the floating tremolo.

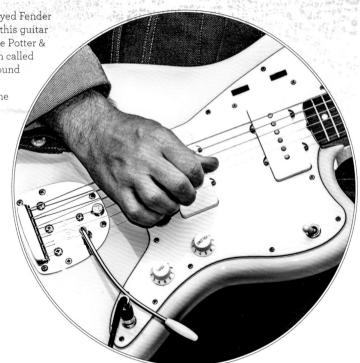

"AS IT IS, THIS INSTRUMENT SPEAKS TO ME UNLIKE ANY OTHER GUITAR I OWN."

BENNY YURCO

2011 | FENDER JAZZMASTER CUSTOM

Opposite: Grace Potter & the Nocturnals, Lockn' Music Festival, Arrington, VA, September 7, 2014

SCOTT TOURNET

1967 | GUILD STARFIRE V

Opposite: Grace Potter & the Nocturnals, Lockn' Music Festival, Arrington, VA, September 7, 2014

PART OF THE REASON I SOUGHT THIS INSTRUMENT OUT was because it wasn't played by my musical heroes. With so much amazing music history on our heels it can be difficult to forge your own path and sound. Teles, Strats, Les Pauls, and SGs are amazing, but they cast a big shadow from the giants that have played them before. The Guild Starfire V seemed to be a bit of a black sheep, and I was attracted to the look of it, and the pickups sounded great.

This was the only guitar I brought when we toured Australia and New Zealand. I had never gone on the road with only one guitar, because I use alternate tunings for a few songs. I also like to have two in case a string breaks or something goes wrong with a guitar. I flew to the tour by myself, so carrying two guitars, a pedal board, and a suitcase was just too much. I had just bought the guitar and never used it on the road before. The intonation had been slipping a little bit so it was definitely a risky move, but I was just so excited to play it, I couldn't help

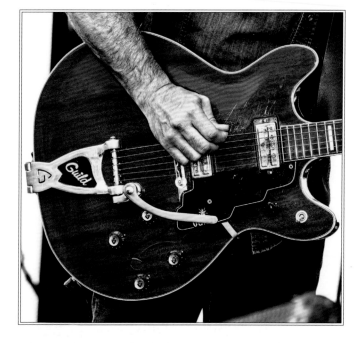

myself. Luckily it worked out, although at one show the strap slipped off and it fell about an inch from the ground before I somehow caught it. Phew!

I've only owned this guitar for a year, but probably the best moment I've had with the instrument was walking out on stage to a sold-out crowd at Red Rocks with it strapped on. It was the first time we truly headlined at the legendary venue. It was sold out, the sun was down, the lights were up, and the crowd was electric. I've got this killer guitar ready to plug into two vintage 1966 and 1967 Fender Super Reverbs—everything was in its right place. Those are the moments you wait your whole life for.

This guitar is all original, which is one reason why I love it. There is just something about the old pickups that can't be replicated in my opinion. The Guild humbuckers in this guitar have that boxy midrange that is pure rock 'n' roll. I also love the look of this guitar—the red finish and mahogany body, the tremolo bar, the stairstep pickguard. It's classy. Going on stage with it is like getting all cleaned up and putting on a tailored suit. It just makes me feel better about myself and instills a sense of confidence.

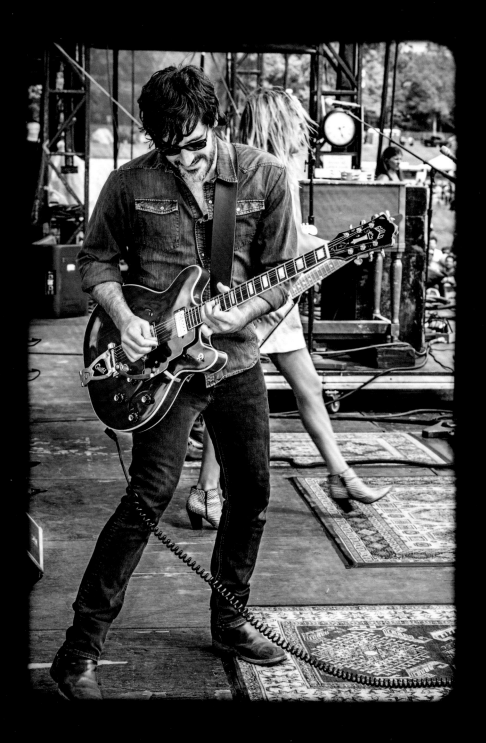

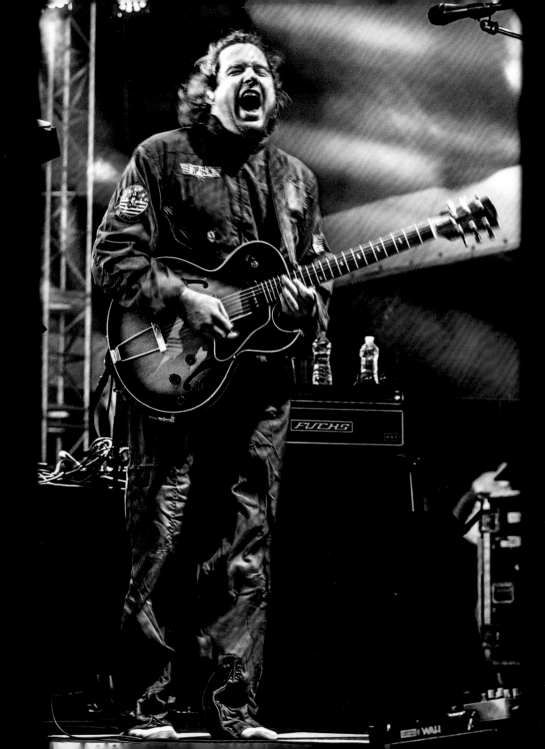

I GOT THIS GUITAR IN 1994. Before that, I had a heavily customized Stratocaster that I used to play. It was a neck-through Stratocaster, and a rare find. I spent my last eleven hundred dollars—I went to the bank and withdrew every single dollar, literally leaving a balance of zero in my account—and I went and bought a green neck-through Stratocaster.

I played that Stratocaster for a while, and it was okay. I didn't love it; I thought it was cool, but I didn't feel 100 percent at home on it. Then I was having problems with the electronics, and I switched out the Lace Sensors for some other pickup. The guy who put the other pickup in didn't do the electricals that great, and it was clicky and buzzy. It was okay for stage, but when we were going in to record our second album, I didn't want to have buzz all over my track. I knew that the recording process was going to expose that guitar, but I had no money. A friend of mine from Philadelphia had a cool Fender Super Reverb and an ES-135. We were going into the studio in twenty-four hours, and he was kind enough to let me take his guitars into the studio.

When I got into the studio, I hooked up both the guitars but ended up playing the Gibson on every track. Afterward, I tried to buy it from him but he wouldn't let me. So I actually took my keyboardist's credit card to one of the guitar shops and I bought the exact same guitar. That's how I found this guitar. It was just plain old luck. I just borrowed it, loved it, and then got my own.

It's a unique guitar. I have a great love for Wes Montgomery and his ability to select what I think is the perfect note at the perfect time. He's a very tasteful player. I thought his jazz stuff was so riffing, and he floated in between scales. He was very aggressive about moving his melodies into the chord changes before the chord changes happened, and I love that. He played a larger, hollow-body, fat-necked guitar like the 135. The ES-175 is the model that most people have—but on the 135 the strings are spaced really far away, and the neck is short and fat and stubby—the way they did the neck before they invented the Stratocaster and the long-form neck. It's got a shorter scale length, to be technical, which is good for lead.

JON GUTWILLIG

1994 | GIBSON ES-135

Opposite and following page: Disco Biscuits, Gathering of the Vibes, Bridgeport, CT, August 2, 2014

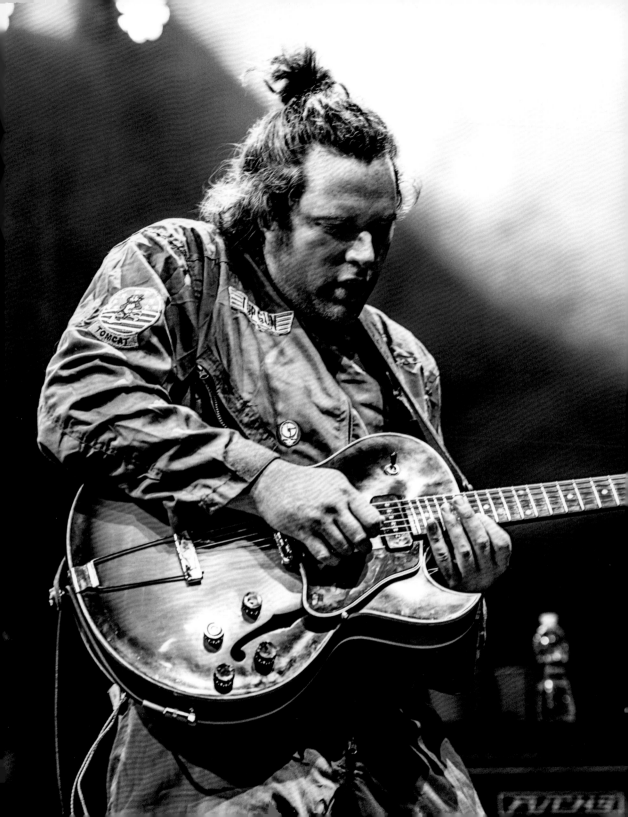

"I HAVE TO MONITOR THE FEEDBACK RELATIONSHIP OF THE GUITAR THE ENTIRE SHOW."

Ryan Adams played a 175. He's more of a singer-songwriter; his strings are much closer together, and that's much better for playing chords and strumming. But for me, for what I do, I really like the extra space.

I love how there's not a lot of twang and there's not a lot of shred in the tone with this guitar. The tone is unapologetically jazzy all the time, no matter what you do to it. You can crunch it and you can add five distortions to it and you can tweak the fucking amp and you can throw it into the bridge pickup, and you still sound woody and jazzy and analog. What our band does is shreddy enough. It's nice to have a guitar tone that actually pulls away from that. If you play really shreddy shit and you're already playing a really shreddy guitar, then you're kind of marching down the path of other musicians. Playing a guitar that's not meant to be shredded gives me an original take. Plus, whenever I put that instrument on, the crowd cheers. The crowd loves that guitar.

This came with P-90 pickups, and I really liked the P-90s because they're single coil and they contribute a lot to the guitar staying jazzy and staying analog. I've never swapped them because I like the dichotomy. If I were to swap them out and put in some shredded pickups or something, I might lose the quality in the guitar that I like.

Another nice thing about this guitar is, if you just let it vibrate, it will. I have to monitor the feedback relationship of the guitar the entire show. I never use distortion; I just pile overdrives on top of one another until I can't press any more pedals. I could pile six or seven overdrives on top of one another with delays, and I'd get a really creamy, awesome, original sound out of it, but at that point the guitar could just fly off the handle. And I'm comfortable with that. It doesn't surprise me. If you just hold a note on this guitar and let it go, it will fly on you. And depending on what key the room is in, it will fly in a different way. Which is another interesting thing—if I can determine the way the guitar is feeding back, I can determine what key the room is in, and then we can go during set breaks and change the set list to include more songs in the key of the room. Sometimes during sound check, I can figure it out, but it's easier during the first set when things are really loud. You can really tell. The whole room vibrates when you're playing in the key of the room.

That's why we love to play Electric Factory in Philadelphia. Electric Factory is straight up in D, and we have a lot of huge songs, huge jams, that are in D. So the room will enhance us when we're in D, and we can feel that as a band, and we'll play to that strength. Some people love when rooms have perfect acoustics or are completely dead, but I don't like that as much. I like a little bit of a boomy room because I like the effect it has on this guitar and the effect it has on the band. We're doing improvisation, and when you're doing improvisation all night long like we're doing, you're making decisions on the fly. When the room gives you a little bit and the crowd gives you a little bit, it makes it easier to tell when things are working and when things are building, and you can actually take things to a much higher level on those conditions—and this guitar, with its lively, almost wild feedback, helps too.

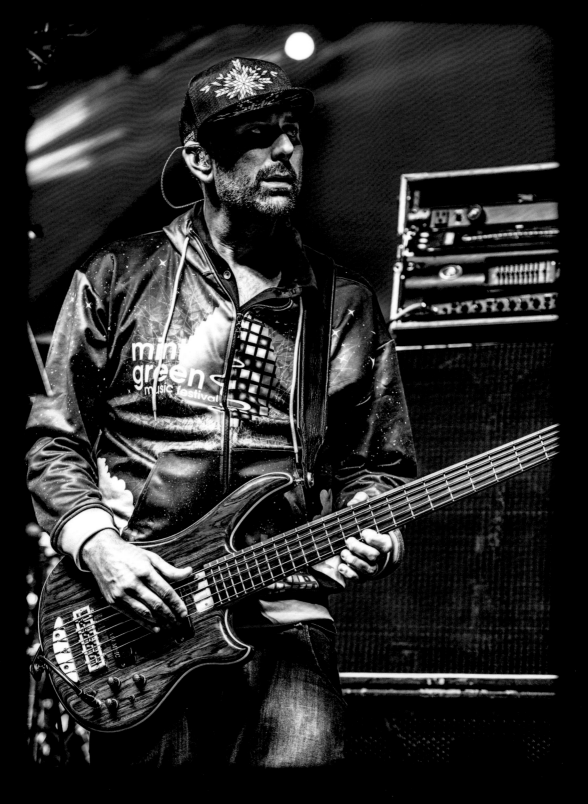

MARC BROWNSTEIN

2010 | ALEMBIC ESSENCE BASS

Opposite: Disco Biscuits, Gathering of the Vibes, Bridgeport, CT, August 2, 2014

ALEMBIC IS WELL KNOWN as part of the extended Grateful Dead family. I knew it more as a guitar company because of that association. Some amazing bass players (such as Stanley Clarke) have played Alembics—but for me, it was all about Jerry.

The significance of Alembic instruments cannot be understated. They were the first company to experiment with active electronics, meaning they put a preamp in the actual guitars. That's revolutionary!

I came into possession of this bass during the summer of 2013, when I was visiting San Francisco to play a late-night show at the Mezzanine after the Phish shows at the Bill Graham Civic Auditorium. My friend Will kept telling me that he was friendly with the people at Alembic; he wanted me to try one out. The thing is, I rarely play on the West Coast, so for a while, it was all just talk.

Eventually we had that show and the bass was there, waiting for me. I remember the exact moment I turned it on. It felt like I had been deaf and I was hearing for the first time. That's the only way to describe it. It was just amazing, the way the sound was coming to life. It was literally music to my ears.

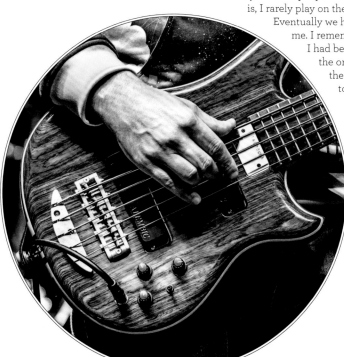

This particular instrument has a series of LEDs for fret markers. That's my favorite custom feature, because we often find ourselves jamming in the dark in the midst of a laser show. There is also a low-pass filter built into this bass. That feature, along with the rare cocobolo wood, creates the signature Alembic sound.

There is a clarity to the midrange of this Alembic that I love. That's a quality of tone that I have never felt comfortable with on any of my other basses. With this Alembic, the bass lines cut through the music, but in the most tasteful, warm-sounding way. I just love the sound. It's all about the sound.

BILL NERSHI

2009 | COLLINGS I-35

Opposite: String Cheese Incident, Lockn' Music Festival, Arrington, VA, September 4, 2014

I GOT THIS I-35 NEW FROM COLLINGS IN 2009. They wanted to get me a guitar, but there were people on the waiting list, so they found me one that had a blemish—but I think they were just doing me a favor. The blemish is a small curl in the mahogany on the back that is about a quarter of an inch in diameter. So, for all intents and purposes it's a perfect guitar. This one has a carved maple top, mahogany sides and back, a rosewood fretboard, and Lollar pickups.

I always liked those 335s that Gibson made, and I owned a '69 Gibson 335, but for some reason it was a little bit of a dog. But I always had an affinity for that kind of guitar from watching a lot of blues guitarists play them. When I went through the Collings factory, I tried the I-35, and the way it played and sounded even unplugged just blew me away. That's when I knew I wanted to get one. Steve

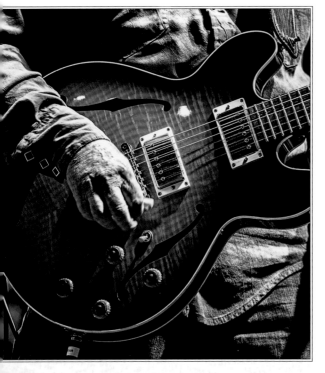

McCreary at Collings Guitars in Austin, Texas, who had taken me through the factory a couple of times, helped get this guitar into my hands, and it's sweet.

I've played a lot of shows with this guitar, but I do remember a specific moment at Horning's Hideout, which is a String Cheese festival that we do every year. We had our friend Scott Law onstage, and I remember that he, Michael Kang, and I were trading solos across the stage. I was playing through a Blues DeVille with two 12s, and I remember hitting the drive button when it came around to me and seeing Mike and Scott's jaws drop. They looked at me like, *How are we going to follow that?* It can get going for sure.

It's a semi-hollow-body—its got that block of wood that runs down the center from the fretboard to the tail—so it gets a great tone but is also very controllable, and sustained notes won't fly on you the way they can on bigger hollow bodies. Its also really even-sounding, and it has a good open sound for chords, too. If this was the only guitar I owned—electric guitar, that is—I would be perfectly happy. It's just a great all-around instrument for everything from rhythm to soloing. You can go from the rhythm pickup with the tone rolled all the way off and get this really velvety tone and then knock it into the treble position in the middle of the solo and just shift gears. For one guitar, it creates a lot of different tones. Playing with String Cheese, I have to be able to play Afro-highlight kind of tunes and then play a full cranking rock overdrive sound on the next song, so I need something that has all those qualities, and this Collings does it.

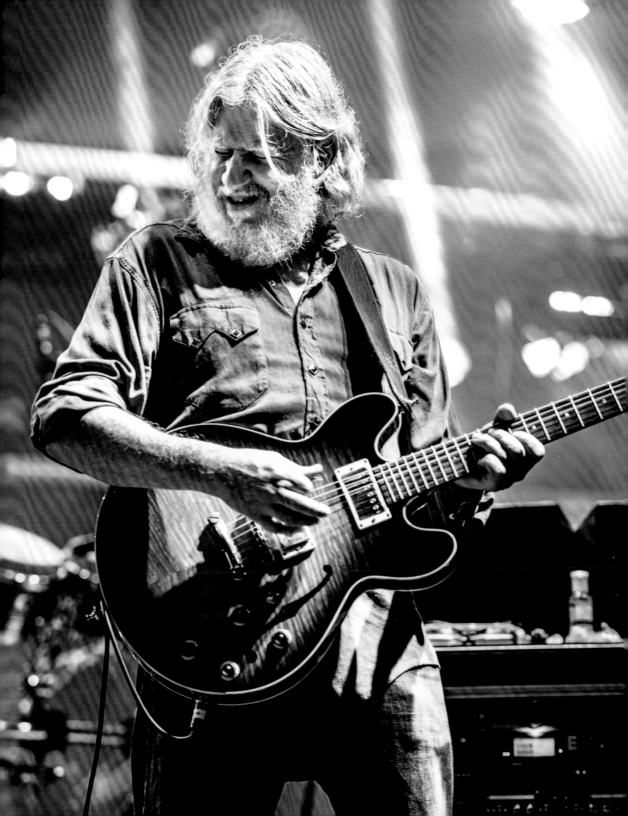

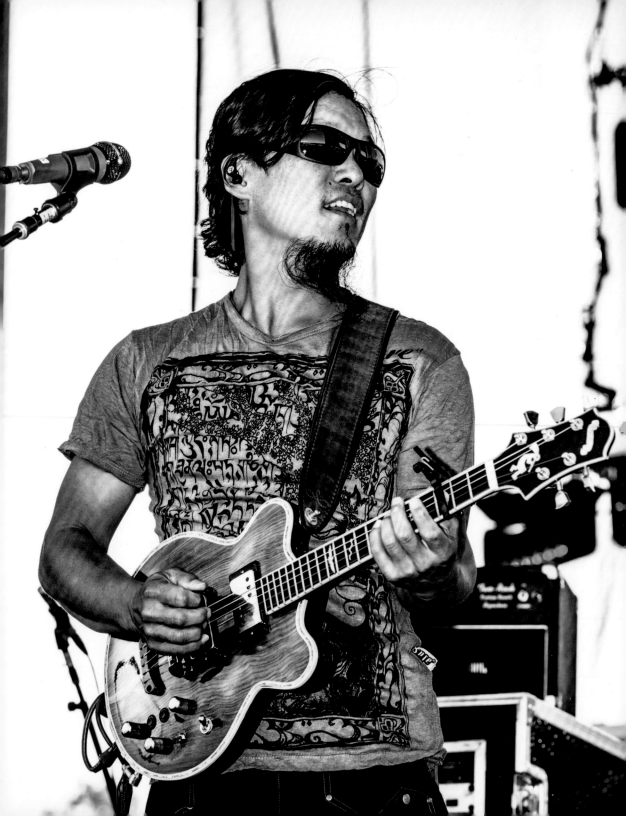

MICHAEL KANG

2002 | RON OATES FIVE-STRING ELECTRIC OCTAVE MANDOLIN CUSTOM

Opposite: String Cheese Incident, Lockn' Music Festival, Arrington, VA, September 5, 2014

THIS IS MY MAIN INSTRUMENT—a custom five-string electric octave mandolin made for me by Ron Oates sometime in 2002. We call this instrument "Kokopelli." It is made out of mahogany and a piece of cocobolo I brought back from Costa Rica. This instrument is the culmination of probably four or five instruments that Ron and I designed together, and when I got it, it was definitely "the one."

I decided to start playing five-string octave mandolins because I always wanted to be able to get large guitar tones out of a mandolin. I was playing five-string electric mandolins early in the band's career, but I wanted to be able to access low tones as well, thus the octave mandolin was born. I have many different mandolin and guitar heroes, but the ones who influenced me the most when I started playing the electric mandos were Santana, Pat Metheny, Sam Bush, and David Grisman. Kokopelli was designed to get similar tones to what I was hearing from those guys.

The real significance of my instrument is that it really is one of a kind and I haven't heard of anyone else playing an electric octave mandolin. I would love to see other people get into the instrument though, just to hear how others would play it. We have tried to replicate this instrument, and Ron Oates has built many electric octave mandolins for a bunch of other guys, but not with the same wood combination or body shape as Kokopelli.

My instrument has seen very little change since its creation, besides frets and the addition of an onboard Roland guitar-synth module. Nothing else has really been added or changed. The Fralin Unbuckers I have in there sound great—a perfect combination of the sensitivity and shimmering high end of a single-coil pickup and the power of a humbucker. I look forward to switching different pickups in and out of the instrument(s) when I have more than one to play around with.

I really do love this instrument for many reasons. It sounds unique, so I feel like I've been able to establish a voice in the realm of mandolinists, while also creating soaring lead tones reminiscent of my favorite guitarists. Kokopelli also tends to occupy its own unique niche inside the sonic spectrum of any band I have played with. It's nice not to feel like you are stepping on the toes of any other guitar player that is onstage. My favorite quality about this instrument, though, is that it gives me the opportunity to emulate my favorite guitar licks and tones, while still being able to have the fingering positions I became familiar with as a violinist and mandolinist. After all, I never became a very good guitar player!

> "I HAVEN'T HEARD OF ANYONE ELSE PLAYING AN ELECTRIC OCTAVE MANDOLIN."

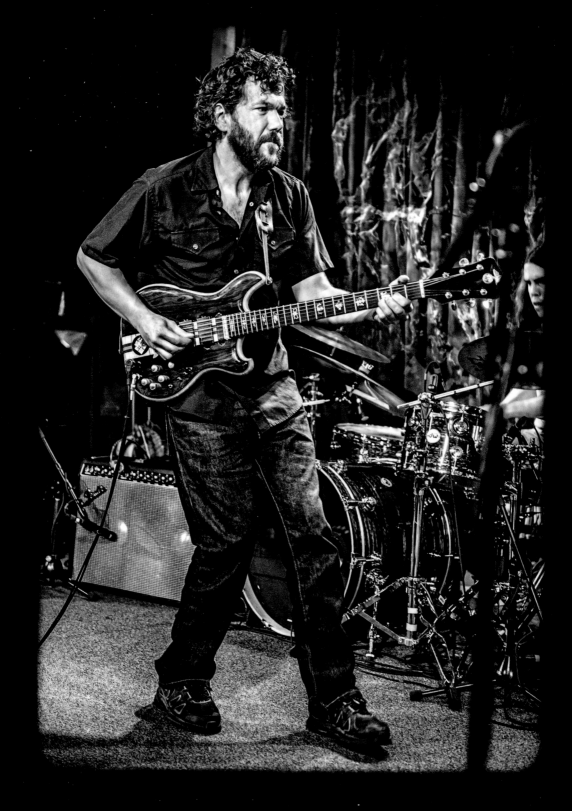

SCOTT LAW

2005 | ALEMBIC CUSTOM

Opposite: Phil Lesh and Friends, Terrapin Crossroads, San Rafael, CA, September 12, 2014

THIS CUSTOM-ORDER GUITAR (often called "Owl," for the mother-of-pearl snowy owl inlaid on the back of the peghead) was completed in October 2005 by Alembic in Santa Rosa, California. The main body is a carved, laminated "sandwich" of cocobolo and intensely quilted maple, with layers of purpleheart and fiddleback maple. The neck features a centerline of cherry that runs the entire length of the instrument. The unbound fingerboard is ebony with abalone inlay designs, and the electronics are Alembic's own circuit.

There seems to be an X factor going on with this thing—a truly remarkable alchemy of sweet sustain, extreme responsiveness, and an uncanny knack for finding its own place in the onstage mix no matter how dense the sonic jungle.

Owl came around through the providence of a good friend, Starfinder Stanley (son of Alembic cofounder and Grateful Dead sound engineer Owsley "Bear" Stanley), and out of my appreciation for Jerry Garcia's tone. I'd heard Garcia's Wolf and Tiger guitars in person, and I had always dreamt of a similar custom instrument—not a replica, but an interpretation within that zeitgeist.

Over the years, much illumination has come from riding high-spirited jams and boxing out of musical corners while digging into these six strings. This instrument demands articulation and holds the player accountable. Every detail of touch and contact with the strings is transmitted directly from fingers to eardrum; notes seem to fly out at the speed of thought.

The tone controls are uniquely powerful EQ adjusters, so you can be forever tinkering with subtle details to keep things interesting. Owl also has a buffered effects loop (TRS with an on/off switch) that stabilizes the input/output sensitivities of effects pedals. Later, the addition of a continuously variable loop/blend knob was added so the percentage of the effects chain in the signal could be mixed in or out, giving even more flexibility.

Beyond all that, Owl is about the easiest guitar in the world to play and pairs well with any amplifier, if you set things right. An F chord (a typically hard-to-reach left-hand shape for guitarists) can be accomplished in complete comfort. Eye candy from a distance, this bird is a striking piece of natural woodwork with seriously musical electronics that make it a pure joy to play, nasty or clean. With perfect weight balance, chimed overtones, rock-solid intonation, and an incredible tonal spectrum, it radiates whatever you put into it. I feel very fortunate to play and care for such an instrument in my lifetime, and continually endeavor to do it justice.

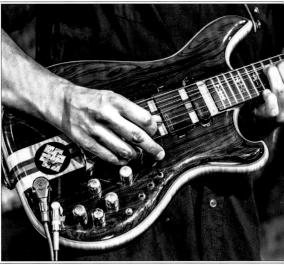

WHEN I DECIDED I WANTED TO GET A TELECASTER, Tim Bluhm and I went to the Guitar Center in Hollywood. I decided that the best way to find the guitar I was going to buy was to bring them all into one of the rooms where the amps were, so Tim and I grabbed seven or eight Teles and he just kept handing them to me and I'd play. Eventually, we narrowed it down to two. One was a tobacco burst, which was really the color I was hoping for, and the other was the white one pictured. I played those two back and forth, over and over. The other one had a rosewood neck, which I thought I wanted, and the white one had a maple neck, but I just kept coming back to it. I didn't necessarily want a white one—it wasn't what I was imagining—but it was just the one. It was mainly the feel of the thing—the way that the neck felt in my hand—that drew me. The treble pickup also had a little bit of a growl that I wasn't getting out of the other instruments.

A couple of key influences led me to the Telecaster. Clarence White played a Tele in the later era of the Byrds. He did a lot of session work in the late '60s and early '70s. He was initially a bluegrass player, but he started playing rock and was one of the founders of the country rock sound. I can't emulate his style, but I admire it. I also know that Jimmy Page used a Telecaster on his first four recordings. He played a Les Paul live, but when he recorded those first four albums he used a Tele.

I bought this particular guitar because up until that time I'd only had vintage guitars—guitars that were preowned and had been around the block. And they're great; those are the ones you want, typically. But I had a little fantasy around buying a brand-new guitar that I could pass down to my firstborn son or daughter. I didn't have a kid at the time, but that was my thinking. And I thought a Telecaster would be a great one to buy new. They're such solid guitars, and their style hasn't changed very much from when Fender first started making them. Well, I have a son now—he's thirteen years old—and now I don't want to give it up! Not till I'm done with it, anyway.

This guitar has come to feel like an old friend. I play it every show, every night—have since I bought it. It's a workhorse. It's so practical and so usable, so accessible for me. The volume and tone knobs are right where I need them. It just has the feel.

GREG LOIACONO

1997 | FENDER AMERICAN STANDARD TELECASTER

Opposite: Mother Hips, Fox Theater, Oakland, CA, March 21, 2014

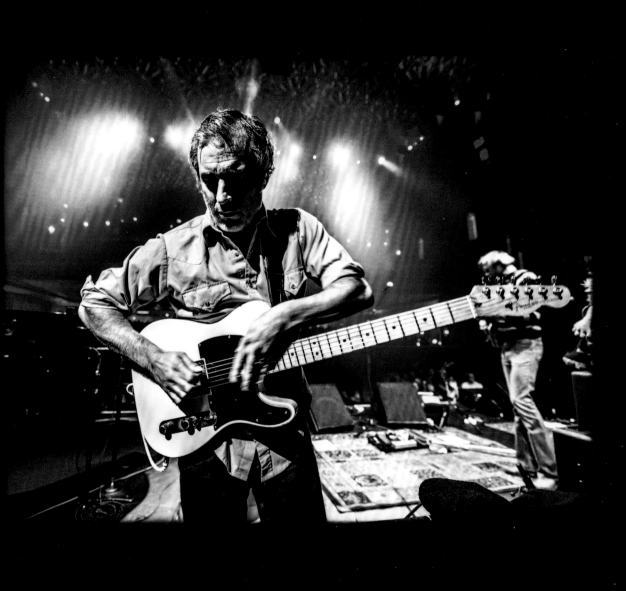

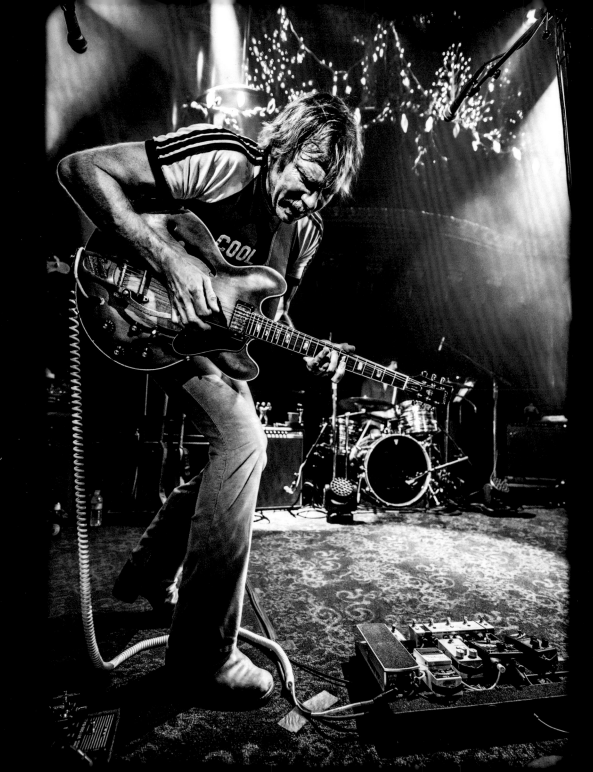

TIM BLUHM

1971 | GIBSON ES-335 TD

Opposite: Mother Hips, Great American Music Hall, San Francisco, CA, December 19, 2014

WHEN I WAS JUST GETTING OUT OF HIGH SCHOOL, Neil Young's *After the Gold Rush* was one of my favorite albums. In the album, there's a gatefold of Neil lying on a couch in the recording studio and there are all these guitars haphazardly leaned up against the couch and the walls. One of them is a Gretsch White Falcon, a giant, gaudy, white, hollow-body guitar. I didn't really know which guitars were making which noises on the album, but I could imagine that the Gretsch was making some of the cool sounds. So I wanted to have a Gretsch White Falcon.

After high school I was back in Los Angeles where my parents lived. I'd just gotten my first credit card and my friend drove me to this guitar shop called Vintage Voltage that was right off Sunset. I wanted to buy a Gretsch White Falcon. I had no idea how much they cost; I knew they were probably expensive but I had no concept.

They had all these beautiful guitars but they were far more expensive than the credit limit on my card. I think the limit was a thousand dollars or something, and I was going to spend it all. Absolutely. I was going for broke. But the cheapest guitar they had was a red Gibson ES-330. It was a 1965. It was beautiful. It was a far cry from a White Falcon, but the Falcon was way more than I could afford. So I bought this Gibson ES-330, and I brought it back to Chico and formed a band. I really dug it, but I wanted to get an ES-335.

A year later I was in Chico going to college and I found a guy selling an ES-335. I was working as a dishwasher, and after I got off my shift, I went to the bar next door, and I met this guy. He brought this beautiful old guitar in, and I played for a little bit. I didn't even plug it in, I just played it for a little bit unplugged and really loved it. I gave him five hundred bucks, and that's the guitar that I still play all the time. That was in 1990.

It was in really good shape when I bought it, and I just played it and played it. I've probably played two thousand gigs with this guitar. It's really beat up now. It's had a hard life. It's fallen over several times, and I've broken the headstock off of that guitar at least twice and had it repaired. It also survived a house fire in Sausalito in 1999.

I'm very sentimental about this guitar because it's come through my whole musical life with me. I feel like that journey has been amazing, challenging, and ongoing. I've definitely attempted to replace it by buying other guitars that are similar. I have a 1968, a 1971, and a 1975, but they're all a little bit different. So my attempts to retire it and replace it have been unsuccessful. I can't find one that's just like it and I probably won't be able to.

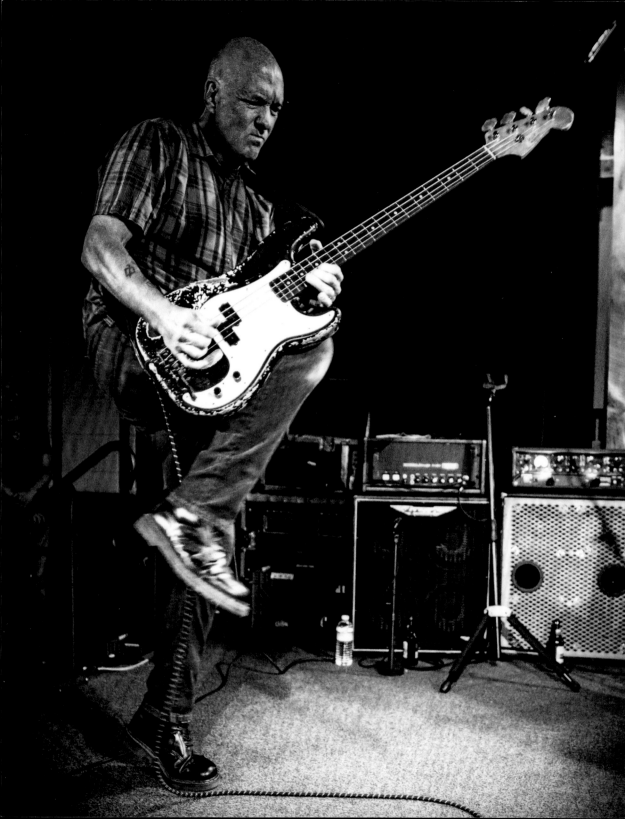

SCOTT THUNES

1965 | FENDER PRECISION BASS

Opposite: Mother Hips, Terrapin Crossroads, San Rafael, CA, June 19, 2014

I WAS TWELVE OR SO when my brother turned me on to Frank Zappa and the Mothers of Invention. In 1974, after absorbing their earlier albums, all my friends and I fell headlong into Frank's album *Roxy & Elsewhere*. Tom Fowler, his bassist at the time, had a black P bass, and the tone on the album attracted me like no other; it was aggressive and sang out through the mix. And it was especially intriguing because the music was so complicated. It was great to hear a "super-rock" tone with roundwound strings playing "impossible" parts.

As fate would have it, I bought the guitar pictured around 1982, with money I made from playing with Frank Zappa! A girlfriend at the time bought it for herself and played in a San Francisco punk band for a year or so. When she was done with it, she offered it to me. I paid around $700 for it.

This bass came to me at a time when I was being "forced" to play a completely different instrument, one that I hadn't owned before and wasn't particularly comfortable with. After getting this in my hot little hands, I told Frank I wasn't interested in playing those other instruments. So, from 1984 through 1988 it was my main axe. As far as many Frank Zappa fans are concerned, this bass changed the way they appreciated Frank's music. For some reason, Frank enjoyed a particular sound from his previous bassist, which I felt was too "bass light." My sound was aggressive, and I have always played very hard, so all the tracks that I appear on (except for *Valley Girl*) are live and mixed aggressively.

I've seen a lot of old Fender Precisions around. But for some reason, I feel my neck is thinner and more delightful than most of the others, which feel gummy or insincere. I like how I sound with this so much that sometimes when I'm playing, I will get distracted by how she feels and what's coming out of her and I'll just kind of zone out from sheer technical connection. She—I have taken to calling her "The Bitch" lately—and I have a great relationship. I can talk to her, and she'll talk back to me, saying, "Keep doing that." It's a rare quality in a person, and in an instrument it's a godsend.

I have many other basses—I also have a completely different Precision bass, two actually—but the particular flavor and combination I love with this bass is sound. Feel. Music. Nothing in my life has come close to the joy this instrument has given me up until meeting my wife and having my children. It's my mistress, so really, it's got equal billing with the rest of my family.

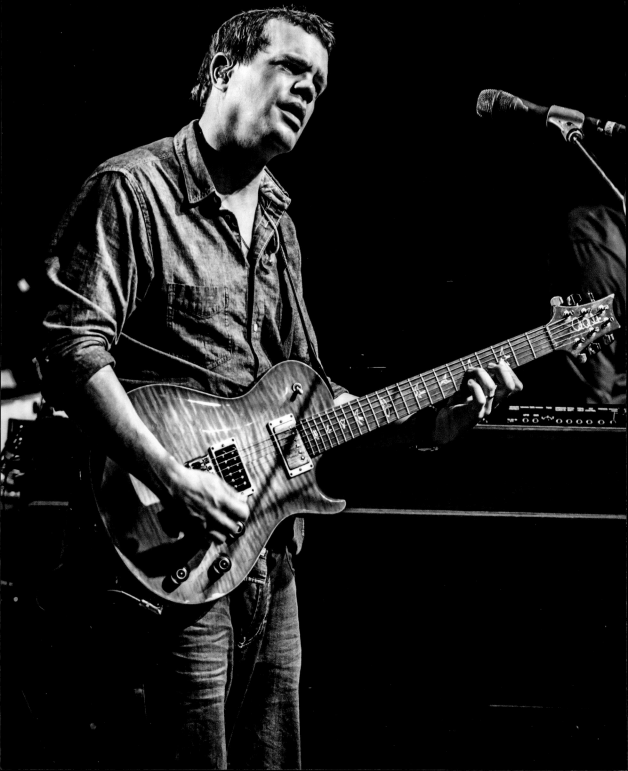

BRENDAN BAYLISS

2007 PAUL REED SMITH MARK TREMONTI SIGNATURE

Opposite: Umphrey's McGee, Fox Theater, Oakland, CA, March 8, 2014

I STARTED PLAYING THIS GUITAR IN EARLY 2008. I've played Paul Reed Smiths since the beginning—I've always loved the feel of Paul Reed Smiths. And since Jimmy Page and Slash are big heroes of mine, I gravitated toward the Les Paul look and feel. This guitar is the closest thing that Paul Reed Smith has to a Les Paul.

This PRS is a Mark Tremonti Signature model but I removed the name "Tremonti" from it, because of his association with Scott Stapp from Creed—I'm just not a Scott Stapp fan. When they sent it to me, they said, "We want you to try the Tremonti." I said, "Don't take this the wrong way, but can you send it to me with a blank name space?" So a lot of the time people don't know what guitar this is because it doesn't have the signature on it.

This guitar's name is "Felicia." All my guitars have female names except the very first one, which is named "Mine." From a distance, the shape of a PRS resembles the hourglass figure of the female body, making it a lot easier for me to justify running my hands all over the guitar and spending so much time with it. That's why I give my guitars female names; it gives me an intimate connection with them. The connection with this guitar was established the very first time I played it. That first night I remember thinking *I'm playing you forever.* Usually it takes a while, but this one, from the first minute I played it, I knew it would be my go-to guitar.

A standout moment with this guitar came at the Summer Camp Music Festival in 2013. We did an onstage switch with moe., and Al Schnier came in and just grabbed the guitar and played it. But my favorite thing about this guitar is the way it feels in my hands. I don't mean the way I wrap my hand around the neck, but when the notes resonate, I can feel it throughout my entire body. Very few guitars I've played have that quality. She feels fantastic—very sexy. This unique resonance and feel is a mystery to me, but it's the reason I started playing it right from the beginning. The guitar sounded great, but it was more about the physical reaction I had than the sonic. And when it feels that good to me, I end up playing better. It's hard to explain; I just have an intimate, almost sexual connection with this guitar.

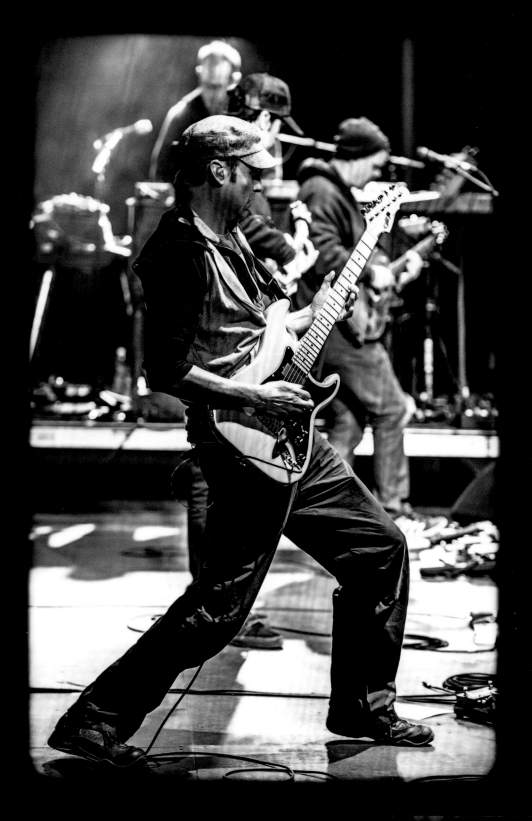

JAKE CINNINGER

2003 | G&L S-500

Opposite: Umphrey's McGee, Mountain Jam, Hunter Mountain, NY, June 5, 2014

THIS GUITAR IS A G&L S-500. I like to call G&L "the real Fender," because they bought the old Fender plant, the pre-CBS plant in California, and that's where they make the G&L guitars. So the same lathes that made the old Strats make the G&L guitars now.

I started playing G&Ls out of the gates when I was fourteen. My first G&L was a black and white Strat that looked a lot like Clapton's black Strat. I ended up getting this particular G&L in 2003. I call it "Butterscotch," because it's got a butterscotch and banana-cream-pie sort of look.

This is really a boat-anchor guitar. When you pick up a normal Strat-style body, it's very light and airy, very feathery. This is made out of swamp ash, so it's got a ton of this weighty wood in it. It rides kind of like a Les Paul, but it sounds like a Strat. The pickups are especially magical because G&L has a certain magnetic pickup patent that no one else can use. So those particular pickups are only in G&L guitars. It's not a coiled wire; it's a magnetic steel pickup, so they kind of honk in a different way, a different mid-range response.

With Umphrey's, I need a guitar that can pull off everything from super hardcore rock to light, tiptoe jazz to a spanky country or reggae top-end-of-the-pickup sound. With this guitar I've got all these split coil options. It's a little switch that gives me that super scooped, mid-range sound, or if I want a big, booming mid-range, I just go straight neck or all the way back to the bridge.

This particular guitar holds up under all conditions on the road, can handle all sounds within a given set, and sings no matter what. The key to finding the right guitar that speaks to you is just walking up to it without being plugged in, hitting the A string, and feeling the whole body and neck resonating together. That's when you know that those wood grains are lining up. That was the one thing I really noticed when I picked up this particular guitar: It sang like a neck-through. For your live beast, you want something that's almost a part of your body; something that, when it's up against your body, feels like it's an extension of you.

This guitar is very recognizable to the fan base too. It's got this solid black center and this butterscotch pudding outside. A fan a while back put a sticker that says "Umph love" on the side, and that's been there ever since. I think it was thrown on there in 2005 or something like that. That little sticker has been on there ever since and can't come off or else the fan base would just freak out. People go to shows with these little stickers that say "Umph love" and put them all over themselves so when I look out there, there are thousands of these little stickers everywhere. It's a real simple guitar, but man, some of the hardcore fans say, "You can't be playing any other guitar! That's the one."

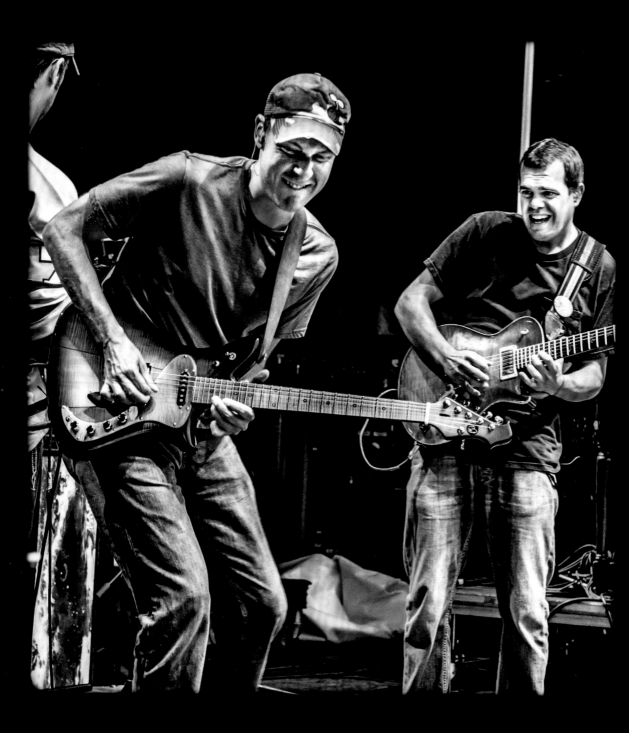

JAKE CINNINGER

2007 | BECKER CUSTOM

Opposite: Umphrey's McGee, Mountain Jam, Hunter Mountain, NY, May 29, 2009

DAN BECKER BUILT THIS GUITAR FOR ME. We had an idea for how a guitar should feel and look, and I wanted this instrument to look like Mother Earth. It has the continents, brown landmasses, in the middle where the pickguards are, and then all around it is the shallow water, and then as you go toward the edges, you get to the depths of the sea. It's got this really cool aesthetic to it. Dan spent countless hours on this guitar figuring out the right kind of wood and the right pickups. There are also seventy clear coats on it. It looks like a racecar.

This is a complete custom model—one of one—so we call it "The Mother Earth." It's my special Jerry-like guitar, because it was made specifically for me and my hands, and the sound I was going after. I didn't have to search it out, it manifested over a series of conversations.

This guitar is a neck-through with maple and purpleheart. And Becker had Seymour Duncan make specific pickups for these guitars, so they're super rare, low numbered, just for these particular guitars, which is awesome. This guitar also has the "Jake Blade," a sort of whammy bar, which I designed years ago—around 2000 or 2001. We took metal from a Harley gas tank, shaved it down to the palm of my hand, wrapped it with plastic wrap, and just fit it into the hole. It responds differently from a normal whammy bar; it's less erratic. So when I'm playing a nice jazz chord, I can do a longer waveform rather than a short, squiggly one. Because the pressure lies right on top of the tremolo, it's less squirrely. It just sounds completely different. You can get these Jeff Beck–type, consistent bends that are right in tune rather than searching for the pitch.

The switch at the top of this guitar is for the pickups, like a Les Paul. The red button is a kill switch—kind of like Buckethead's kill switch on his guitar—which allows me to lay down a chord and then tap it in time and create a sort of choppy sound. I can blast a big, distorted chord and just cut the tone off instantly with the button and then release it, and it opens back up.

This guitar is great to play live and reacts really well in a place like Red Rocks. Red Rocks can be a daunting, difficult place to play a show, because you're really against the elements. It can be blasting rain sideways one second, or frigid, or super hot and dry. This guitar responds really well to all those conditions. My knees are already shaking when I walk out to a big show at Red Rocks, so I need my guitar to be totally reliable, and this one pulls me through.

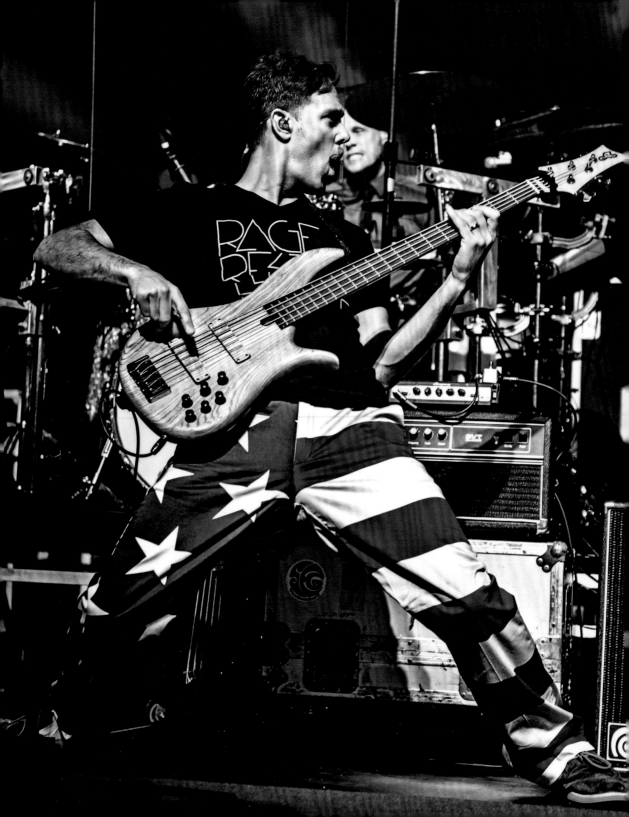

RYAN STASIK

c.2008 | F BASS BN5

Opposite: Umphrey's McGee, Fox Theater, Oakland, CA, March 16, 2013

MY GOOD FRIEND MIKE BENDY, who plays with Felix Pastorius, used to play this bass. He was getting married and needed some scratch, and I needed another fretted bass on the road as a backup, since the only other bass I had was a fretless. After acquiring it from Mike in 2012, I instantly fell in love with it, and the F Bass quickly became my main axe. Michael League from Snarky Puppy plays one as well, and I dig all of his work.

Mike Bendy and Felix Pastorius are two big influences for me, and both are absolute monsters on the bass. Not only am I fortunate to be friends with both of them, but now I have one of their former basses! I'm sure it's been around the block a few times, and I'm thrilled to have a part in its journey.

At the Wanee Music Festival this past summer, Oteil Burbridge sat in with us and crushed a version of "When the World Is Running Down." I was blessed to witness the magic he pulled out of that bass. That man is a musical saint, and I was honored to have him play my F Bass.

It is easily the baddest bass I have ever played. Easy to play, warm, punchy, and sexy to boot. Its sexiness is my favorite quality.

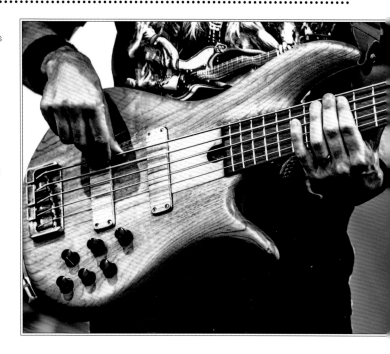

"IT IS EASILY THE BADDEST BASS I HAVE EVER PLAYED."

JOE SATRIANI

2010 IBANEZ JS2410 MCO (MUSCLE CAR ORANGE) PROTOTYPE 1

Opposite: Chickenfoot, TRI Studios, San Rafael, CA, September 26, 2011

I'VE OWNED THIS GUITAR since the Ibanez custom shop in Los Angeles built it for me in late 2009. This design features a few changes in my model's line, specifically the alder body and the twenty-four-fret neck with a bubinga stripe—and the color.

Now, about that color! One day, while taking a break from a Chickenfoot recording at Sammy Hagar's studio, we walked across the street to the Franzini Brothers Interiors custom auto shop to have a look around. Sitting in the shop was a beautiful '73 Camaro in "Hugger" orange, with a white racing stripe and chrome trimmings. I took a picture of it and sent it off to the Ibanez custom shop with a note saying, "We should make a JS guitar in this color!"

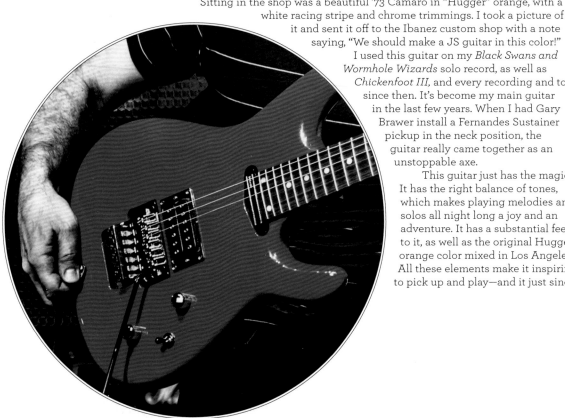

I used this guitar on my *Black Swans and Wormhole Wizards* solo record, as well as *Chickenfoot III*, and every recording and tour since then. It's become my main guitar in the last few years. When I had Gary Brawer install a Fernandes Sustainer pickup in the neck position, the guitar really came together as an unstoppable axe.

This guitar just has the magic. It has the right balance of tones, which makes playing melodies and solos all night long a joy and an adventure. It has a substantial feel to it, as well as the original Hugger orange color mixed in Los Angeles. All these elements make it inspiring to pick up and play—and it just sings!

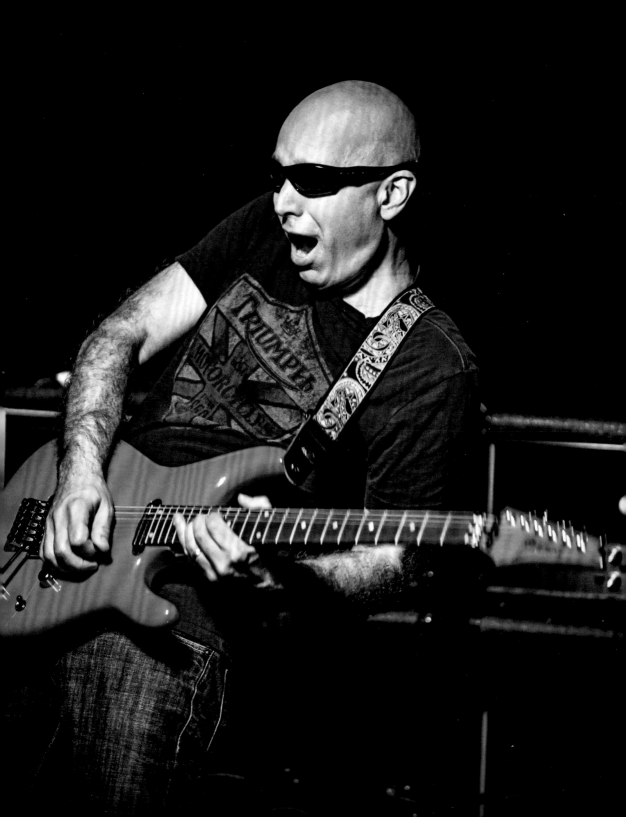

JIM JAMES

1997 | GIBSON FLYING V

Opposite: My Morning Jacket, High Sierra Music Festival, Quincy, CA, July 1, 2011

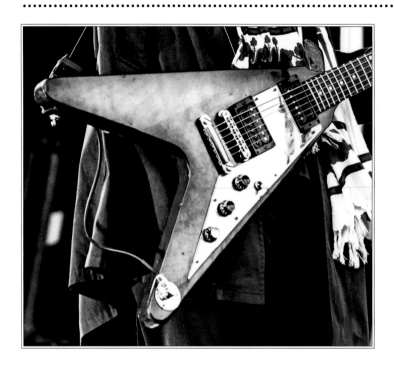

I HAD A DREAM as a small child that, along with world peace, I would someday own a brown, wooden flying V, with a mirrored pickguard. I made that dream a reality.

This guitar has much personal significance to me. There are many wonderful stories about this guitar, all of them beyond words. Playing this guitar feels like harnessing the power of the wind, or climbing onto my favorite old horse that knows just how I like to ride into battle and will defend me till the end. It fits perfectly into my hand and against my body. It knows the ways of the world and of my soul.

"PLAYING THIS GUITAR FEELS LIKE HARNESSING THE POWER OF THE WIND, OR CLIMBING ONTO MY FAVORITE OLD HORSE THAT KNOWS JUST HOW I LIKE TO RIDE INTO BATTLE."

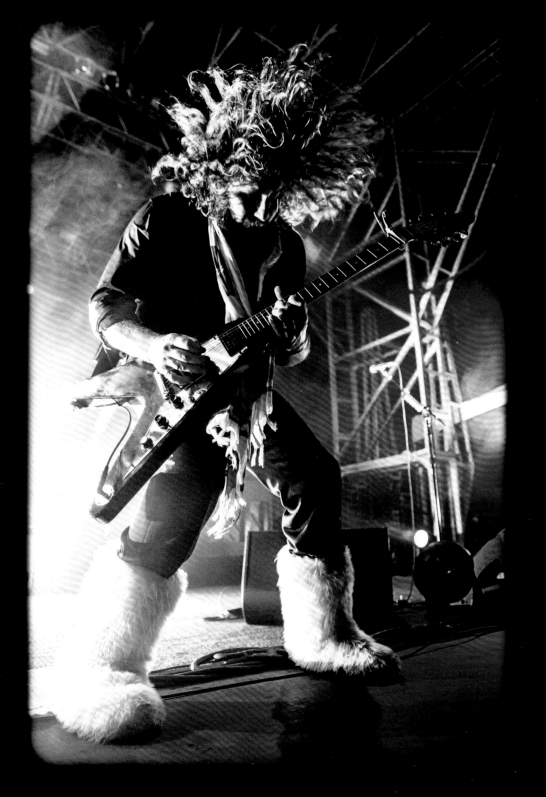

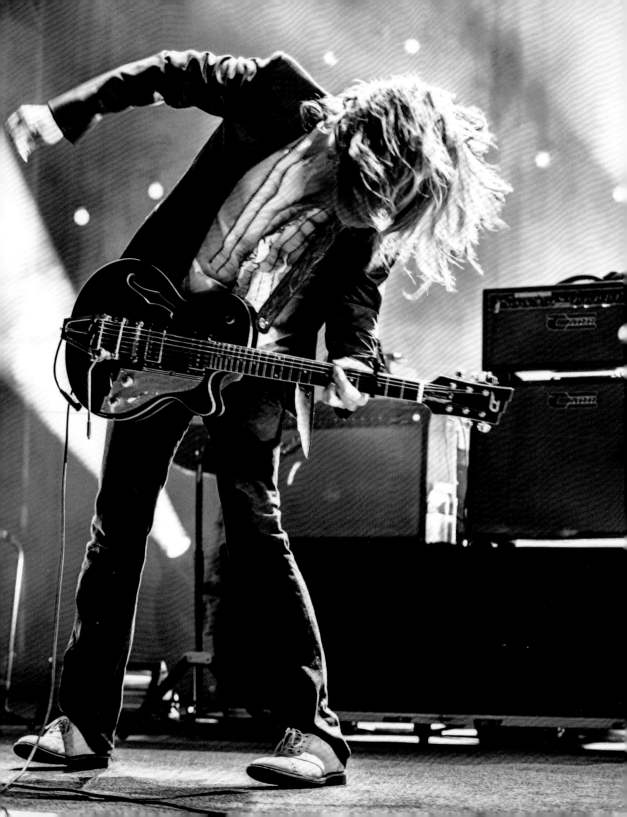

CARL BROEMEL

2008 | DUESENBERG STARPLAYER-TV

Opposite: My Morning Jacket, Greek Theatre, Berkeley, CA, September 15, 2012

I FOUND OUT ABOUT DUESENBERG GUITARS from my friend Mike Wanchic who runs Echo Park Studios in Bloomington, Indiana. He played with John Mellencamp for years. I went to school at the college in Bloomington, so I spent a lot of time at Mike's studio, and he had a Duesenberg twelve-string Double Cat. I loved that guitar; the pickups sounded great.

I ended up contacting Duesenberg and buying a Double Cat twelve-string. Then Nathan from Duesenberg brought me this guitar, because he knew I loved Les Pauls. I have a black Les Paul with a Bixby that's always been my number one guitar. So Nathan brought this one, and said, "Just take it for a couple weeks." And I fell in love with the guitar.

I got it right before we started working on the My Morning Jacket *Circuital* record. We were recording the song "Slow," and I thought, *I'll try my new guitar on this song.* It worked so great that I tried it on our song "Circuital," which has a bunch of solos, and it just felt like this guitar was inspiring in a different way than my Les Pauls were. That's when I started to fall in love with it.

There are a lot of people playing these guitars now, but one of the cool things about it for me is that it's not a classic guitar. It's not a Les Paul or a Telecaster or whatever, and it feels nice to have an instrument that Jimi Hendrix didn't play or Jimmy Page didn't play. I don't really feel like I'm revolutionizing the guitar, but sometimes it's nice to not have the weight of history on you all the time. So that's one of the psychological appeals of this guitar.

It also stays in tune incredibly well. I love a Bixby on a guitar. I have a Gretsch as well, and some of my Les Pauls have Bixbys, but the way this one is designed just works so much better than the regular Bixby. When I go to a recording session, especially if it's not with my band, there's no time to fix something. You just show up with something that's kickass. This guitar has never failed me in a recording session.

Sonically, the pickups are super articulate. It's modern sounding, but not in a bad way. It kinda sounds like a Les Paul; it kinda sounds like a Gretsch, but it doesn't sound like either of those. It's its own beast. It almost feels more like a rhythm guitar than a lead guitar, but playing leads on it is great, too, but not in a Hot Licks lead guitar player way; it's more like a paintbrush kind of lead guitar. When you play lead on it, you're just kind of flinging paint around.

There's a lot to love about this instrument. Discovering a new guitar and using it as inspiration to try to figure out how to play something new is exciting. And I love that it feels a little bit untapped. I'm really into old amps at the moment, but I like having a new guitar. There's something about having a guitar that was made this decade and trying to make music that's happening this decade. I have older guitars, too, and they definitely come in handy, but this one just feels like me right now.

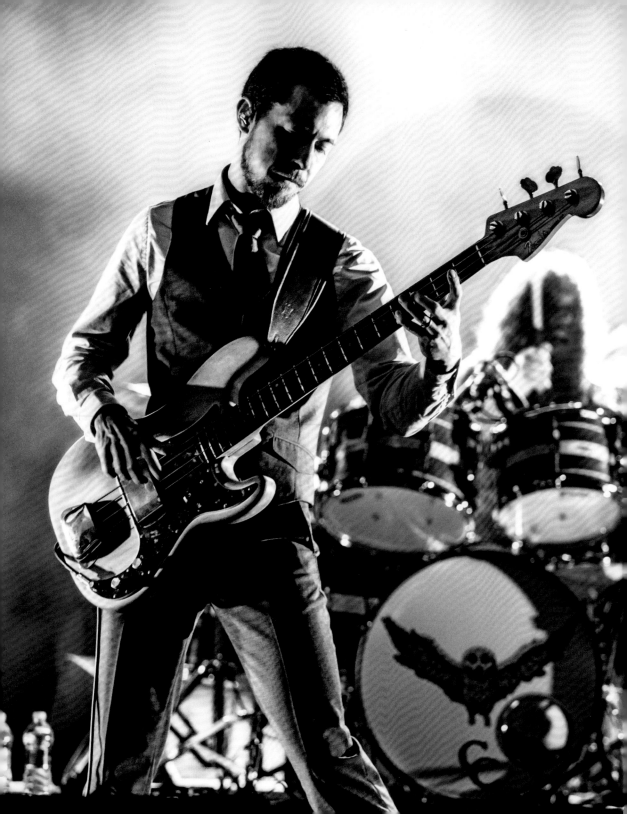

TOM BLANKENSHIP

1964 | FENDER PRECISION BASS

Opposite: My Morning Jacket, Mountain Jam, Hunter, NY, June 5, 2011

I'VE GONE THROUGH SOMETHING CLOSE TO THIRTY BASSES in the past sixteen years with My Morning Jacket, like an exhausting adventure to find the holy grail of low end. At the end of that journey was the first instrument I bought to audition for My Morning Jacket—a cheap import P bass. I'm going to play a Precision through an Ampeg until James Jamerson floats down from heaven to tell us that he's created something that sounds, plays, and feels better.

On tour in 2010 I found this particular bass at Chelsea Guitars in NYC. According to shop owner Dan Courtenay, he had purchased the instrument from the widow of Bob Rosenfeld, who played for Rick Nelson's Stone Canyon Band and toured with Neil Diamond.

When My Morning Jacket played a late, late night set with Preservation Hall Jazz Band on the *Belle of Louisville* steamboat a few years ago, this bass almost fell in the Ohio River, along with Carl Broemel, on the walk to the show due to equal parts excitement and exhaustion on the pitch-black waterfront.

When I got the bass, it was all original except the former owner had stripped the paint off the body, thrown in some cheap pickups, and replaced the Fender decal with his own hand-painted logo (which is especially cool!). I replaced the pickups with a new set from Lindy Fralin and in the process discovered the metal pickguard shield was painted a psychedelic swirl of purple, and the body along the neck pocket was Smurf blue—great combo!

What I've always loved about the P bass (and why I returned to it after my aforementioned journey) is how simple the design is. This bass feels exactly like what it is—a few pieces of wood joined together with a pickup—so it just feels like a big resonant chunk of wood that goes *THUNK*. It's the sound we all identify with electric bass. With this particular instrument, I love its hand-painted Fender logo, the half-rusted chrome hardware, and the fifty years of sweat, grime, and love that have soaked through the wood to create its crazy smoky patina.

STEVEN DROZD
1967 FENDER JAZZMASTER

Opposite: Flaming Lips, Bimbo's 365 Club, San Francisco, CA, February 21, 2012

WHEN I BOUGHT THIS GUITAR in the summer of 1993, a lot of my favorite guitar players were playing Jazzmasters—J. Mascis, Kevin Shields, Thurston Moore all played Jazzmasters—and it was relatively cheap at that time.

Since getting this guitar, it has been my go-to and has been at *every* Flaming Lips proper concert since 1994. I also used it on one of my favorite guitar things I've ever done—the guitar solo on "Feeling Yourself Disintegrate" from *The Soft Bulletin*.

Also, Courtney Love borrowed it at Lollapalooza 1994 in Philadelphia—I asked her not to smash it, and she told me something like, "You need to stop reading books by Steve Albini!"

I haven't really modified this guitar, but Wayne Coyne replaced the original bridge pickup with a Hot Rail, which helps a lot in controlling feedback, if you need that.

The first time I picked it up, I knew it was special. The neck is a little wider than most other Jazzmasters, and it plays just perfect for me. At this point, I just love that it's been with us for so long and is such a part of the recorded and live history of the Flaming Lips.

"COURTNEY LOVE BORROWED IT AT LOLLAPALOOZA 1994 IN PHILADELPHIA— I ASKED HER NOT TO SMASH IT, AND SHE TOLD ME SOMETHING LIKE, "YOU NEED TO STOP READING BOOKS BY STEVE ALBINI!"

NELS CLINE

JERRY JONES DOUBLE NECK LONGHORN, CUSTOM

Opposite and following pages: Wilco, Fox Theater, Oakland, CA, January 31, 2012

I DO NOT KNOW THE EXACT YEAR of this guitar, but there's an interesting story behind how I got the instrument and what I've learned about it. I love Jerry Jones guitars. My friend G. E. Stinson, the great guitar player who lives in Los Angeles, started getting Jerry Jones guitars right at the beginning of their production out of Nashville. He had one of the first twelve-strings that Jerry ever made. He also had a more conventional six-string Longhorn, which I used to play sometimes with him in a band called A Thousand Other Names. So I was very enchanted with Jerry's work, the sound, the feel, and the look. I played a Jerry Jones twelve-string with the Geraldine Fibbers.

So I started getting into Jerry Jones guitars. It was great when you called Jerry Jones Guitars, he would answer the phone—just, "Hello," and you'd talk to Jerry. He and I never talked about this guitar because he retired. He just closed his shop, sold all the tools, sold all the jigs. Boom, gone! Gone fishin'.

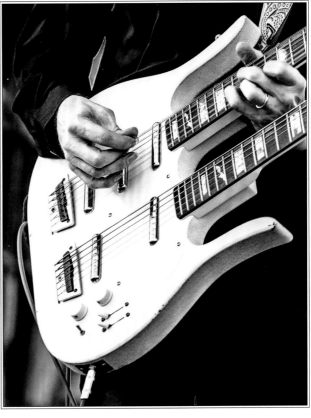

After he retired I was searching for Jerry Jones guitars on Olivia's Vintage Guitars online, and there was this double-neck—I couldn't believe my eyes. It was white, even white on the back of the neck, which I don't think he'd ever done before. And it was a twelve-string and baritone double-neck, which is completely weird. And it had inlay work on the neck, which Jerry never did. And it had wood bridges, the original Danelectro style bridge, which I thought was pretty risky stuff for a twelve-string, because even Jerry, when he started making twelve-strings, used a regular tunable, metal bridge.

So I called up John Woodland, who everybody calls "Woody," immediately and said, "Woody, look at this guitar on Livia's page and see what you think of it." He had this trepidation about the wood bridge on a twelve-string, but I think he already knew that the writing was on the wall. It wasn't that expensive, and I was flipping out because I needed this, the weirdest Jerry Jones guitar.

And I said, "I'm buying this, Woody."

He said, "Well, have them send it to me."

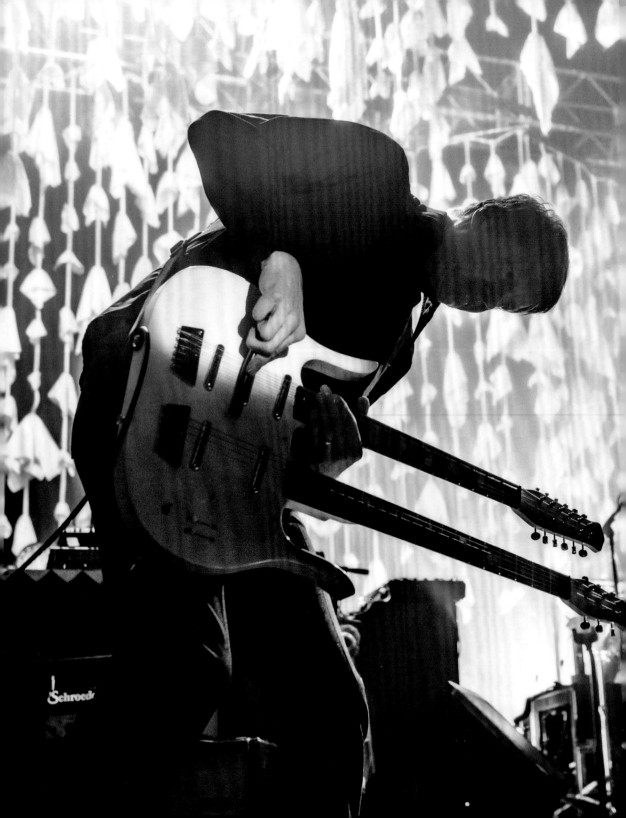

So they sent it to Woody first, and then he intonated the twelve-string bridge by hand carving it. I mean, he literally hand carved the bridge so that it plays perfectly in tune. I really bought it just to collect it. I thought, *God, this is just the weirdest*. I already have a Jerry Jones Longhorn baritone and six-string that I bought used years ago on a Wilco tour. Everybody who saw it said, "Whoa! What is this with the double-neck?" I have a friend and collaborator, Carla Bozulich, the leader of the Geraldine Fibbers, who once made me promise to never rock a double-neck on stage. And here I was with my double-neck, and the Wilco guys loved it.

Anyway, I got this guitar, and I literally didn't know what I was going to do with it. But we were tracking the Wilco record *The Whole Love*, and I had this song called "Dawned on Me" where I played the low-key guitar part, but on the rest I played the twelve-string. It didn't occur to me until we were about to tour that I couldn't play the song live because of the two parts. Then it dawned on *me, Whoa! I'll have to take out this double-neck for one song only.*" And that's what I do.

I started casting about for information on this guitar because it's so bizarre. The inlay work has this hippie religious theme. It's got Adam's and God's fingers touching from the Sistine Chapel. It's got a cloud; it's got birds, fish, all these kinds of things. I still haven't been able to find out anything about it.

Sonically Jerry Jones guitars resemble those old Silvertones and Danelectros with those lipstick pickups, but Jerry's are of a much higher quality. Jerry's love for those guitars was so intense that he took it upon himself to reissue them but make them more lovingly. Then Jerry started the Neptune line, which I love. That's what I play with Wilco. I have the Shorthorn, and I play the twelve-string. Now I've got a backup for the twelve-string. And I love my baritone guitar. The sustain on my Jerry Jones baritone guitar is unbelievable. It's just an insane instrument. You can hear it on a piece that I did on one of my old records with my band, Nels Cline Singers, called "Caved-in Heart Blues."

There's something completely signature about these Jerry Jones guitars. They're classic, they're well made, and this double-neck is really unique.

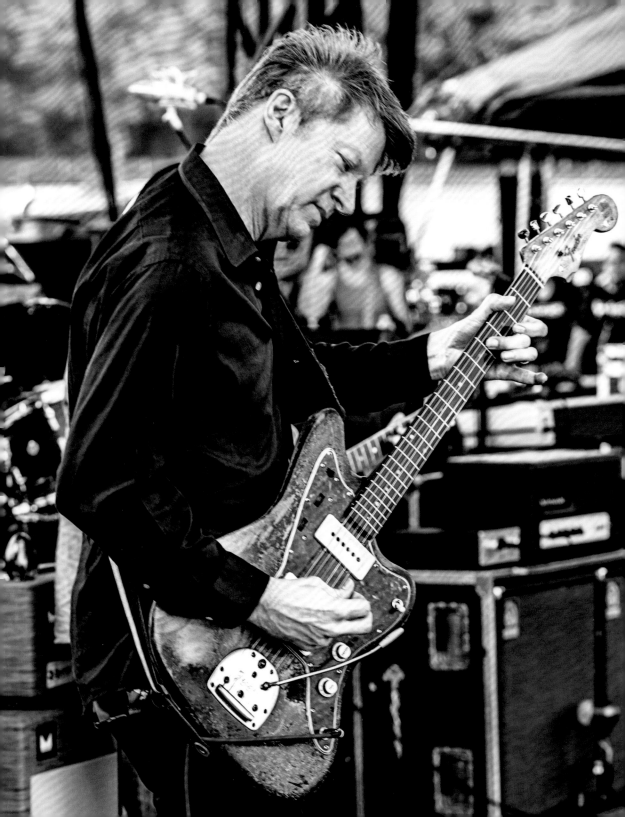

I BOUGHT THIS GUITAR IN 1995—before that it belonged to Mike Watt. Watt's name is engraved in two different places: one in the back at the very heel of where the neck joins the body and also on the tremolo assembly. It says "Watt." That's why I call it "The Watt."

I first saw The Watt when I had a concert series in Santa Monica for a few years on Monday nights where my old trio, the Nels Cline Trio, would play. Quite often we would have Joe Baiza in there playing with Universal Congress Of and the Mecolodiacs. He always played a sunburst Strat, and that was a great guitar, but he also played The Watt.

There was this one night at the Alligator Lounge where he was playing a black Jazzmaster, and I couldn't believe my eyes. I said, "Joe, what happened, man? Where did you get this guitar?"

And he said, "Oh, this is Watt's guitar. My Strat's being refretted." I was about to go on tour with Watt that year—'95—and I was thinking that the Jaguar wasn't really cutting it; it wasn't really rock enough.

So Joe said, "Look, just take the guitar. I don't need it. Just take it, and when the tour is over, you can buy it from me for what I paid for it." And that's the story there.

The standout memories with this guitar are from the early days when I didn't realize I had this very valuable, beautiful guitar. I had decided that it was my rock guitar, and I was just going to use it as a kind of musical weapon. When I was playing in the Geraldine Fibbers, we did this song called "Dusted," and sometimes we'd end up in a demolition derby at the end of the set. Sometimes I would just hurl it over to our drummer, Kevin Fitzgerald, and he would slam it on his floor tom and play with drumsticks on it, and a couple of times he just ripped the strings out with his bare hands. Sometimes, on a good night, he'd do something and cut himself, so there's been blood on that guitar, blood on the pickup covers, lots of distress.

I love the fact that I am probably the only person alive that uses the neck-only setting—which some people call the "Jazz" setting—which is activated by the little black switch above the strings. You just push that up, and it goes to the "neck-only" thing and has its own tone and volume controls. The neck-only pickup is a very lovely sound in my opinion. But really, I like everything about this guitar. The feel of the neck, the feel of the body, the sound, the versatility—it's a great instrument.

NELS CLINE
1960 | FENDER JAZZMASTER

Opposite: Wilco, Lockn' Music Festival, Arrington, VA, September 6, 2014

LARRY LALONDE

2010

FENDER AMERICAN DELUXE TELECASTER

Opposite: Primus, Fox Theater, Oakland, CA, December 31, 2014

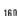

GROWING UP I HAD SEEN TELECASTERS in the hands of some of the heaviest of heavies: Keith Richards, Jeff Beck, Steve Cropper, and even in some early photos of Jimmy Page. There were a lot of guys who really made the Tele look cool, and I wanted to play one too, but I really couldn't get one to do everything I need a guitar to do live. The Tele is a great, classic-sounding guitar that's gritty, twangy, even beautiful, but not so good at making robot sounds and spaceship noises or trying to pull off Eddie Van Halen or Frank Zappa antics.

In 2010, when we started rehearsing for a Primus tour after a couple years off, the only guitars that sounded right were my Stratocasters. I ended up at the Fender factory where the guys there quickly found what has become my favorite Strat ever: an American Deluxe Stratocaster. But I had one problem. There are a lot of songs where I prefer a guitar with a non-tremolo, hardtail bridge. It stays in tune a lot better when it comes to bending strings and hitting chords really hard. When I asked if they had any guitars with a hardtail, they said they had started making a Telecaster version of the Strat that I had just fallen in love with.

My first thought was that the build of a Telecaster is such a vintage design it probably won't work. But they brought out this Deluxe Tele, and I was floored. Here was this beautiful, classic-looking Telecaster, but with modern hardware and electronics. Kind of like a 1953 Corvette on the outside and a Tesla on the inside. But it had a crazy neck on it. Fat as a baseball bat. No one knew why. I asked if they had one with a regular neck on it, but this was the only one, so Alex Perez from the custom shop took off with it to work his wizardry. Chris Boone from Fender said, "Do you have time for a tour of the factory while they try to fix that?"

Oh, I had time. Walking through the famous Fender factory and custom shop in Corona was something I had not anticipated getting to do when I woke up that morning. In a world where you picture factories as automated and passionless, it was great to see the level of craftsmanship and love of guitar building at Fender that day. I was on cloud nine by the time we got back to Chris's office, when Alex handed me the Telecaster.

"How's this?" he said. It was amazing. Everything about the guitar was amazing! I drove home that day with the biggest smile that kept getting bigger every time I looked at the case in my back seat. I just kept thinking, "I finally get to play a Tele like the real dudes."

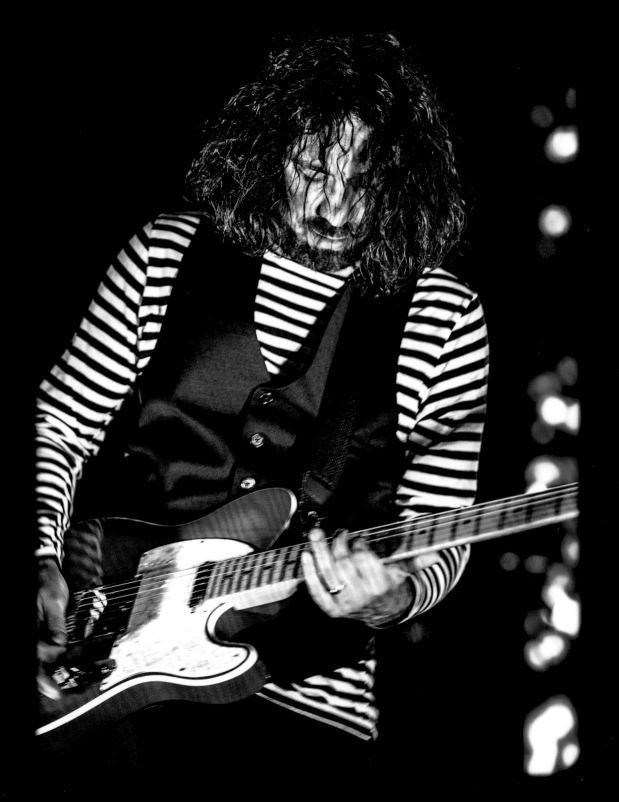

LES CLAYPOOL

2010 | PACHYDERM BASS

Opposite: Primus, Harmony Festival, Santa Rosa, CA, June 12, 2011

THIS BASS IS THE ORIGINAL PROTOTYPE of a bass that I designed called the Pachyderm Bass. It was made by a buddy of mine who I went to high school with named Dan Maloney, who used to work for Zeta Music Systems and now runs Maloney Stringed Instruments. For this particular instrument, I did a lot of the shaping myself.

I had been playing Carl Thompson basses exclusively for many years and had a particular Carl Thompson four-string that I had owned since I was in high school. I love that bass, and I actually wanted to retire it just because it had so much history and I was worried that I was going to beat it to death out on the road. So Carl Thompson made me a replica of it, which was very nice. He is a great luthier. He's like the Stradivarius [sic] of bass guitars. But the thing about his instruments is they're like pieces of art; each one is very individual, and they're very different from each other. I really wanted something that was specific to my needs. So my design has got a little bit of Carl Thompson in there, a little jazz bass in there, a little Rickenbacker, and a lot of innovations of my own. It's very ergonomic, it's very light, and it's very punchy. Not a lot of electronics—I don't like a lot of electronics. In designing this bass I wanted to keep it very simple. That's the way to go. I want the tone of the instrument to stand on its own as it's leaving the body, and if I need to manipulate it, I use pedals.

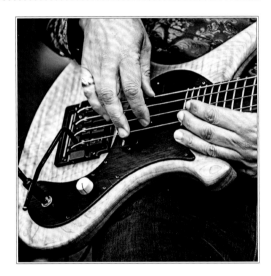

We've made five others since with various woods, and a couple of them we've sold. We sold one a handful of years ago for a benefit for my little nephew who passed away from leukemia. When he was fighting leukemia, we sold the instrument for fifty thousand dollars. That was a drop in the bucket financially for what my brother had to deal with, but it definitely helped, and it was a great thing to help raise awareness.

In my mind, the greatest thing that ever happened with this bass was the last tour we did. We're doing this whole Primus & the Chocolate Factory thing where we were doing the music from the original *Willy Wonka & the Chocolate Factory*. We did a show in Los Angeles, and some friends came down and sat in: Stewart Copeland, Danny Carey from Tool. They came and sat in with us, and then Stanley Clarke came out, and he played this bass. Stanley was one of my uber-heroes when I was growing up, and it was my first time getting to play with him. And he just killed it; it was spectacular. So for me, that was the most magical moment for that bass.

It's very sentimental because it's the very first of its kind. But sonically, it's a fog cutter. Stanley was blown away by it, and now he wants one. It slices through the mix, yet it still has a punch and a nice bottom end that lets you lay down a foundation.

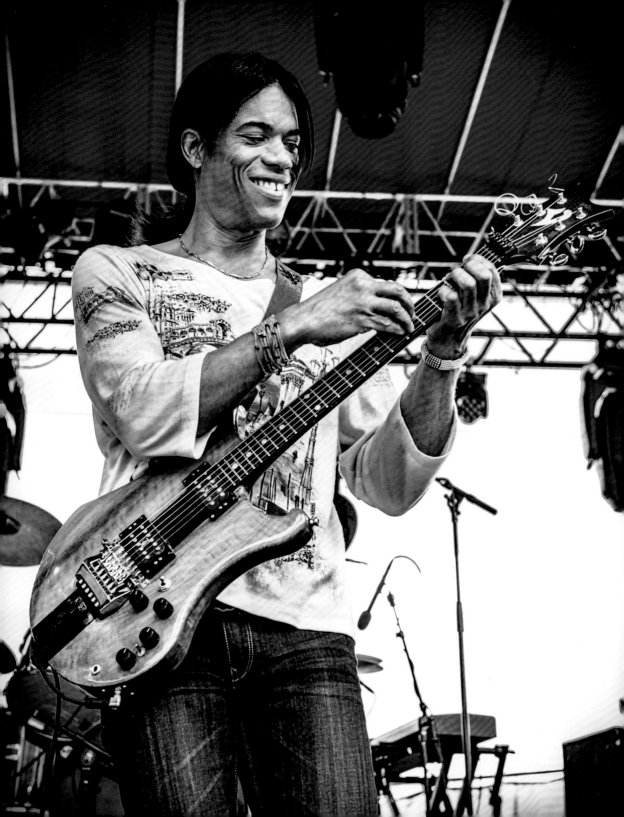

STANLEY JORDAN

1988 VIGIER-ARPEGE II

Opposite: Stanley Jordan Trio, moe.down, Turin, NY, August 11, 2013

I STARTED PLAYING VIGIER GUITARS BY CHANCE. I was in Paris doing an interview. Vigier is based in Paris, and the journalist who did the interview knew about Vigier guitars and brought a couple of them just to see what I thought. So I played them, and I was amazed, because I'm always looking for an instrument for my touch technique. It's kind of a picky thing, and finding the right instrument is not easy. But with this Vigier, I found it easy to use the technique right away.

There are a couple of specific things about this guitar that make playing my touch technique especially easy. The construction is really accurate, so you can get the action down really low without buzz. Also, the fingerboard is naturally flat. I find that I can make arched fingerboards work as long I don't bend any notes with the low action. The more accurate the fret job is, and the more accurate the instrument in general, the more you can get the action down, but the flat fretboard helps too.

The other thing that's great about it is the pickups, which are especially hot. That extra boost gives me a little bit more volume, which helps because the hammer-on technique is not as loud as picking. The pickups were made by Benedetto. Vigier told me that Benedetto had retired, and that he convinced him to come back just to make these pickups for this model of guitar. And the pickups sound amazing; it almost makes it sound like it's an acoustic guitar. It's like you're not just hearing the strings, but you're hearing the air around the strings. Even though I know that they're magnetic pickups, it still sounds microphonic to me. So they pick up a lot of nuance of what's happening with the instrument.

With the touch technique, a lot of guitars have either one problem or the other: Either the sound is too tinny, or the sound is warm but the high notes don't come out strong enough. It's rare to find a guitar that has both. This guitar has a warm sound and the high notes come out really strong. I don't know what it is about it that makes it do that, but it's just thoroughly well balanced for the touch technique.

It's a graphite neck-through, and the graphite neck is really stable. With the touch technique, you have to have really low action, and you can run into problems with the low action. What that means is that you're really sensitive to any changes in the action of the instrument. The nice thing about the graphite neck is that it's so stable that temperature and humidity don't affect it very much. So wherever I put it, it pretty much stays there.

My favorite quality about it is definitely the sound. The best way I can describe it is it's just so frickin' hi-fi. Hi-fi-est guitar I've ever heard. It's got a really great deep, warm, low end, and at the same time, it's sparkly at the top. It's just very even.

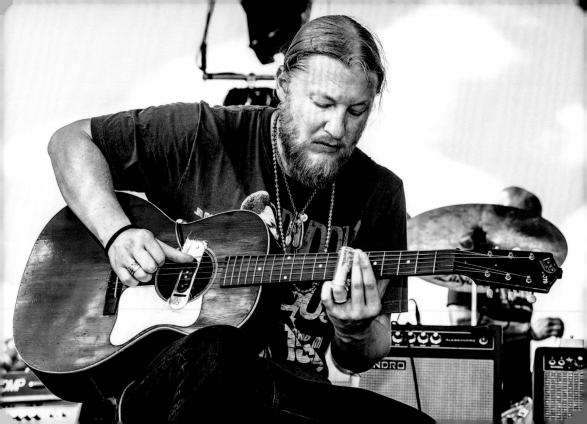

DEREK TRUCKS

1936 | GIBSON L-00

Opposite: Tedeschi Trucks Band, Lockn' Music Festival, Arrington, VA, September 6, 2014

THIS IS A 1936 GIBSON L-00.
The pickup is a 1950s or maybe 1960s DeArmond pickup, which is what Lightnin' Hopkins or Elmore James would've used. There's something about this line of 1930s Gibsons—they're little parlor guitars—and this one is the best-sounding acoustic I've ever played.

When I first got this thing, I'd stay in my hotel room and just wear it out. It's an amazing-sounding instrument. What I love about it is that you can tell it was played a lot. You can just tell that this thing was not lying under somebody's bed. It was out and probably played every day. There's a mystery about this guitar I really like. You can look at the neck and tell where it was played. You can tell which chords were played often. You can tell which frets were used each time—they're scalloped out where people have dug into them over the years. There was a hole in the

headstock that was filled in somewhere along the way. They call that the "farmer's hole," because people would put a hook on their wall and hang the guitar through the headstock. Just drill a hole through the headstock. It's a well-played working man's guitar. It wasn't coddled, but it held in there.

When you put a pickup on it, it's a different animal, and you get that Elmore James gutbucket sound. Those DeArmond pickups, there's nothing like them. It puts you in that place. I've had a lot of memorable moments with this guitar, but the most fun I've had playing it was recently, when we had Jerry Douglas sit in with us at the Beacon. I had this guitar and Jerry was playing a dobro, and the two sounded amazing together.

I love this instrument. If the house was on fire and I could only take one or two guitars, I'd reach for this. It'd be one of the first ones I'd snag. After I got my kids out, of course.

> ## "IT'S A WELL-PLAYED WORKING MAN'S GUITAR. IT WASN'T CODDLED, BUT IT HELD IN THERE."

DEREK TRUCKS

1957 | GIBSON LES PAUL GOLDTOP

Opposite: Allman Brothers Band, Jones Beach Theater, Wantagh, NY, July 24, 2012

THIS IS THE '57 GOLDTOP, the guitar Duane Allman played on the first two Allman Brothers records; it's got a long, storied past. This guitar has been on some of the most iconic album tracks of all time—it played the solo on "Layla," which is hugely significant to rock history. Duane eventually traded the guitar for the Les Paul sunburst, but the goldtop somehow ended up in Daytona Beach, Florida, for years and then found its way back to the family. It's a magical guitar. There are some spirits in this thing.

In the last decade, the owner has been trying to get it out and have it played by people who'll appreciate it. I've been lucky enough to take it for a spin a handful of times. The first time I played it, it was clear the guitar had its own personality. I've had a lot of musical flashbacks while playing it; the one that stands out the most is just recently, when we did the final Allman Brothers shows. They had all three of Duane's Les Pauls together, which I don't think had ever happened before because he had traded them when he was alive, and they were never all in the same place. Having the goldtop and the two sunbursts onstage together, being played, was pretty special. And it happened on the Allman Brothers's final night, at the Beacon Theatre. It felt appropriate.

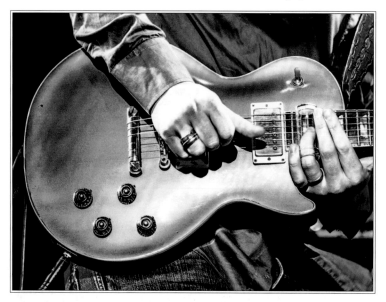

Some instruments want to be played a certain way, and when you tap into that it becomes really easy to play them. They almost direct you toward what they want to do; certain harmonics really take off. This guitar has a serious personality. You can definitely see why Duane stuck with it for as long as he did—why it was the guitar that was played on those now-historic albums. It has a distinct sound. You can play fifty guitars from that same era, and two or three are going to be really special. This one happens to be in that realm. You don't come across those very often—especially from that era, when every guitar was unique. When you're dealing with wood, the pickups being hand wound, all of those things, every instrument is going to be different. You just never know what you're going to get. This one has the thing.

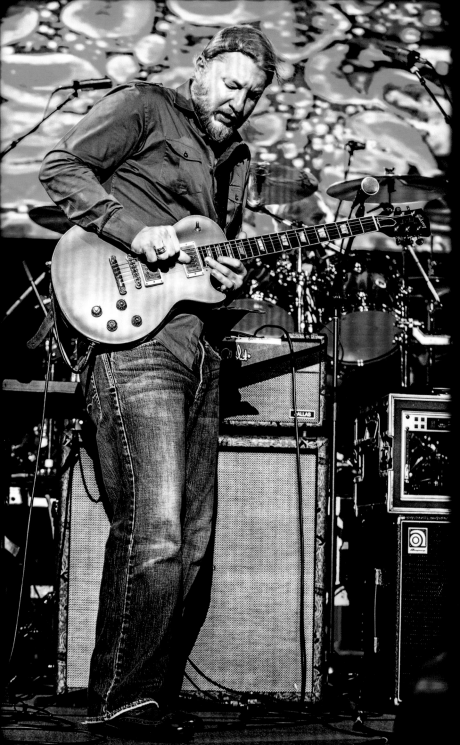

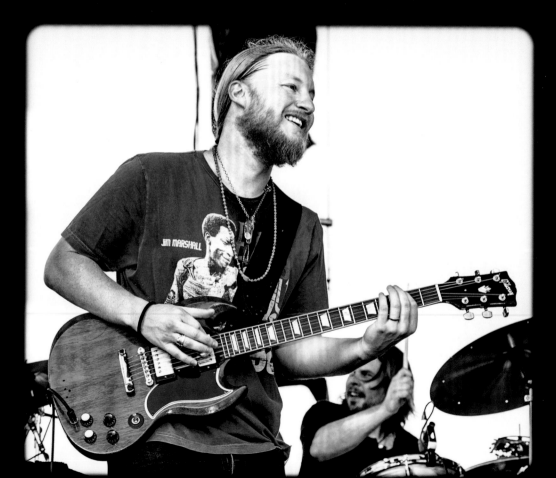

THIS IS MY MAIN GUITAR. I've played an SG since I was eleven years old, but I've had this one for the last eight years—it was a gift from Galadriel, Duane's daughter. Dickey Betts and Duane Allman had a guitar they traded back and forth, and Gibson made a handful of copies of it. I had always played SGs, even vintage ones, but I was apprehensive about bringing the vintage ones on the road because they're fragile. This one has the sound and the feel of an old one, and it feels a little sturdier, so I've been using it pretty exclusively.

Gibson has made reissues of the vintage SGs, and I've played a few of them, but this one just felt right the first time I played it. It's a lot lighter than the other ones. I think the wood is a little drier, so it sings a little bit more. It's just a super comfortable guitar to play. I generally stick with one guitar at a time, and when I found this it became my main guitar. I played another SG for many years, and I was looking for an excuse to put it down. It had a ton of signatures from people I'd played with over the years, and I really wanted to get it home and get it off the road. When I found this one, it gave me that freedom. You know, you find a guitar that you love and you just don't think about it. I've tried a ton of guitars, but I always seem to go back to this one. When I have an SG that feels right, I don't have to think about it. It's all there.

This thing's been with me nonstop for the last four, five, six years. There've been a lot of highlights. It's a great tool, but it also becomes a kind of witness. Whatever highlights you have, it's there with you.

With this guitar I didn't even have to plug it in to know it was right. The wood speaks; sometimes you just pick a guitar up and it tells you that it's right. That's the case with this one—the feel of it, the weight. You can knock on the wood, and it seems pretty lively. Some instruments just feel right, and this is one of them.

The wild thing is, it doesn't matter how much a guitar costs. You can find a sixty-dollar guitar that speaks to you, or you can spend a boatload and want it to be great, and it's not. I've seen it happen both ways. It's important to be open to that when you're looking for something. You can't force the connection.

DEREK TRUCKS

2003 | GIBSON SG

Opposite: Tedeschi Trucks Band, Lockn' Music Festival, Arrington, VA, September 6, 2014

SUSAN TEDESCHI

1993 | FENDER AMERICAN STANDARD TELECASTER

Opposite: Tedeschi Trucks Band, Mountain Jam, Hunter Mountain, NY, June 5, 2010

I GOT THIS GUITAR YEARS AGO, from an old music shop in Porter Square in Cambridge, Massachusetts. It was hanging up on the wall and I played it one day. I went home, thought about it, and actually had a dream about the guitar. I went back the next day and bought it—a basic American Standard with a rosewood neck. It felt great—just a solid guitar. And it had a really nice, warm pickup, and that was the thing that really drew me to it; most Telecasters sound bright and kind of thin, but this one was really warm and fat.

Each pickup is hand wound, and something about the way these were wound gives this guitar its rich sound. The rosewood neck helps, too; rosewood always gives a warmer, darker sound, whereas a maple neck can be a little brighter.

I have a bunch of guitars, and they all speak a little differently. Some of them want to play swing and jazz, others want to play gutbucket blues, and other ones just want to play country cowboy chords. They all have different personalities. This one likes to play blues and rock. And it likes to play country a little bit, too, but good, old country.

So it came with that rich sound—but the signatures are another story. In 1997 I was supposed to open for Clarence "Gatemouth" Brown on Martha's Vineyard at the old Hot Tin Roof. We got over there—you have to get on a ferry and bring all your gear—and we were getting ready to open, and then we were told the gig was canceled. I'd been anticipating the gig for months, but President Clinton had decided to rent out the building for a party for his secretary's thirtieth birthday. They were still going to have Gatemouth play, but Carly Simon owned the place and she wanted to open.

I was kind of bummed, but they let me go even though I wasn't playing, and I got to hang out with Gatemouth the whole day. We hit it off and I asked him if he would sign my guitar. And so he signed my guitar and he told me that he was going to adopt me and I was going to be his new granddaughter.

So, Gate was the first one to sign the guitar. Then in '98, I went on tour with B.B. King, Buddy Guy, and Dr. John, and we all became really close. I got the three of them to sign it, and that's when I started getting a lot of my heroes—Jimmie Vaughan, Herbie Hancock, and all sorts of amazing people I got to open for or meet—to sign this guitar.

This was really my first electric guitar, and it helped set my career, helped get me on the right track. I made my first couple records with this guitar. It's very sentimental to me, but I also love the way it plays—the sound, the way it feels, its versatility. I love it all.

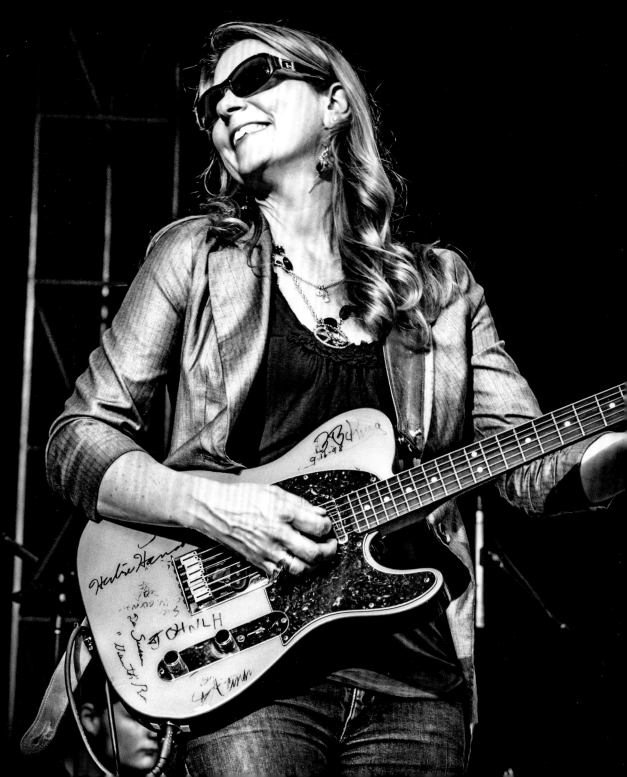

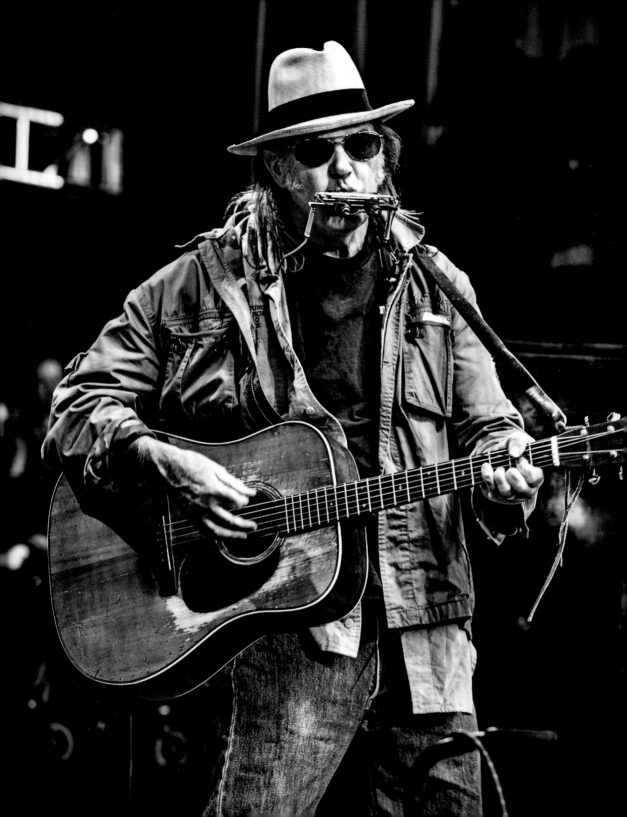

THIS ONE IS CALLED "HANK," because it used to belong to Hank Williams. It's a Martin D-28 from 1939. A Nashville collector, Tut Taylor, who's pretty well known in Nashville, traded some expensive collector shotguns to Hank Jr. for it, which somehow makes sense. Anyway, a friend of Neil's, Grant Boatwright, who also was a guitar collector and sometimes dealer in Nashville, hooked Neil up with this guitar, and it is a particularly great-sounding guitar. It really is spectacular. It has stereo FRAP pickups in it. I developed the stereo FRAP concept in '78, so all of his Martins have those in them. Other than that it's all original—original frets, original everything. Brazilian rosewood back and sides, spruce top, with an ebony fingerboard and an ebony bridge.

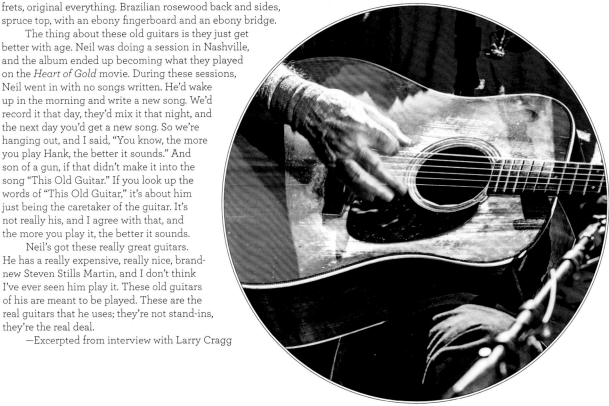

The thing about these old guitars is they just get better with age. Neil was doing a session in Nashville, and the album ended up becoming what they played on the *Heart of Gold* movie. During these sessions, Neil went in with no songs written. He'd wake up in the morning and write a new song. We'd record it that day, they'd mix it that night, and the next day you'd get a new song. So we're hanging out, and I said, "You know, the more you play Hank, the better it sounds." And son of a gun, if that didn't make it into the song "This Old Guitar." If you look up the words of "This Old Guitar," it's about him just being the caretaker of the guitar. It's not really his, and I agree with that, and the more you play it, the better it sounds.

Neil's got these really great guitars. He has a really expensive, really nice, brand-new Steven Stills Martin, and I don't think I've ever seen him play it. These old guitars of his are meant to be played. These are the real guitars that he uses; they're not stand-ins, they're the real deal.

—Excerpted from interview with Larry Cragg

NEIL YOUNG

1939 | MARTIN D-28 ACCOUSTIC

Opposite: Neil Young, Shoreline Amphitheatre, Mountain View, CA, October 24, 2009

NEIL YOUNG
1953 | GIBSON LES PAUL

THIS IS NEIL'S MAIN ELECTRIC GUITAR. It's a 1953 Les
Paul goldtop that's been painted black. In 1953, they only made
gold Les Pauls. It's got a mahogany neck and a mahogany back
with a maple cap on the top.

Originally, the '53 Les Pauls came with what's called a
"trapeze bridge." The strings came from underneath the bridge
because the neck wasn't tipped back far enough in '52 and
'53, which made the guitar pretty much unusable. In '54, they
got rid of that bridge because they tipped the neck back to
its present position, but the thing with having less of a neck
angle is that you can have a lower bridge, which works much
better for a Bigsby, which Neil has used extensively. So this
has a Gibson Tune-o-matic bridge on it, and it has a Bigsby
B7 vibrato on it.

Originally, this guitar was made with two P-90 single-coil
pickups. In the early '70s, Neil took it to a luthier to have some
modifications done. When he came back to pick up the guitar,
they'd gone out of business. Neil tracked down the guitar, but
the bridge pickup was gone. So they put in a late '50s Gretsch
pickup, a DeArmond pickup with adjustable magnets for the
poles. It's a special Gretsch pickup, and it's only in the bridge
pickup. The neck pickup was still the P-90, but they put a silver
cover on it. I started working for Neil in '73, so this was the
condition I found the guitar in, with the DeArmond pickup and
the Bigsby and the Tune-o-matic.

After a year I put a Gibson Firebird pickup—a small, two-
coil humbucking pickup—in the bridge position. The Firebird
is a very unusual pickup noted for its particularly bright tone. This particular
pickup is remarkably microphonic. If you tap on the guitar, you can hear it. Neil
has even talked into it, screamed into it, and you can hear it coming out of his
amplifier. It's that microphonic, which contributes to the unique sound he gets.

I found the remnants of a switch in the middle of the four knobs. No switch
was there, and what it did I don't know. So, what I ended up doing was put a mini-
switch in that hole and routed the bridge pickup directly to the jack, bypassing
both the volume and the tone control on that pickup. After I did that, Neil said,
"It's like it goes to eleven now." You'd be surprised how much energy and tone gets
absorbed by the volume and tone control. It's a remarkable guitar. It has extremely
low action and plays really great. —Excerpted from interview with Larry Cragg

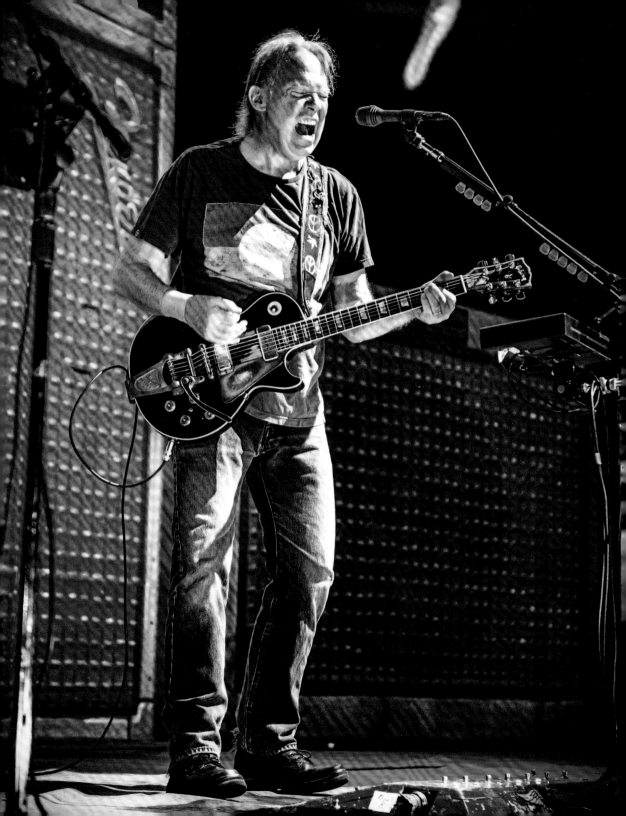

JORGEN CARLSSON

2008 | GIBSON THUNDERBIRD BASS

Opposite: Gov't Mule, Central Park, New York City, NY, August 11, 2010

IT ALL STARTED WITH JOINING GOV'T MULE. A lot of Allen Woody's bass tracks where done on Thunderbirds, and the fact that both Warren Haynes and Brian Farmer loved the sound from it made picking up this instrument an easy choice. If it sounds anywhere near the way it looks, I'm in!!

I never really paid any attention to Thunderbirds prior to owning one, playing one was more of a delayed reaction—but I do remember Walter Becker playing one live in '73.

Before I had done any gigs with Gov't Mule, Brian Farmer had arranged for this bass to be shipped to my address in Los Angeles without me knowing—a fucking Gibson bass in the mailbox!! This is still the only Thunderbird I use live.

I haven't made any modifications to this instrument yet. Farmer and I were talking about putting Firebird guitar pickups in it to get some more "grain" out of it, but we never got around to it. I feel like I have to go ahead and do it just to see and hear what he had in mind.

There's a lot I love about this instrument. The fact that it was selected for me and sent to me by Brian Farmer is incredible. It also looks amazing, and there's always something special when Warren switches to a Firebird at the same time in E-flat tuning. And I love the tone—it sounds like a distorted grand piano!

"BRIAN FARMER HAD ARRANGED FOR THIS BASS TO BE SHIPPED TO MY ADDRESS IN LOS ANGELES WITHOUT ME KNOWING—A FUCKING GIBSON BASS IN THE MAILBOX!!"

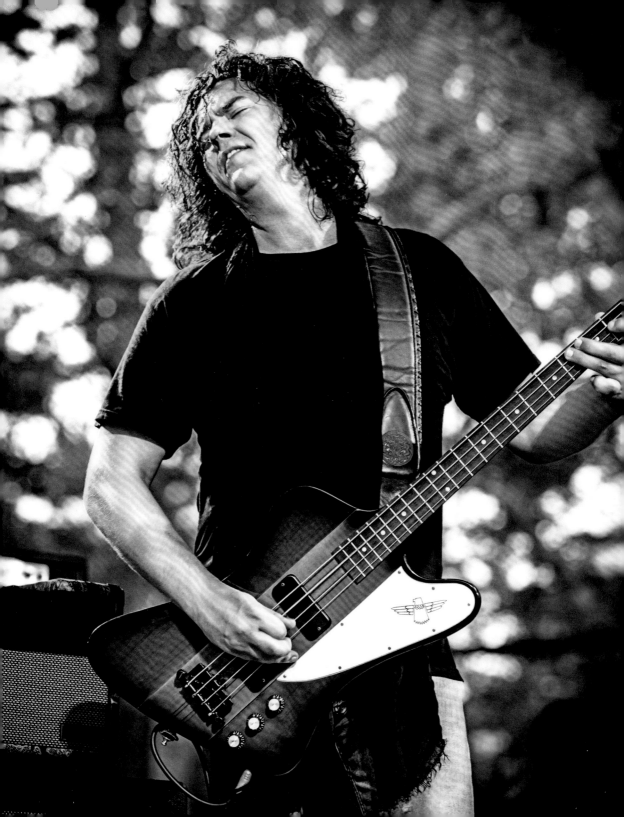

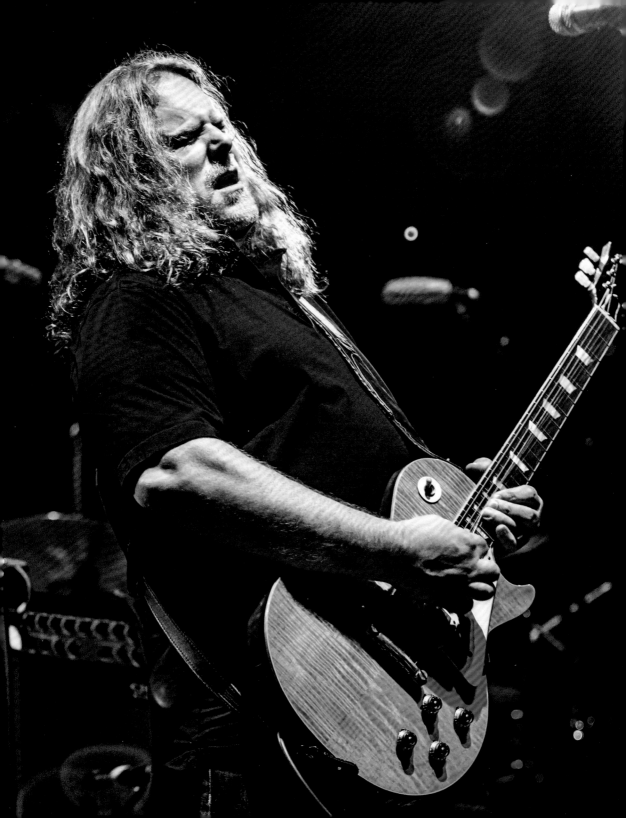

I JUST RECENTLY ACQUIRED THIS LES PAUL. I had been borrowing it and played it at several Allman Brothers shows. For the last six shows that we did with the Allman Brothers at the Beacon, I played it for the first time as the owner, and for the most recent show we did, I played this guitar quite a bit. That was a standout moment for me and this guitar.

Before that it belonged to my friend Ronny Proler, a vintage guitar collector in Texas. He had actually donated the guitar to the Big House, which is the Allman Brothers museum, and then I wound up striking a deal with them and acquiring it with Ronny's help.

I've always been drawn to the big, fat sound that Les Pauls have. A lot of my favorite players early on got wonderful sounds from Les Pauls. Eric Clapton played one with John Mayall and the Bluesbreakers, and that legendary tone that he got was a Les Paul through a Marshall. It was a sound that influenced many generations of guitar players. Duane Allman, Dickey Betts, Peter Green, Billy Gibbons—everybody, including Hendrix and Johnny Winter, played Les Pauls from time to time. I just always loved that fat sound. In the back of my mind, I was always looking for the sound of my guitar and the sound of my voice to be similar—to be a reflection of each other— that's what I've tried to achieve through the years.

The three best years of Gibson Les Pauls were '57, '58, and '59. The wood they used for all of those instruments back then was amazing and has a sound all its own. But the PAF pickups are probably the most important thing—PAF stands for "patent applied for." Those are famous pickups that have a unique sound that nobody has been able to duplicate. For this particular Les Paul, Brian Farmer mentioned at one time that he had heard dozens and dozens of '59 Les Pauls, and that this one had the sweetest front pickup of any he had every heard. In the past several years I have been playing a multitude of Les Pauls, including the three legendary ones that belonged to Duane Allman, and this is my favorite of all of them.

This one just has its own unique sound. I've had people tell me they could recognize the sound from a distance, that they could tell when I switched to that guitar. It's not a myth; there is definitely truth to the fact that these old instruments have a unique sound that you can't get with a new instrument. That's not to say that you can't get a beautiful, magical sound with a new instrument, but you can't get that exact sound. It's like a Stradivarius violin, which has that extra 1 or 2 percent that, to people who are connoisseurs of tone, makes a huge difference.

WARREN HAYNES

1959 | GIBSON LES PAUL

Opposite: Allman Brothers Band, Bryce Jordan Center, University Park, PA, October 13, 2008

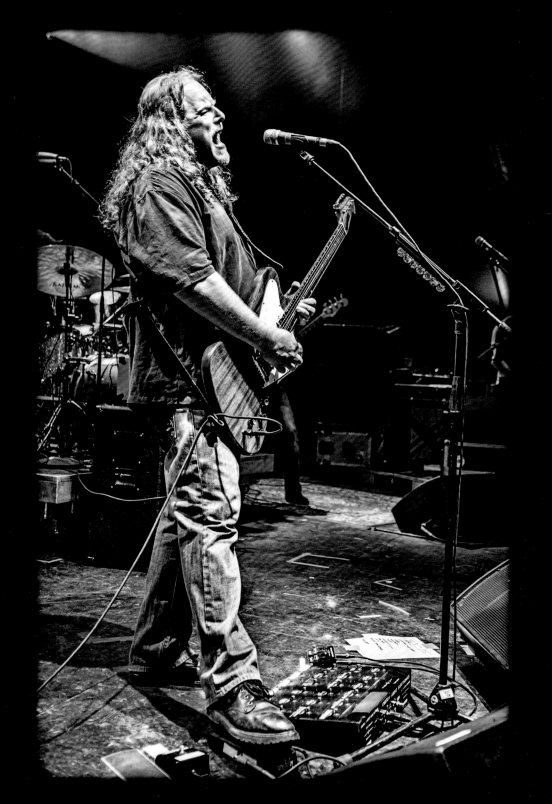

WARREN HAYNES

c. 2004 GIBSON FIREBIRD CUSTOM

Opposite: Gov't Mule, Mountain Jam, Hunter Mountain, NY, May 31, 2008

ORIGINALLY THE FIREBIRD was Gibson's answer to the Stratocaster. Because Gibson guitars are known for their warmth and their meaty sound, they wanted to make a guitar that had a bite and a cut similar to a Strat or a Tele. For someone like me, it's a nice middle ground; I can get a bitier sound, but still not go all the way to a Stratocaster or a Telecaster. Since the scale length of the neck is shorter—it's a Gibson scale length as opposed to a Fender scale length—it's easier for me to play, because I'm more accustomed to the way the Gibson scale length feels.

The first person I ever saw playing a Firebird was Steve Winwood in Traffic. He played a blue one that was really beautiful and had a unique sound. Gatemouth Brown played a Firebird, as did Brian Jones, but probably the most famous proponent of the Firebird was Johnny Winter. Johnny got such a unique, fantastic sound out of his Firebirds that people gravitated toward them after they heard him play.

I didn't start playing Firebirds until we were making the *Dose* record in '96. Allen Woody had one, and I played it on a few songs in the studio and fell in love with it and called Gibson and had them build one for me. I've since acquired probably a dozen of them; my oldest one is a 1964, which is pretty fantastic. A lot of the guitars I play were built for me in the Gibson custom shop, which is the case with this one.

Of all my Firebirds, this is the one I've played and recorded with the most. It's a non-reverse Firebird, meaning the top horn is longer than the bottom one, which is the opposite of the original reverse Firebird. I generally keep it tuned down a half step. That's something that Jimi Hendrix did a lot. So I've used this guitar for many of the songs that we play tuned down a half step, including "Bad Little Doggie," "Lay Your Burden Down," and "Lola, Leave Your Light On." Both of our live albums that just came out feature this guitar on the tracks that are tuned down a half step.

It has Burstbucker pickups. There's a Burstbucker Type 1 in the bass position and a Burstbucker Type 2 in the treble position. That's a different sort of sound as well. I'm able to get the thickness that I want but still get that bite, and that's important to me in a big environment on a big stage.

In my opinion, the non-reverse Firebirds have a little bit more thickness to them and play a little more in tune than the traditional Firebirds. This particular guitar just happens to really sound good on a big stage. Slim Judd, our front-of-house soundman, who has been with Mule forever and has been with the Allman Brothers forever, always mentions how good this guitar sounds coming through the PA. There is a difference in which guitars sound great onstage and which ones sound great in the studio. Some do both, but some are better for one or the other. This one does both.

MIKE GORDON

2014

VISIONARY INSTRUMENTS MOIRÉ BASS, CUSTOM

Opposite and following page: Mike Gordon, The Fillmore, San Francisco, CA, March 18, 2014

THIS INSTRUMENT IS ONE OF A KIND. It was finished for me just in time for my March 2014 tour, and Ben Lewry of Visionary Instruments flew out to some of our locations to make some final tweaks. The 3D light patterns were my idea, and they make for some great photographs—especially Jay Blakesberg's! There's also a 3D effect you can only see in person.

When I picked up this instrument, I wanted to transcend the typical jam band stage set by finding new themes that could encompass the entire concert experience from visual to auditory to interactive. I started noticing moiré patterns everywhere, and an exhibit by artist Annica Cuppetelli inspired the idea of an interactive use of these patterns. Ben Lewry had created some instruments for notable people— guitars with LCD screens or robot control knobs, so he was the perfect person to carry out my idea for the invention of a new kind of bass. He appreciated that, in an age steeped in digital projections, this concept is entirely organic—like two screen doors on steroids. It was Ben's genius that allowed an instrument to wirelessly take lighting cues and to react internally to the notes being played, without any compromise to the tone. Every time you use LED lights there is a pulsation that can put hum into guitar pickups, not to mention the various wireless circuits, and despite that the instrument has a better sound than any bass I've ever played!

What's most significant for me about this instrument is that when I was five I wanted to be an inventor. This bass allowed that dream to come true. I've never seen anything like it, other than the guitar version, which was simultaneously made for Scott Murawski. Interestingly, Trent Reznor has spoken about *avoiding* moiré patterns during Nine Inch Nails's inspirational stage visuals, where porous screens were walked across the stage in front of other screens. I set out to cultivate and find beauty in a pattern some see as menacing. I love looking over at Scott and seeing a vast pool of depth inside his instrument because of the 3D effect of the patterns. I also love that they sound great and that so far no one else has one!

"THE JAM SEEMED TO SCREAM OUT TO THE STRATOSPHERE, LEAVING A TRAIL OF BEIGE FIRE."

I've had several great moments with this instrument already, but one that stands out occurred when my band was playing "Peel" in Vancouver, and it became a long exploration. I even picked up a bouzouki at one point and then put the moiré bass back on, and then the music took us to some Portuguese hamlet. We had left the bass and guitar lights off, when all of a sudden the lighting designer, Liggy, blasted bright beige (a color only available when beamed from the outside) into the bass, the guitar, and the set pieces, and the jam seemed to scream out to the stratosphere, leaving a trail of beige fire.

It's amazing version one worked so well considering the research and development was being done almost until the day it shipped! Ben got the different kinds of circuits to coexist peacefully, and he's got great enhancements for version two, now in the making. The new one will have more colors, will react more dramatically to different notes being played, and will have some of the circuits consolidated inside. We are toying with an additional effect that would create a new feeling of depth using two-way mirrors and glass that changes color when it's charged.

When creativity is flowing well, I find it mushrooms to different facets of the same experience. It was exciting to get together with Scott Murawski and say, "Let's not just write a couple songs; let's make ourselves a whole new repertoire, and while we're at it, let's also make ourselves a mesmerizing dreamworld on stage that envelops us." It was on our first inspirational walk in Boston in 2008, fresh with a new band, that we also decided the audience should be able to "play the band" at certain moments. Little did we know that we would be designing new instruments to match, and the audience would be able to play those instruments from the crowd!

I remember lying on the family couch with my first guitar when I was about twelve. Every day I had a few minutes of slowly plucking notes and getting into the Zen of the tone decaying, the instrument balanced on my chest. My favorite thing is to pluck (or pick) a note on the moiré bass and feel a little bit of the metal screen after striking the note—it's a metaphor for the way I've taken my career into my own hands; I've pushed myself in a new direction unique to me. And really I've only scratched the surface! I wasn't intending a pun, but I can't really back out of that one.

TREY ANASTASIO
2002 | PAUL LANGUEDOC CUSTOM

Opposite: Trey Anastasio Band, Brooklyn Bowl, Brooklyn, NY, August 17, 2014

THIS GUITAR IS THE ONE I ALWAYS GO BACK TO. Paul used to be my roommate, so we talked guitars together frequently. This was going to be the guitar that could do it all. It would be hollow, but it would have the scale length of a Strat, and it would also have coil drops, which would make it single coil. A guitar that could have Strat-like tones and also jazzy tones, one that could go from Jimi Hendrix to Jim Hall. We were looking for a sound that didn't exist.

Paul built me three guitars before this one. I love each one of them. In some ways those three were stepping-stones, as he perfected his design. This is the fourth in the series, and the model for the guitars he builds today in this style. He's very meticulous around machinery, but one day while working at the shop when we lived together, he had an accident and all four fingertips of one hand went through the table saw. He came home after going to the ER, and I remember sitting on the kitchen floor together, drinking beers. Paul never complained about anything, but that evening he held up his hand and said, "I don't like to complain, but this really hurts." I think about that kind of stuff when I'm playing. An instrument is more special when you know that somebody has poured his heart and soul into it.

It's made of koa—a gorgeous, medium density wood—and it's braced like a mandolin, so it's hollow like a mandolin. It doesn't have a block of wood in it the way most hollow-body guitars do. Mandolins are braced that way so that you can get more volume out of them. An earlier version of the guitar was made of spruce and maple, and the neck had warped, so this guitar has layers of fiberglass in the neck to make it stiffer. Paul used a sliding wedge dovetail joint to connect the neck to the body. The pickups are Seymour Duncan PAF pickups—the same kind of pickups they had on Les Pauls in the 1960s, like what Jimmy Page played—a lower output pickup than a lot of the pickups used on guitars today. Paul's thinking was that the guitar is so hollow and resonant that it feeds back fine without the high output.

For some reason, it just seems to be *the* guitar for Phish. It's also the guitar I use when I play with orchestras. I always am nervous when I meet these great musicians, and the guitar is often the icebreaker. I'll put it on the stand and a couple of musicians will come over and say, "Wow, what a beautiful instrument. What is it?" And they'll tell me about their instruments, and that always makes me feel really honored when they do that. My favorite single quality about this guitar is how it feels against my body—it's so curvy and warm, and it just fits. I put it on, and it's like it disappears. It feels like a living thing, a piece of art when I play it.

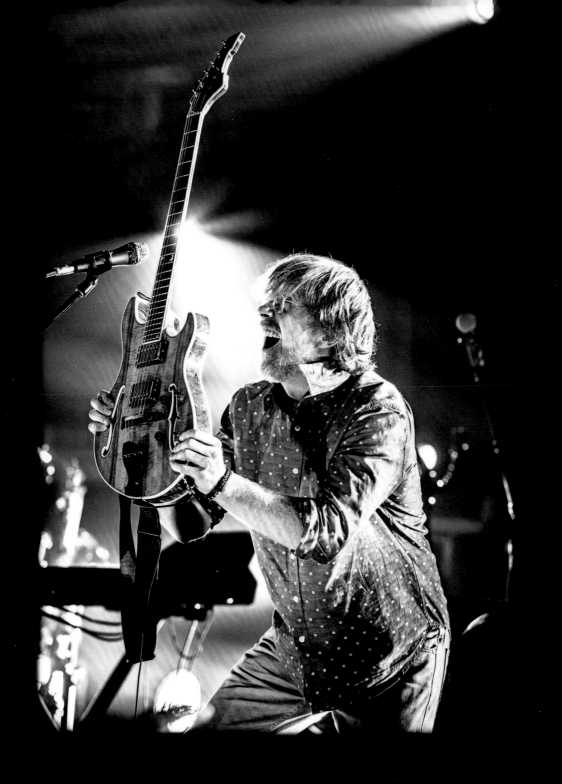

DEDICATION:
This book is dedicated to the memory of Brian Farmer. Farmer—as he was known—was loved by many. He dedicated his professional life to taking care of many of the most important guitars the Jam world has known. He is missed everyday! May the four winds blow him safely home . . .

NOTE FROM THE PHOTOGRAPHER:
Shooting live rock 'n' roll is exhilarating! The power of live music is undeniable and touches many. I love the experience of shooting everyone onstage; waiting for the magic to happen and capturing it in a fraction of a second. This book is a celebration of stringed instruments—guitar, bass, and mandolin—and those who play them. Guitars are beautiful pieces of art, and once in the hands of the musician, they become incredible tools with which to create new art and explore the multitude of sonic possibilities. It's an amazing cycle that I am privileged to photograph with frequency. For more than thirty-five years, I have been documenting the rock 'n' roll experience, and it is wonderful to be able to share this collection of guitars and the stories behind them through my photographs and through firsthand accounts by the artists! This completes another chapter in my ongoing journey to capture rock history, which continues to be an important part of our culture.

<div align="right">—Jay Blakesberg, San Francisco, January 2015</div>

Opposite: moe.'s gear, Carriage House Studios, Stamford, CT, November 8, 2013
Above: Warren Haynes (left) and Brian Farmer (right), Mile High Music Festival, Commerce City, CO, July 19, 2009

INSIGHT EDITIONS

PO Box 3088
San Rafael, CA 94912
www.insighteditions.com

©2015 Insight Editions
All photographs © 2015 Jay Blakesberg
All digital file preparation and retouching done by Ben Kautt
All interviews conducted and edited by Dustin Jones
All text written exclusively for *Guitars That Jam* except Jerry Garcia text, which
is courtesy of Blair Jackson, *Grateful Dead Gear* (Backbeat Books, 2006).
Used with permission.

Library of Congress Cataloging-in-Publication Data available.

ISBN: 978-1-60887-525-2

Publisher: Raoul Goff
Co-publisher: Michael Madden
Acquisitions Manager: Steve Jones
Art Director: Chrissy Kwasnik
Designer: Christopher Kosek
Executive Editor: Vanessa Lopez
Project Editor: Dustin Jones
Production Editor: Rachel Anderson
Editorial Assistant: Katie DeSandro
Production Manager: Jane Chinn

Find us on Facebook: www.facebook.com/InsightEditions

Follow us on Twitter: @insighteditions

ROOTS of PEACE REPLANTED PAPER

Insight Editions, in association with Roots of Peace, will plant two trees for each tree
used in the manufacturing of this book. Roots of Peace is an internationally renowned
humanitarian organization dedicated to eradicating land mines worldwide and converting
war-torn lands into productive farms and wildlife habitats. Roots of Peace will plant two
million fruit and nut trees in Afghanistan and provide farmers there with the skills and
support necessary for sustainable land use.

Manufactured in Hong Kong by Insight Editions

10 9 8 7 6 5 4 3 2 1

Front matter captions:

Pages 2–3: moe., Red Rocks Amphitheatre, Golden, CO, July 4, 2013
Page 4: Neil Young & Crazy Horse, KeyArena, Seattle, WA, November 10, 2012
Page 6: Phil Lesh and Friends, Terrapin Crossroads, San Rafael, CA, March 9, 2014
Pages 10–11: Phil Lesh and Friends, Terrapin Crossroads, San Rafael, CA,
February 20, 2014

I want to thank the many friends and family who
helped make *Guitars That Jam* happen!

Laurie Bienstock, Sam Blakesberg, Ricki
Blakesberg, Dustin Jones, Steve Jones,
Raoul Goff, Michael Madden, Ben Kautt, Emily
Sevin, Warren Haynes, Stefani Scamardo, J. Bau,
Adam Kowalski, Brian Farmer, TJ Centrella, Peter
Banta, Chris Austin, Eric Hanson, Adam Fells,
Jon Topper, Skip Richman, Vince Iwinski, Bobby
Haight, Blake Budney, Mick Brigden, Jimmy Mac,
Randy Miller, Matt Busch, AJ Santella, Chris
Charucki, Chris McCutcheon, Kent Sorrell, Jason
Colton, Julia Mordaunt, Kevin Morris, Patrick
Jordan, Richard Glasgow, Christine Stauder,
Nate Erwin, Brad Sands, Leanne Lajoie, Jennifer
Kimock, Bradley Shulak, Drew Granchelli, Cam
Morin, Carrie Lombardi, Jeremy Stein, Nadia
Prescher, Todd Zimmerman, Alicia Karlin, Jesse
Aratow, Eric Baecht, Jill Lesh, Kathy Sunderland,
Emily Sunderland, Fred Cox, Robbie Taylor,
John Joy, Jenna Lebowitz, Eric Mayers, Mike
Martinovich, Scott Booker, Chris Chandler, Peter
Shapiro, Dave Frey, Michael Bailey, Gary Chetkof,
Richard Fusco, Drew Frankel, Don Strasburg,
David Foster, Dawn Holliday, Ian Goldberg, Jay
Goldberg, Arlan Goldberg, Mike Armintrout, Don
Sullivan, Stacey Waterman, Jon Dindas, Kirk
West, Ken Hayes, Leda O'Callaghan, Stephanie
Blatt, Vicki Casella, Jodi Goodman, Mary Goree,
Bill Wood, Gregg Perloff, Sherry Wasserman,
Steve Welkom, Allen Scott, Mary Conde, Bryan
Duquette, Dan Kasin, Sarah Fink-Dempsey,
Emily Welmerink, Chris Tetzeli, Pete Costello,
Dave Margulies, Rebecca Sparks, Roy Carter,
Aaron Kayce, Paul Winston, Michael Klein, David
Lefkowitz, Larry Sykes, Howard Sapper, Charles
Twilling, Steve Lopez, Joel Byron, Carolyn Herring,
Brian Sarkin, Amy Finkle, Blythe Nelson, Blair
Jackson, Eric Johnson, Elliot Roberts, Frank
Gironda, Bonnie Levetin, Frank Robbins, Nate
Pientok, and Larry Cragg

And a special thanks to the following venues:

Red Rocks Amphitheatre, Terrapin Crossroads, New
Orleans Jazz Fest, Mountain Jam, Great American
Music Hall, Fox Theater Oakland, Summer Camp
Music Festival, moe.down, Lockn', TRI Studios,
Gathering of the Vibes, The Bridge School,
Shoreline Amphitheatre, Stern Grove, Crystal Bay
Club, Greek Theatre, Brooklyn Bowl, High Sierra
Music Festival, Sweetwater Music Hall,
The Warfield, The Fillmore, Harmony Festival,
and The Capitol Theatre, Port Chester, NY